To Alan
With love from Aud
Christmas 19

DAVID BELLAMY'S

Painting
—*in the*—
Wild

A PRACTICAL GUIDE

DAVID BELLAMY'S
Painting
—in the—
Wild
A PRACTICAL GUIDE

HarperCollins*Publishers*

*To Catherine, whose advice on painting a
watercolour in a snowstorm is 'Colour it over
with watercolour crayons and pretend you're
doing a pattern'.*

The video *Mountain Adventures in Watercolour*
from APV Films complements this book

Published in 1992 by HarperCollins Publishers
London

First published in Great Britain 1988 by
Webb & Bower (Publishers) Limited
in association with Michael Joseph Limited
Reprinted 1988, 1990

Designed by Peter Wrigley
Produced by Nick Facer/Rob Kendrew

**A catalogue record for this book is available from
the British Library**

ISBN 0 00 412683 1

Text typeset in 12/13pt Photina
Typeset in Great Britain by Keyspools Ltd, Golborne, Lancs

Printed and bound in China produced by Mandarin Offset

CONTENTS

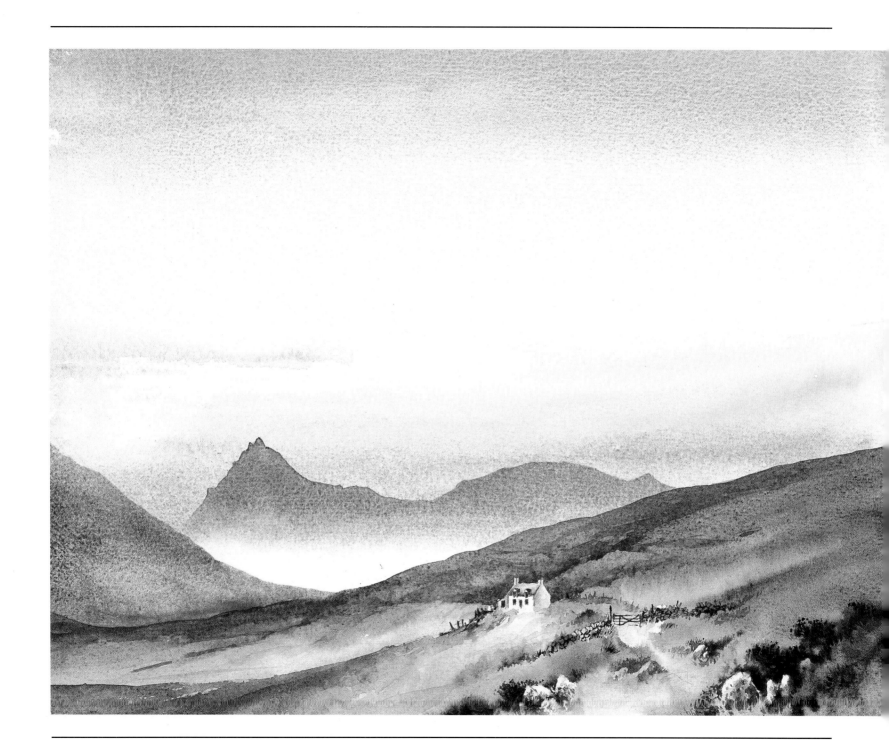

I
INTRODUCTION

I live not in myself, but I become
Portion of that around me; and to me
High mountains are a feeling, but the hum
Of human cities torture

LORD BYRON

SGURR NA H-AIDE
A low-level scene painted with French
ultramarine, raw sienna, burnt sienna,
crimson alizarin and some raw umber.
Splashes of colour, especially crimson
alizarin, have added interest into the
ground passages.

Soft snowflakes began to fall gently as I climbed the last few feet to the summit of Red Pike, high above Wasdale. To the east the sky darkened. A snowstorm swept across the fells, quickly blotting out Great Gable. The atmosphere rivetted me to the summit crags, so that I became totally enraptured by the seething mass of snowflakes swirling towards me. I sketched furiously in watercolour. The storm arrived, quickly turning the wet washes into a dripping mess, a soggy multicoloured mess that changed patterns as it fluttered in the wind. There must be a better way of doing this, I thought, packing the sketch into the mapcase, and creasing it on the way in. Yet later when I looked at the sketch it possessed something for which I had been striving hard: a loose spontaneity with a powerful image.

I remember that incident well for on those rocks on Red Pike I realized that my main ambition in life was to paint mountains; to capture that elusive mood of the hills; and that despite the mess, I had achieved something which could be improved upon. No one could tell me how to paint up high mountains, for I knew of no one who had painted on high peaks before. So I had to let Nature teach me, and this she did, much more effectively than any book or teacher. Books and teachers can help speed your journey but ultimately landscapists must seek out nature for themselves, in order to really improve. So it was the mountains that led me into art.

Painting to me is a joyful, at times crazy, experience. The more I paint, the more it inspires me. I firmly believe that no artist will achieve the finest work without an emotional response to the subject, whether it is a landscape, vase of flowers, nude model or whatever. To me it is the wild, elemental forces of nature, the wind through the crags and the storm over the peaks, that fire my brush. When painting becomes a routine formula or is made to follow rigid disciplines it becomes stifled and negative. There is no room for dogmatic rules in watercolour painting, for it is super-lative in evoking nature's moods, and at its best free and spontaneous. It is the ideal medium for painting in the mountains.

The painting of mountain scenery did not develop properly until the mid-eighteenth century. Before that travellers were horror-struck at the prospect of venturing into wild mountains. Climbing mountains for pleasure was considered eccentric, and it still is in some quarters, even today. This was also around the time when watercolour painting began to emerge as an accepted medium in which to paint pictures, for until then it had been little more than tinted monochrome drawing. In both watercolour and mountain scenery the influence of Paul Sandby (1725–1809) became considerable. As a surveyor in the highlands following the battle of Culloden he began to draw the public's attention to paintings of the wild scenery of Scotland and Wales. He was chiefly a topographical artist: the topographers recorded scenes in a realistic way, in most cases recasting part of the picture in classical Claudian terms. This involved rearranging elements of the landscape in a more formal, idealized style, in particular with buildings or ruins in the middle distance, thus imitating the manner of the French landscape artist, Claude Lorraine (1600–1682).

Interest in the mountains was also kindled by the fact that travellers embarking on the grand tour, seeking the classical art of Italy, had to pass through Alpine scenery. As cameras had not been invented the well-to-do often took along an artist. The Alpine wilderness had a profound effect on the work of artists such as Francis Towne (1739–1816), John 'Warwick' Smith (1749–1831), John Robert Cozens (1752–1797) and William Pars (1742–1783). Gradually, towards the latter half of the eighteenth century, the topographical approach was transformed into the romantic landscapes of Turner, Cotman and Girtin. Gone was the

EILEAN DONAN CASTLE
A romantic and dramatic subject, and in the true Picturesque style I have slightly emphasized the height of the mountains and increased the dramatic atmosphere. Even though the castle is some distance into the painting it still is unduly large compared with the background mountains, so increasing their height is not really changing the landscape in this instance. It is in fact giving nature its rightful prominence. The background mountains contain no detail, which is absent until the eye wanders across to the the left-hand side of the painting where a suggestion of trees is indicated. The work has been painted on Turner Grey hand-made tinted paper and the highlights brought out by painting on white gouache straight from the tube.

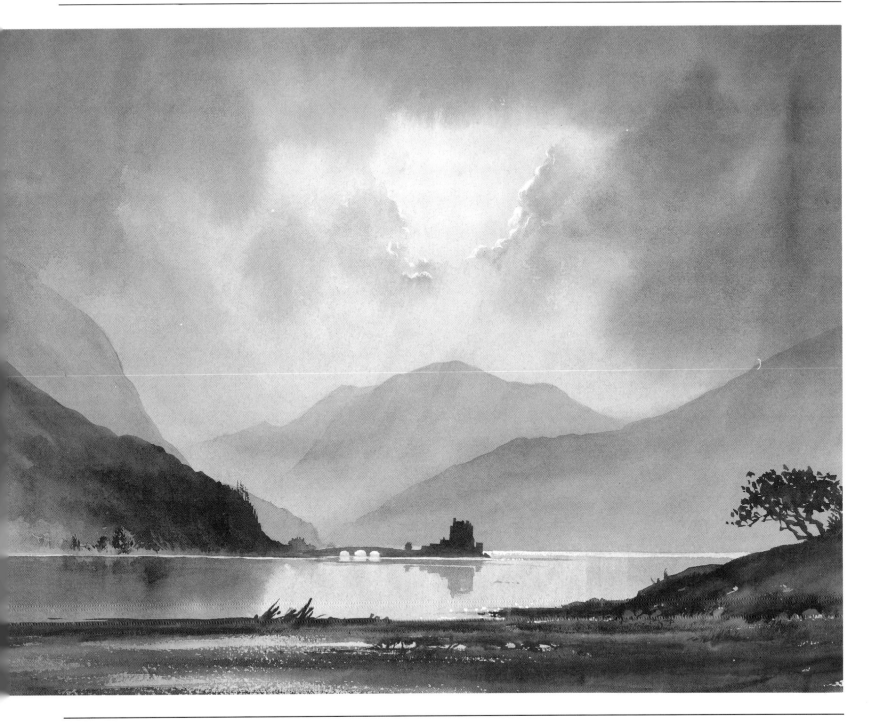

precise rendering of scenery, and in its place a more personal, poetic interpretation of nature and its moods, at times imagined, even eccentric, and thus allowing far more creativity. A strong influence here was the Welsh artist Richard Wilson (1714–1782), an oil painter. His painting of Snowdon from Llyn Nantlle, being in the topographical vein, was reasonably faithful to the landscape, with certain Claudian elements incorporated into the foreground in the form of figures and trees acting as a frame. However, in painting Llyn-y-Cau, on Cadair Idris, his approach was quite different: liberties have been taken with the mountain, hinting at a sense of romanticism.

With the French Revolution and subsequent wars in Europe, British artists were forced to turn to their own country for inspiration. Every landscape artist worth his salt headed for the Lake District and North Wales. This was the age of the Picturesque, which, according to the Reverend William Gilpin (perhaps the leading authority on the subject), involved the rearranging of nature to artistic advantage.

In America one of the early painters entranced by wilderness scenery was Thomas Moran (1837–1926). The spectacular landscapes of Colorado, Wyoming and Utah caught his imagination and through his paintings of Yellowstone he was instrumental in creating the first national park in America.

All artists are inspired by others to a greater or lesser extent. Without doubt Turner has had the most penetrating influence on my work, for not only did he respond to the same sort of subjects, but was also a great outdoorsman. At times he revealed emotion and was moved by historical events, which perhaps explains his greater emotional re-

SCAFELLS FROM BOW FELL
A high-level subject showing the rocks bathed in warm evening sunlight, painted mainly with cadmium red and French ultramarine.

DARK POOL
Clear water on a sunny day can be one of the most exasperating subjects to paint: particularly in watercolour. Not only are rocks below the surface of the water visible, but this effect is broken up by surface reflections, cast shadows, sparkle and ripples on the water. I sketched the scene, a gorge in mid-Wales, became frustrated with my poor work and then jumped into the pool. A refreshing interlude on a hot afternoon, and one which I wish I could do more often.

sponses to the Welsh scenery than the later Alpine works. He put himself into situations in which few other artists found themselves, and so at times was sadly misunderstood. You only have to be on the mountain-tops on a really bad day to appreciate some of Turner's more ethereal works, composed mainly of light and moisture. I can well understand how he became excited about absolute nothingness when transported to the wilds, where at times forms are indefinite—what goes up or down, or to one side you cannot define—where the world is a haze of surrealistic shapes bound in the warm, mysterious fog of mountain atmosphere.

I cannot promise you any mysterious fog, but in this book you will find ways of seeking out the most glorious scenery in the country, and methods in which to capture it on paper. The book, a comprehensive guide to painting in watercolour, progresses in a logical order from outdoor sketching to finished paintings. The following chapter discusses ways of finding subjects, preparation for sketching and puts forward several ideas. This is followed by chapters on sketching outdoors, producing paintings from the sketches, creating mood and drama, presenting the final picture and improving your work. Chapter nine is a guide to some of the most picturesque sketching locations in the mountains, and most of the places selected are well within the capacity of the average Sunday stroller. Finally, equipment and materials are covered in depth in chapter ten.

True art is an emotional conflict in which on the one hand the artist finds inner peace within the beauty of painting, and yet on the other hand strives, constantly unsatisfied, for that elusive perfection. The lonely mountains enhance this inner peace, and the higher you climb, the greater the feeling of peace and freedom. Whether you wish to climb high for your subjects or simply work from the car, I hope this book will fire a longing to capture the wild places in paint.

2

PLANNING YOUR SKETCHING TRIPS

Mountains are the beginning and the end
of all natural scenery

JOHN RUSKIN

Why subject yourself to the dubious pleasure of sketching out of doors—especially on a wild day? Is there any point in doing what is at times an arduous task when there is so much available material from which to copy? There are many reasons why you should get outside and work directly from nature. Firstly, no photograph can give the range of tones, intensity of colour, amount of detail or feeling of atmosphere that is before you in the great outdoors. There you can move around and compose the work as you wish, unhampered by the borders of a photograph, postcard, or whatever. You can therefore choose to add or omit features as appropriate. Secondly, it is your own original creation. You are not copying a style, whether that style is painterly or photographic. The third reason for sketching is that nature teaches us so much: to observe forms, effects of light, the interplay of hard shapes against soft ones, plus a host of other visual sights. You quickly learn how to depict the subject, what are the effects of weather on it, and how it relates to its environment. As with many facets of life, we understand better if we find out for ourselves first hand, rather than continually rely on others to show the way. Nature is full of visual surprises, waiting to be discovered.

A further reason for working outside, particularly when the weather makes sketching a little difficult, is in having to work rapidly. Then there is no incentive to over-labour the composition, but a need to grasp the essential points immediately, leaving out unnecessary detail. It demands decisive action, yet being a sketch and not a finished painting it can be tackled with much greater panache. At times it will result in a mess, especially in bad conditions, but much will have been learned. This I feel is the best way to achieve

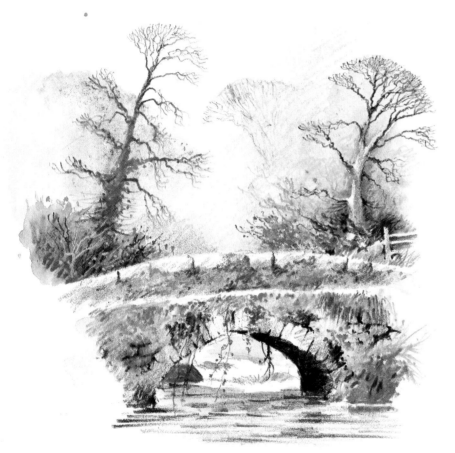

BRIDGE ON BECCA BROOK, DARTMOOR
This is a study done purely with Derwent watercolour pencils, using an old brush to push water across the paper and blend in the initial pencil marks. It was not an easy subject, as I had to climb out on to a fallen tree across the river to obtain the perfect view. Alas, the tree was festooned with branches and twigs, several of which kept tickling my nose as I sketched. As I dislike hacking anything down the only answer was to fend off the infuriating foliage with my left leg, but as this involved keeping it higher than my left shoulder it soon became rather tiring, not to mention the somewhat peculiar pose I offered to any passers-by.

CLACHLET
This was a targeted subject—that is, I knew that I wanted to paint the mountain. No climbing was involved as the sketch was carried out from beside the road which runs across Rannoch Moor. It could even have been done from the car if necessary. Two Rivers cream-tinted rough paper helped provide a warmer base colour than the usual stark white.

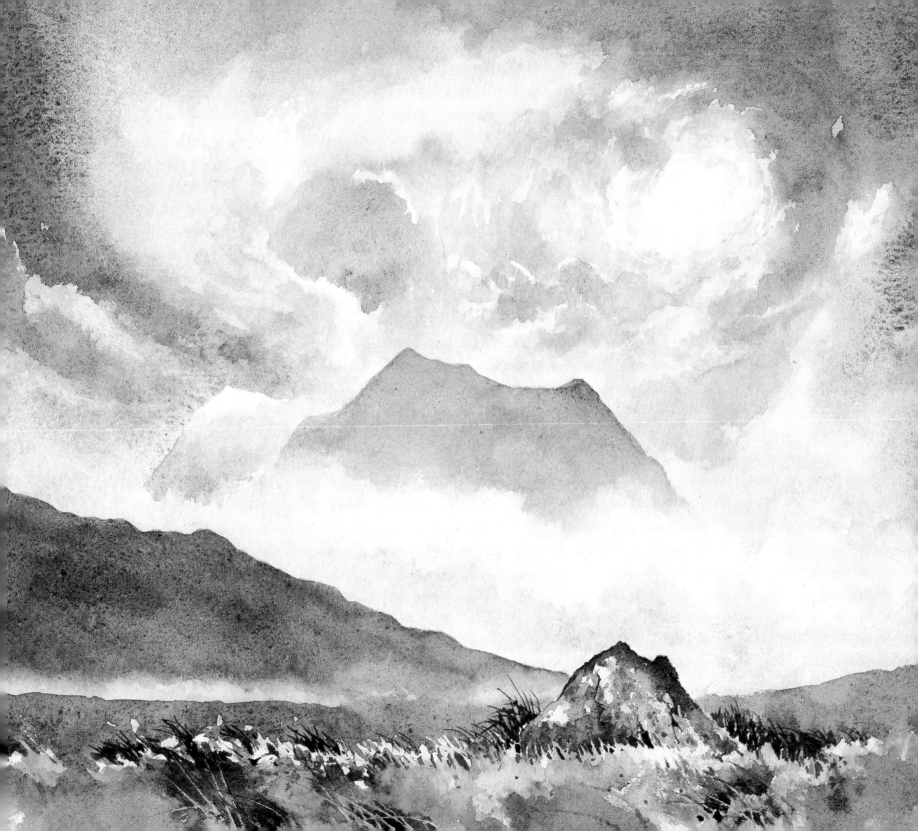

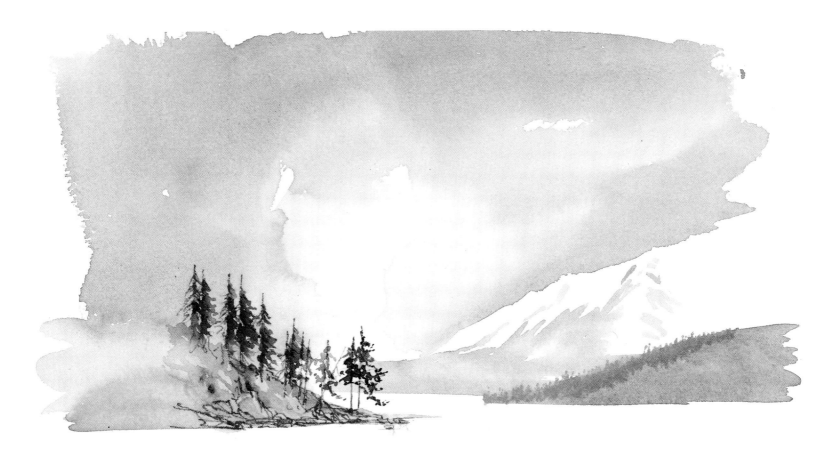

spontaneity, the hallmark of a good watercolour. Sketching is therefore a learning process as well as a means of acquiring subject material for a painting.

There are three basic types of sketching approaches: a study, a compositional sketch and an atmospheric sketch. The study is a highly detailed rendering which helps you to understand how to draw or paint a certain object—a tree, a wall or whatever. It enables the student to learn how to record the basic elements of the landscape, but also to provide a pool of graphic information that is useful to include

ABOVE:
LOCH LAGGAN
A rapid watercolour sketch carried out using Payne's grey and raw sienna, and an example of a compositional sketch aimed at capturing a more general scene than the bridge study.

ABOVE RIGHT:
**SEMERWATER AND
 ADDLEBOROUGH**
This is an example of what I call my 'atmosphere sketches': a misty morning

The sketch has been done on good quality cartridge paper, using a sponge to create the misty feeling after the hill had been painted in and allowed to dry. I then rewet the lower hillside with muted colour and worked in some detail to suggest trees using a brown watercolour pencil. A black one would have been too powerful, obviating a feeling of recession. Gradually I worked down the paper, suggesting trees and wall this side of the lake

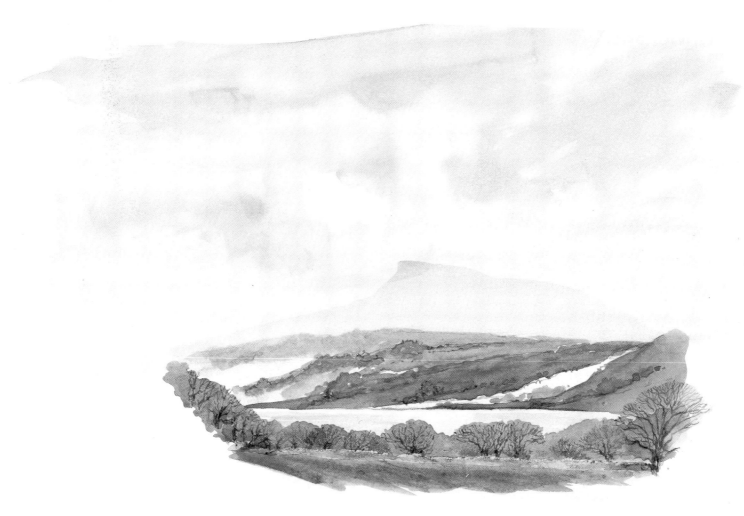

in future paintings. The compositional sketch is less detailed and provides an overall view of the scene, concentrating mainly on the centre of interest and how it fits into the scene. Atmospheric sketches are those where the elements are paramount: the wind, rain, blizzard, mist, and so on. Here the artist concentrates on capturing these ethereal qualities at the expense of the topography. When you are out looking for subjects consider which of these three approaches suits the occasion.

FINDING SUBJECTS

Before going into the wild blue yonder it is a good idea to consider how you should approach the task of obtaining subjects. As the mountain environment can at times be extremely hostile, you need also to think about comfort, and indeed survival if the intention is to climb high or venture any distance into a mountain range. Walking and sketching are two highly compatible pursuits, and you may actually find that sitting in the car for any length of time in cold weather can be worse than being out in it, for usually when

walking you maintain body heat. Certainly a twenty-minute walk will normally provide enough heat to carry out a quick sketch, even on icy days in the Scottish Highlands.

How do we go about finding subjects? It is all very well going off on a walk, but even if we take a guide book it often does not give any indication of the feast of visual delights that may or may not lie before you. Should you just trust to luck along the way? No, subject-finding should be a much more scientific process. And I don't agree with those old text books that say you should, if blindfolded and taken to a spot in the countryside, paint the first thing you see when the blindfold is removed. I firmly believe that you should seek out only the type of subject in which you are interested: what you enjoy painting, what gives you inspiration. I find that my best work is done when there is a strong emotional response to a scene. Memories of a battle for survival in the subject area tend to heighten my awareness and enthusiasm when painting the final work. It may take a while to discover the sort of subjects that move you, but it is well worth while taking pains to find out. If you have a thing about combined harvesters, what are you doing in the mountains? I cannot get excited about red saucers, so I don't paint them, though once a colleague got so worked up about one that I thought she was going to swoon before she got her pencil out.

Finding subjects involves preparation before making the trip. Having decided on the general area to explore, search through books, illustrated guides, brochures, postcards, paintings, prints and anything that will give you an idea of what might be an appealing scene. Usually it can be pin-pointed on the map; but sometimes it needs a little detective work. For instance, I once saw a photograph of an interesting packhorse bridge in a magazine, but the caption only mentioned the valley, which was quite long. This provided me with an excellent objective for a walk: find the bridge! Looking at the map it soon became obvious that the bridge could only be in three or four positions, at one of the intersections of stream and old packhorse route. Even then, it took some finding, but proved to be a magnificent subject. Visiting art shops and galleries in an area is of course

interesting in itself, but look out for local paintings that portray subjects which might appeal, with an eye to finding that subject for yourself. Turner made extensive preparations for his sketching journeys, writing out comprehensive notes from the available guidebooks, and even making thumbnail sketches of scenes depicted in books and magazines. He also sought out views painted by other artists.

The Ordnance Survey 1:50,000 map series is superb, and after a while you should be able to read them like a book when searching for subjects. For example, the Dartmoor one shows many clapper bridges, a feature which has always fascinated me. Lonely buildings set on the hillsides before a huge mountain are indicated, and you can see where a stream can provide you with a lead-in to a painting of a corrie or mountain. The character of lakes, mountains and the general topography can be gleaned in this way. Routes can be planned alongside streams and also in the best direction to take advantage of the views. The most direct route is not always pictorially the finest. Additionally, from the map you may get an indication of the optimum time of day to approach a subject, such as a huge cliff face, with regard to the lighting. For instance, on the Cwm Glas side of Crib Goch the crags of Crib Goch are at their most impressive when lit up by evening light. The 1:25,000 scale maps give even more detail. The maps are also of use to the non-walker of course, as they provide so much information on what can be seen from the roads. If you begin your walk with a fair idea of what you are looking for, and have one or two targets in mind, it makes life easier. However, keep your eyes and mind receptive to subjects which suddenly present themselves. Setting objectives decreases the chances of going home empty-handed. I was once given a grid reference and compass bearing and asked to paint the view—quite a novel

COTTAGES, NORTH STAFFORDSHIRE MOORS
An opportunity subject, but one which I expected anyway if I drove around for long enough. This one, I admit, was sketched from the car in pencil: I see little point in diving into the nearest ditch and making life difficult when the optimum view is from the car

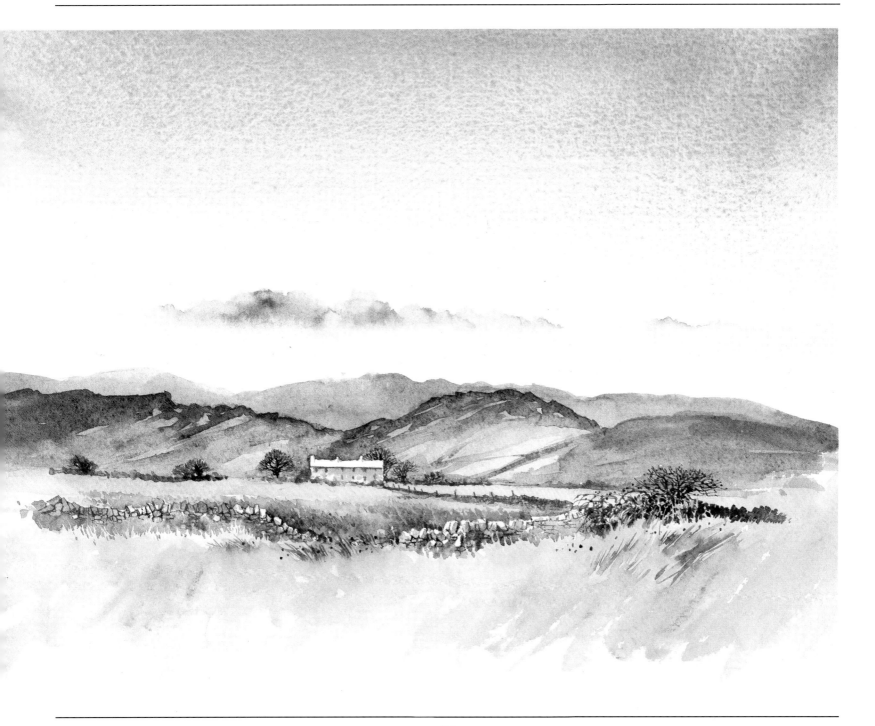

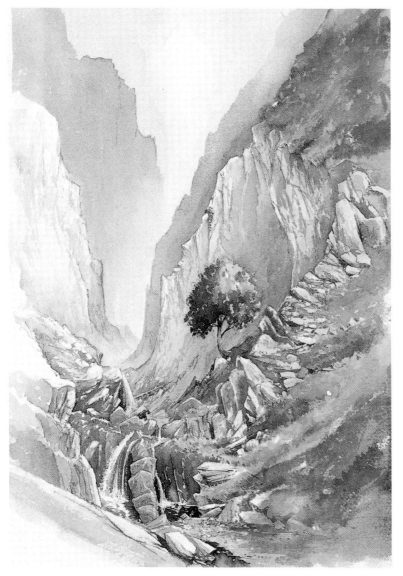

LAKELAND GILL

Typical of many Lakeland Gills, this is what I call a 'terrain-targetted subject'. It was found by looking at the map to seek out what appears to be an interesting feature, although not having seen a photograph or picture beforehand

there is an element of doubt as to whether it will turn out to be of interest. On this occasion the mist induced me to search for this type of scene, which can be enhanced by mist when the fells are not worth climbing for subjects' sake.

commission. It turned out to be part of the Cyfrwy Ridge from the middle of Llyn y Gadair on Cadair Idris. Luckily it was summer, so I swam out and managed a rough sketch.

THE VALLEYS

Much can be done in the valleys without the need to do any climbing. Farms, bridges, rivers, distant mountains, lakes, cattle and even some low-level crags and rugged scenery provide ample material. Many roads climb quite high. Take the main road across Rannoch Moor and you might be in the middle of that great wilderness—especially in thick mist. Do move around though and get the optimum view. Just a short walk can sometimes make all the difference, by providing you with an interesting foreground, or a slight elevation. When the mists close in of course it is rather pointless seeking out high-level subjects, but even in thick mist you can usually achieve something in the valleys.

THE HIGH PLACES

Here, beauty and danger are often close companions, but you need only go as far as your experience of mountains dictates. A new world is opened up: tarns, crags, rocks, bothies, summits, ridges and sparkling mountain streams. Rarely will you be disturbed by onlookers here, and the atmosphere and peace of the high fells can have a profound effect on your work. The views across to other peaks can be stunning, and quite often it is the lower, less popular peaks that afford the best views. On the highest fells, unless you are painting the sky, generally you can only look down on subjects.

THE WORLD OF ICE AND SNOW

In winter the mountains are transformed. They seem so much more impressive and clear. Again, without the need to climb you can get many exciting scenes from low level, but get out early in the day when it is crisp. Fresh snow is the ideal, pictorially, but in the high places freshly fallen snow can be highly dangerous, bringing risk of avalanches. A fine day in the winter mountains is a memorable experience, but

to climb high you need to be fully conversant in the use of an ice-axe. Ice-falls, snow-bridges, cornices and frozen tarns provide totally different types of subjects, in a variety of subtle hues.

PREPARATION

Working in the hills can be great fun, but as with any holiday it does need adequate preparation. Routes have to be planned, maps and guides obtained, clothes and equipment checked and accommodation booked. Try out your equipment and materials at home first—I recall one of my students on our first day out trying to insert a one-and-a-half-inch flat brush into a water container with a one-inch neck. Whatever happened to the simple jam-jar? Take the minimum of equipment: try to get away from the 'Christmas-tree mentality' of having so many things dangling from your neck. Another student carried an enormous box on straps—big enough to hold sufficient art materials for several courses. An easel in the mountains, unless you are sketching near the car, is more of a liability than an asset. Some types are difficult enough to erect in the studio: in a force ten gale they take on a will of their own. One student asked me to erect an easel for her: after several years she had failed to set it up herself. I battled for some fifteen minutes with its twenty or so legs, managed to get it up, and was then handed the instructions.

To begin with, unless you have tried it already, you are unlikely to have any definite views on how you would like to approach sketching: maybe you are more concerned about those hordes of awful people who descend on the unfortunate landscape artist sitting nervously before an easel. This prospect, however, seems worse than it actually is. Normally people make kind and encouraging remarks about the most atrocious paintings. If you wish to discourage viewers, position yourself against a wall, on a narrow ledge, in the middle of the stream, or crouch as though with evil intent in the undergrowth. Even so, the occasional artistic voyeur comes along and will stop at nothing to manoeuvre into position to see your work. I find, however, that when I am

OVERLEAF, LEFT:
PENNINE BARN NEAR ALCOMDEN
This was an opportunity subject, as my main target was the bridge nearby, for which I not only had a written description, but also a grid reference. The barn, however, excited me more than the bridge. For this painting I chose a Two Rivers paper with a NOT surface: I saw no need to use rough paper as I planned quite a lot of delicate detail in the trees and barn.

I began by wetting the sky liberally with clear water, then painting in a streak of lemon yellow in the sky just above the roof of the barn with a one-and-a-half-inch flat brush. Without pause I then brushed on Payne's grey mixed very slightly with some burnt umber, from the top of the sky, bringing it down softly into the lemon yellow. Still working quickly I then laid a wash of crimson alizarin mixed weakly with Payne's grey into the lowest part of the sky, blending it into the still-wet yellow above. All this needed planning beforehand, for it would be fatal to delay and possibly cause run-backs if the earliest washes had begun to dry.

The painting was then left to dry before the distant mass of trees was indicated with little detail. Once the hills had been rendered work on the barn could begin, initially by laying in a weak base of raw sienna. For these secondary washes I used a number eight fine sable brush. Next I painted the foreground field with a mixture of raw sienna plus a weak element of Payne's grey. Once this had dried completely I darkened the roof with raw umber plus a hint of Payne's grey and then worked on the hedging and fencing, which to the immediate right of the barn was done by delineating the dark bushes with a raw umber and Payne's grey mix, leaving the positive fence-shapes to show. Burnt sienna mixed with Payne's grey produced a rich dark for the trees and bushes to the right,

all rendered with a rigger brush, which was also employed on the barn to suggest stonework, windows and the doorway. Next came the sheep, in raw sienna with a touch of Payne's grey. Finally, the foreground dark area was laid over the earlier wash, this one a more powerful version of the Payne's grey-raw sienna mixture, together with a suggestion of grass.

OVERLEAF, RIGHT:
CIR MHOR
Cir Mhor is one of the most impressive peaks on the Isle of Arran and was a high-level targetted subject. I knew well in advance that there were several excellent views of it from both high and low-level, so my route was planned to take in quite a few of these, including the summit. Alas, when I reached the summit it was in dense mist, so all I could see were my feet and a few rocks. Later on it cleared to allow an exciting day's sketching and scrambling.

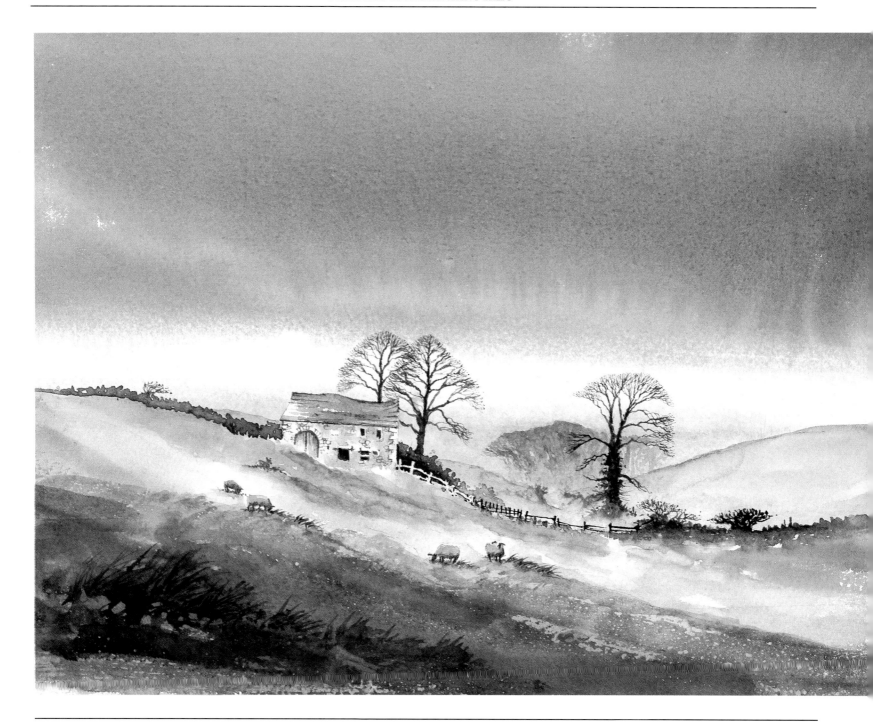

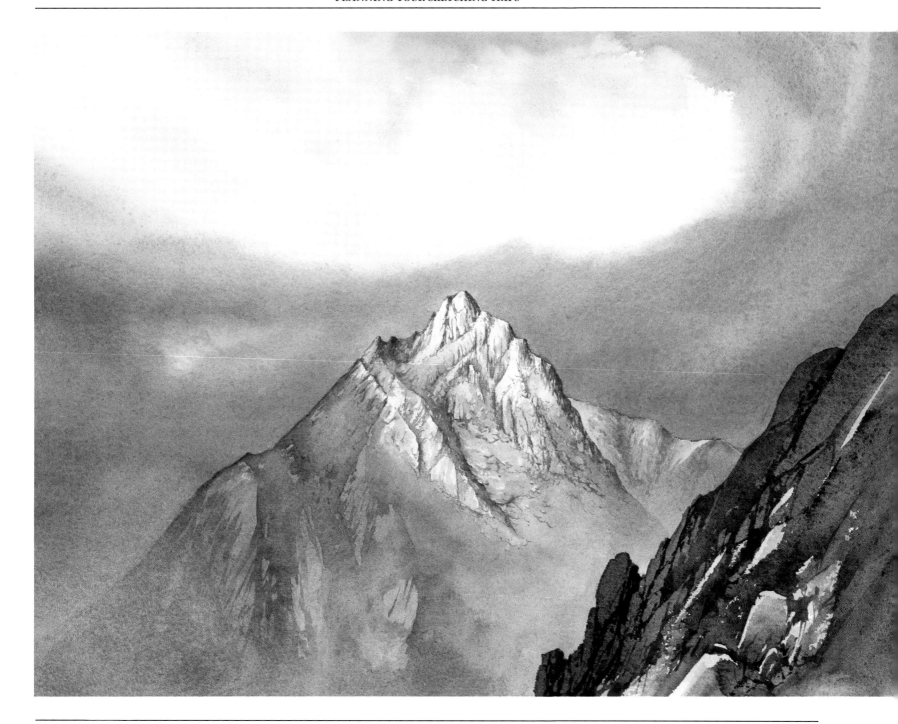

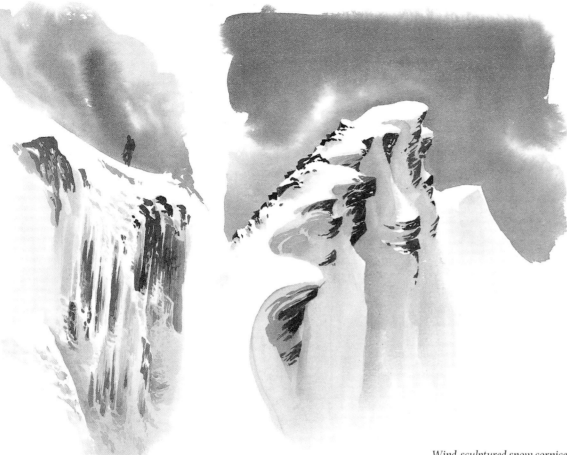

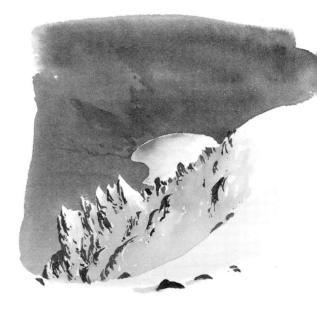

Ice-fall on Ben Nevis.

Wind-sculptured snow cornices on An Teallach.

Looking down on Ffynnon Lloer — Well of the Moon — from Pen-yr-ole-wen.

sitting in a furious snowstorm people tend to keep well clear. There are times when a family turns up, as once happened to me by Innominate Tarn on Haystacks: dad tripped up to the tarn and encouraged the kids to hurl stones into the water. Pretty soon it was like sitting at an easel in the middle of the D-Day landings. But such moments do not happen often.

SKETCHING GEAR

If you have not tried sketching before, simply buy a pad of good quality cartridge paper about 6 × 8in plus a selection of pencils graded from 2B to 4B. These, together with a sharp knife to keep good points on the pencils, will suffice for the initial few trips. There is no need for any expensive outlay. The pad can be kept in pocket or mapcase and rapidly brought into action. A mapcase is extremely handy, as it can hold loose paper cut to the right size. Viewers don't often realize you are sketching when working with just a pencil and pad, so it is an ideal way for the timid to begin. They may just as easily think you are a poet, mystic or DHSS official, as

Snow, ice and water: fascinating patterns appearing eerie in highland mist.

Icy highland stream.

Dark water, white snow in the Brecon Beacons.

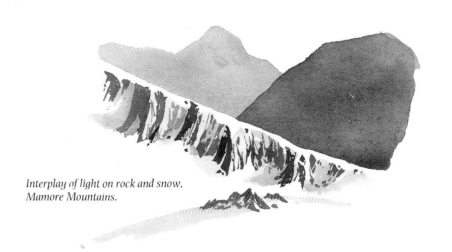

Interplay of light on rock and snow, Mamore Mountains.

an artist. An excellent tool for sketching in inclement weather is the Karisma Graphite Aquarelle pencil, manufactured by Berol. These pencils allow you to apply tone by rubbing with wet brush or thumb, and so introduce atmosphere into a pencil sketch. Alternatives to the pencil are charcoal, conte crayon, and pens. Charcoal naturally tends to be messy, but has a rich quality. Large areas of tone can be applied quickly. A damp rag for cleaning hands and a fixative spray to prevent loss of definition in the finished work, are essential additions. Conte crayon, a hard chalk, comes in pencil and chalk form, in black, white, sanguine and sepia. It is excellent for producing quick monochrome studies, and should be fixed like charcoal. Pens come in such a wide variety that it is advisable to experiment with several types until you find those that suit your temperament. They can be extremely effective should you wish to rescue a watercolour sketch that has gone wrong. Personally, however, I hardly ever sketch with a pen because it is not much use in the rain. On wet paper it is as much a disadvantage as trying to sketch with a wild gorilla manacled to your wrist: the ink goes everywhere. There is a wealth of sketchbooks available, from the humblest cartridge pad to tinted papers and attractively bound books.

Eventually you should consider sketching in colour as you are then better equipped to record atmosphere. A full oil-painting kit is hardly practicable if you wish to cover any distance on foot, and carrying a wet canvas across sodden moorland in a force nine gale has all the charm of dancing with a live octopus. Pastels are an excellent sketching medium, with beautiful, rich colours, though you need to take a large range of pastels with you as they do not mix like paints. Pastel pencils, now available on the market, do obviate much of the mess associated with ordinary pastel crayons. As with charcoal, a damp rag and fixative is helpful and it is best to use tinted paper of the Ingres type, though an ordinary cheap scrapbook will suffice provided it is only for sketching, and not for more permanent works as it fades rapidly. With pastels a pad is superior to loose paper which will rub laterally, causing some of the pastel to smudge or be removed from the paper. Rain does not respect pastels.

I find that watercolour suits me best for sketching in colour. It is perhaps easier to represent rain or snowstorms in watercolour than in pencil, though naturally not easy to carry it out in such conditions. Watercolour certainly provides the best means with which to put across the atmosphere of a place. Even if colour is washed off, enough usually remains to provide a guide. It normally dries fairly quickly outdoors, especially if you use a good quality smooth cartridge paper or watercolour paper. Watercolour paper comes in various weights with a **hot pressed** (smooth), a **NOT** (not pressed, so less smooth) or **rough** surface. The rough and NOT varieties take slightly longer to dry but on hot days they come into their own.

Only a few colours are needed, as mixing colours should be encouraged. To start, I recommend the following: French ultramarine, burnt umber, lemon yellow, new gamboge or cadmium yellow, Payne's grey, raw sienna, burnt sienna, and cadmium red. Take three or four brushes: a half-inch or one-inch flat, a number five or six round and a number one or two rigger are fine for sketching, as you will not be working on a large scale. Red sable brushes are the best for watercolour, but they also tend to be the most expensive. Naturally I don't carry my most treasured brushes about the hills. Brushes and pencils can be kept in a plastic tube as sold in art shops. I use an old plastic foam bath container, the cap of which unscrews to provide a water receptacle for sketching at high level, though I use a larger pot otherwise.

My pads and paper are protected by a heavy-duty plastic envelope large enough to take a variety of sizes. Even with this protection I sometimes find that after several days of continuous rain in the hills the pages become saturated and stick together, forming beautiful blobby patterns over the sketches. All these items except paper are all kept in a rucksack pocket with reserve brushes kept separately in case the brush container rolls over a precipice. The humble rubber band and bulldog clips are vital for preserving one's sanity in wild weather: it's no joke having to retrieve a sketch from mid-stream.

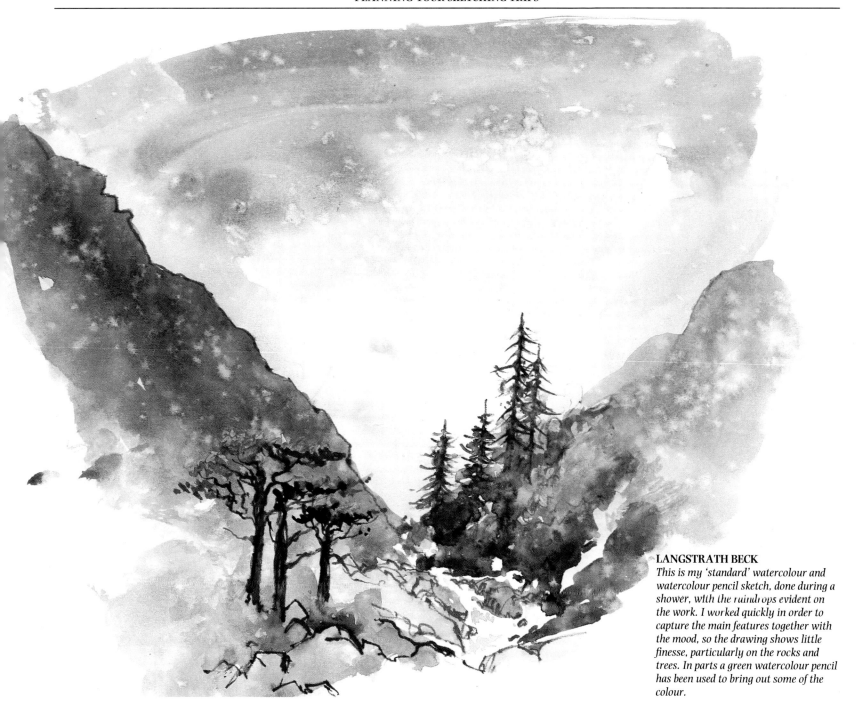

LANGSTRATH BECK
This is my 'standard' watercolour and watercolour pencil sketch, done during a shower, with the raindrops evident on the work. I worked quickly in order to capture the main features together with the mood, so the drawing shows little finesse, particularly on the rocks and trees. In parts a green watercolour pencil has been used to bring out some of the colour.

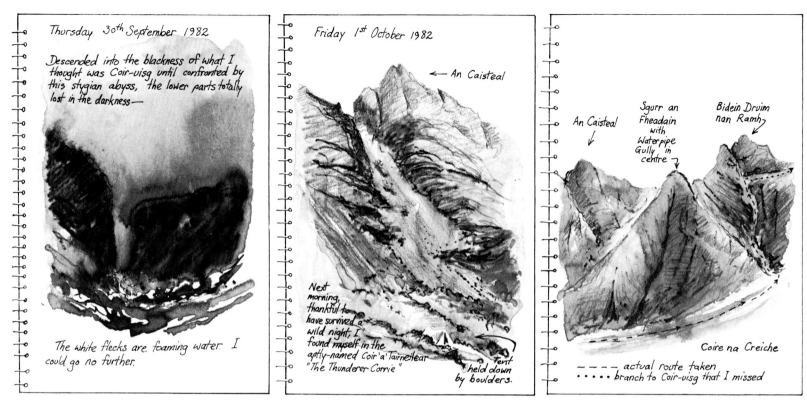

Thursday 30th September 1982

Descended into the blackness of what I thought was Coir-uisg until confronted by this stygian abyss, the lower parts totally lost in the darkness—

The white flecks are foaming water. I could go no further.

Friday 1st October 1982

← An Caisteal

Next morning, thankful to have survived a wild night, I found myself in the aptly-named Coir'a'Tairneilear "The Thunderer Corrie"

Tent held down by boulders.

An Caisteal ↓ Sgurr an Fheadain with Waterpipe Gully in centre ↴ Bidein Druim nan Ramh ↴

Coire na Creiche

– – – – actual route taken
· · · · branch to Coir-uisg that I missed

AN ALL-WEATHER SYSTEM

This, however, does not give you an all-weather system. Rain and snow hold no aesthetic pretensions. My secret here is the use of water-soluble pencils. These are often dismissed as child's playthings. They are not a substitute for watercolour, but have their own delightful characteristics and provide a superb sketching medium. Unlike ordinary pencils they actually improve when the weather turns nasty: essential weaponry in the mists of Snowdonia. Make a start with four colours: black, blue, brown and green. They can be used in a number of ways, on their own or combined with watercolour washes. My own preference is to use the pencils with watercolour, firstly laying a watercolour wash on the paper, keeping it wet and immediately starting to work into the wet wash with a watercolour pencil. This has the advantage that you need not stop working to allow the wash

PICTORIAL DIARY

These are three page-drawings I have constructed from sketches, photographs and notes of an actual expedition in the Cuillins of Skye. When I first went up the mountains with a sketchbook I wrote quite a lot of notes on the loose sketches, not just technical notes, but covering anything that moved me to write. Organized properly into diary form this could be an interesting way of recording

a expedition or holiday. More notes could be included than I have actually shown. The right-hand page could not have been done at the time, as it is drawn from a photograph taken with a long-range lens especially for a post-mortem on why plans went askew on that day. Therefore it would be useful to leave the odd page blank here and there to add in details at a later date.

to dry, thus speeding up the sketching process. I simply draw the features of the scene as though starting with a normal pencil. The black or brown pencil is best for this, although the blue one is excellent for rendering the outline of distant hills, automatically giving a feeling of recession. The pencils can also be used by dipping them into water and then

drawing, but this needs constant dipping and the softness of the pencils necessitates a lot of sharpening. Tones can be obtained by rubbing the pencil over the appropriate area and then brushing water across; if you wish to do this it is worth extending the range of colours you take. I would recommend the Rexel Derwent Watercolour pencils as they have an excellent range of colours and are softer than most others on the market. They produce subtle gradations without necessarily leaving the original pencil marks on the paper.

When actually sketching I prefer to sit down on a rock, log or whatever is available, with the sketchpad on my knee. My seat is made of closed-cell foam which can be bought from mountain gear shops and is normally used as a sleeping matress when camping. It is only 9mm thick and can be cut to any size required. Totally impervious to snow, water or mud, it provides a comfortable, warm seat even on sharp, angular rocks. At times it is necessary to stand and sketch and on occasion I have had to stand on one leg, work from the end of a rope, sink into a bog whilst sketching, dance, crouch and try to keep upright in the middle of a river.

THE PICTORIAL DIARY

When you go off on an expedition or holiday, you may wish to keep a pictorial record of the trip, other than just photographs. This may be even more important to you than producing finished paintings from the sketches. In this case keep all your sketchbooks of uniform size, paper, format and appearance. Good-quality cartridge paper which comes in a wire-bound book is best, as ordinary sketchbooks will, after some use, start to lose their pages. You can stick or wrap a personalized cover around it, and even start with a title page, objectives, members of the expedition, or whatever. Notes can be interspersed with sketches, diagrams, maps, etc. Alternatively it could be a Munro-bagging exercise, showing details of how you climbed each Munro, the conditions, route, and so on. A Munro is a Scottish peak over 3000 feet and a Munro-bagger is someone who is attempting to climb them all. But there's no need to limit that to Scotland, or even just to those over 3000 feet. Alternatively you could have a pictorial diary on vernacular architecture, rivers, long-distance footpaths or whatever fires your imagination.

A FINAL POINT

Before venturing out into the wilds in the next chapter, think about one point: are you painting the right subjects? Many artists paint scenes which are far too complicated, or to put it another way, paint everything before them instead of filtering out irrelevant detail. Simplify things! Find out which subjects move you most of all. Don't expect to find the perfect composition, for only rarely will you come across it. Initially work on a small scale, and gradually realize your ambitions. With that in mind you are ready for the outdoors.

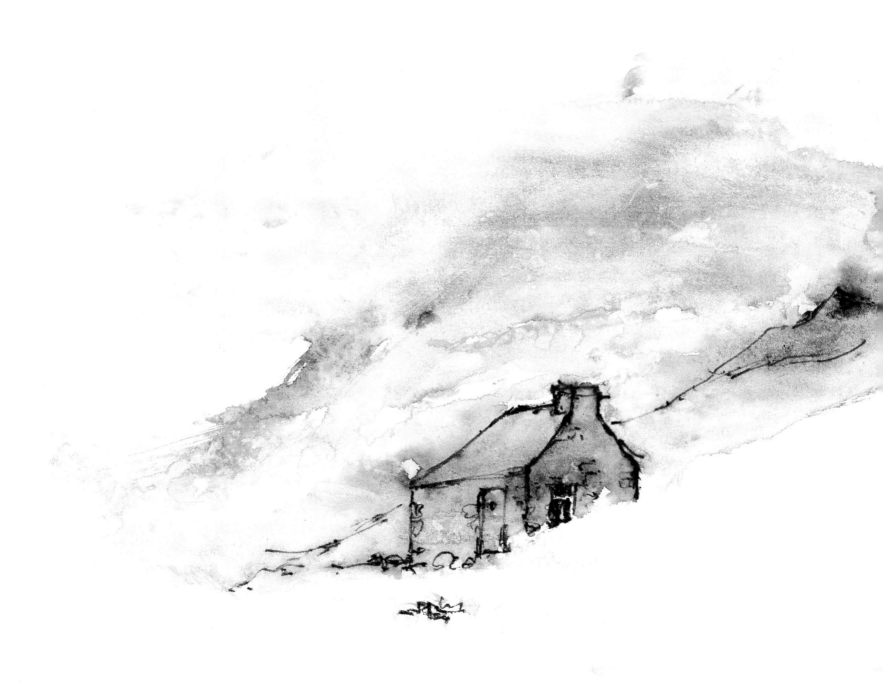

3
SKETCHING

I love snow, and all the forms
Of the radiant frost;
I love waves, and winds, and storms
Everything almost
Which is Nature's and may be
Untainted by man's misery

PERCY BYSSHE SHELLEY

LAIRIG LEACACH BOTHY

This sketch was painted in the most appalling conditions. Although there were several possible angles from which to sketch the bothy, including one with the wind behind me, I could not resist the best view—into the wind of course! Crouching down in an icy ditch I began laying in the washes, and the blizzard began helping with a faster accumulation of snow than I could cope with. I worked quite some detail into the attractive stonework of the building, but the blizzard favoured a more simplified approach and washed away my nicely defined stonework. The palette disappeared beneath a flurry of snow, but I soon found it when my fingers dived into a generous lump of moist cadmium red. Without any assistance from me the sketch conveys a true feeling of the wildness of the blizzard. Much of the colour has been washed away, but enough remains to work from without any problems.

On a wet, windswept mountainside, carrying out a watercolour painting may be regarded as the height of madness. Yet watercolour is unrivalled in capturing the moods of these wild places. Working in these conditions is perplexing, and time is needed to cultivate working methods, but with perserverance it will immeasurably improve your general watercolour techniques. This is because you have to get down the essentials quickly; because you are forced to work in a loose and bold manner, without the thought that someone will see the finished work on display; and because you are not afraid of making a mess and spoiling a painting. I don't expect you to work in extreme conditions, but this chapter will help you cope with some of the hazards of working outdoors.

Rapid sketch-notes can be done with a pencil. I often use just a pencil on a subject where colour and mood are not paramount. Having a sketchpad available quickly from pocket or mapcase will help enormously, and since the advent of water-soluble graphite pencils you can continue drawing no matter how wet the paper. Colours can be indicated by writing either in the margin or on the feature concerned. For very fast work (perhaps a bull is approaching) if you need to draw a large farm, for example, then concentrate on the most important lines: the roofs, chimneys and general sizes of buildings in relation to each other. If necessary, simply use one line to cover everything. Turner at times would draw a whole village with one deliberate stroke of his pencil by putting in only the line of the roofs.

Mild, warm weather is fine for sketching, but you limit yourself drastically if you wait only for hot summer days. Anyway, I don't believe in being too comfortable. As Ruskin said, 'There is no such thing as bad weather, only different

KARISMA GRAPHITE AQUARELLE PENCIL
Four quick sketches done with the graphite watercolour pencil, illustrating the versatility of this marvellous pencil.

BELOW:
A simple quick line of the most important elements in a sketch of buildings in the mid-distance, the sort of indication that Turner would use to describe a village in haste. This was carried out dry as with a normal pencil.

RIGHT:
I have indicated the background tone very strongly in this sketch, and only merged it slightly so that you can see how it is first laid down then subsequently washed with a wet brush. More rubbing would eliminate the diagonal pencil lines.

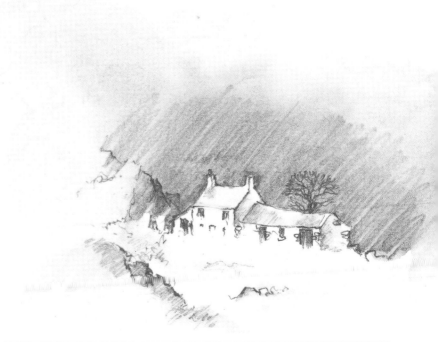

kinds of good weather'. Bad weather holds certain attractions: rain freshens up the landscape making colours more intense and vibrant; mist and haze simplify shapes and colours, hiding irrelevant detail; angry skies at times provide complete and dramatic subjects in themselves. There is no better way of observing the moods of nature than sketching in unsettled weather. Winter should not be ignored: it has many advantages that outweigh the obvious drawbacks of cold and discomfort. The sun is lower in the sky, and therefore more directional, giving greater contrast throughout the day. There is more variety in colour than in summer. Snow brings a fresh look to the landscape, and of course there are no midges or nettles to annoy us. Nothing is worse

than having to scratch, dance and hop about as I did whilst sketching once during a midge attack in the mountains.

When at last we stand sketchbook to hand and a scene in front of us, where do we start? Look carefully at the subject. What excites you most about it? Perhaps it is the light, the texture of stonework, a distant cottage or even shadows cast across a grassy verge. If possible move closer and around the subject. Work out the best viewpoint: don't necessarily use the first one offered. Try not to put too much in—keep it simple. Begin with that part of the scene which first caught your eye and work outwards from this centre of interest. In your early sketching days forget about problems of perspective and just get the basic scene down on paper. Concentrate

RIGHT:
These are two rocky ribs leading to the summit of Y Llethr. The background one was drawn in, then partially lost with violent scrubbing with a wet brush— don't use your best sable for this—then the closer rib was introduced, the lower part of which was drawn on dry paper.

BELOW:
Here the background misty trees were drawn first, then washed over with clean water. Whilst this was still wet the foreground tree was strongly delineated: you don't have to stop when the going gets wet with these pencils!

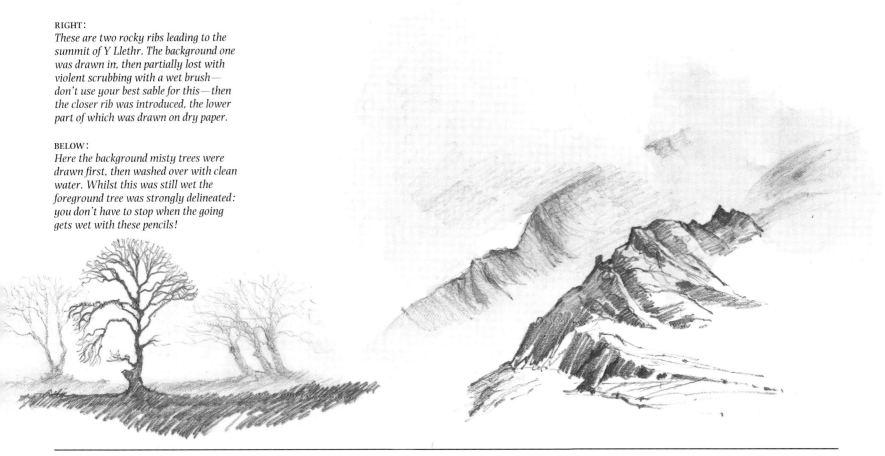

on capturing as close a likeness to the original scene as possible. Look hard at the subject before committing pencil to paper: observation is the key to success. With patience you can achieve much by studying nature. Many artists find it helpful to look at a scene through a rectangular frame—a simple card one will suffice—to isolate the interesting part of the subject from a confusing surround. Observe both shapes and tonal relationships—the differences in the darkness or lightness of an object when set against an adjacent part of the scene. Forget that your mind tells you that the rocks are black gabbro and so black actually is the local colour, for if they are wet and the sun is shining the rocks might well be the lightest part of the subject. The range of tones in the natural world is many times greater than that which we have at our disposal in any painting medium. Therefore we have to make full use of what is available. For instance, the light tone on a rock, say, caught in sunlight could be enhanced by simply leaving the paper white if there is to be no brighter light in the painting. This is because the white paper is the watercolourist's brightest tone.

Bear in mind all the time how you want the finished painting (not the sketch) to appear. You will probably be working on a larger scale back home, so you need to ensure that there is enough detail in the sketch to fill a larger sheet of paper. This can be achieved with several sketches of the scene. With subjects such as cottages and farms I find it useful to go in close, work in the detail, then retire to draw the building in its environment—mountains, trees or whatever stands around it. If your eyesight is not what it used to be and you want to make out the detail of farm buildings in the middle distance, consider using binoculars as an aid. With complicated subjects broadly indicate the main areas in pencil first, so that the relationships and sizes of the main areas are reasonably faithful, and also to ensure that you get it all on the paper. Hold the pencil at arms length, close one eye and critically study the length or height of an object using the pencil as a measuring device, then use the same process to work out other objects. In this way the shapes and relative sizes can be quickly worked out.

MOORLAND SUBJECTS

Moors often provide quite a challenge. You may wish to capture the feeling of a wild, open moor, yet the view before you has no obvious point of interest. Every nuance of rising moorland needs to be emphasized, a boulder or clump of gorse exaggerated, and full use made of tones and colours. Beware of vivid purple heather, as purple is such a powerful, overwhelming colour which can produce disastrous results if overdone. If it needs to be painted in then weaken it with more water, and less intense colour as it recedes. One method of obtaining an attractive composition in a moorland painting is to keep the horizon fairly low on the paper, and concentrate on producing an interesting sky. This will certainly make up for a lack of ground detail.

WIND

Strong wind is possibly the worst element in which to sketch, but ample supplies of bulldog clips and elastic bands ensure that there is less chance of tearing sketchpads, or finding your almost-complete work of art face-down in a muddy puddle. Shield the sketch with your body or in the lee of a boulder or wall if possible. Present a low profile by hugging closely to the ground. Holding yourself against rocks will reduce buffeting. Weigh down lightweight items like palettes and paper with rocks in case they are blown into a river or over a precipice. In the mountains don't stay motionless in cold winds for long, as the body temperature will drop rapidly.

RIGHT, ABOVE:
CNICHT
This is an unfinished watercolour sketch in which I have drawn the outline first in ordinary pencil, before painting. If a subject is complicated and the paper not affected by rain or snow I often begin with ordinary graphite pencil. This more usual method gives better control when a lot of detail is involved.

RIGHT, BELOW:
MOORS NEAR PATELEY BRIDGE, YORKSHIRE
Almost a pure watercolour sketch on a scrap of Arches NOT paper, with some slight detail work with a black watercolour pencil. To add interest I have made the most of the slight undulations in the terrain. Most distant detail was lost in the atmospheric morning haze.

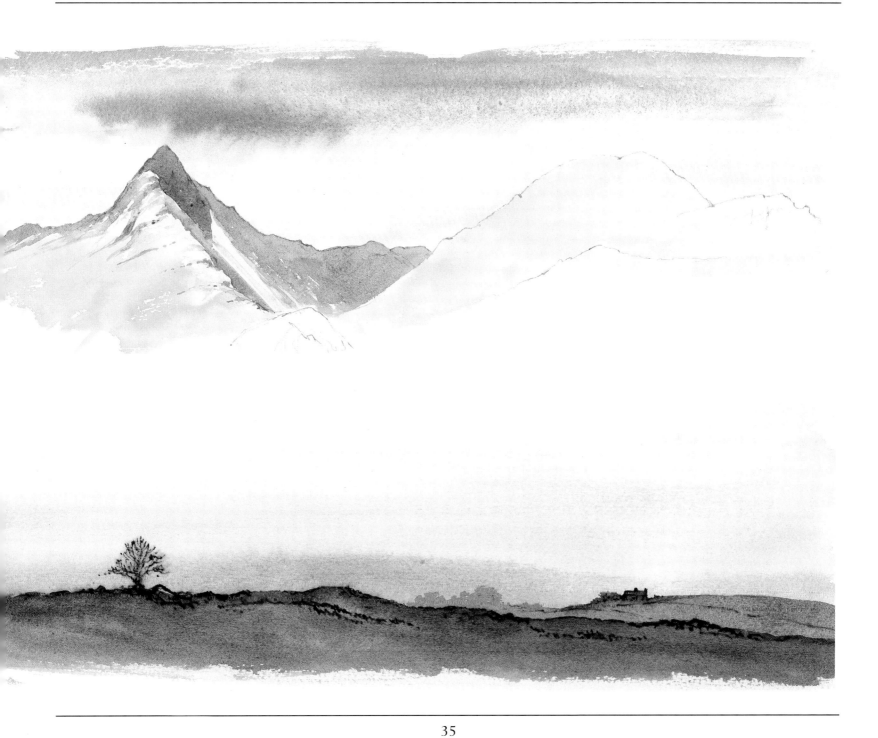

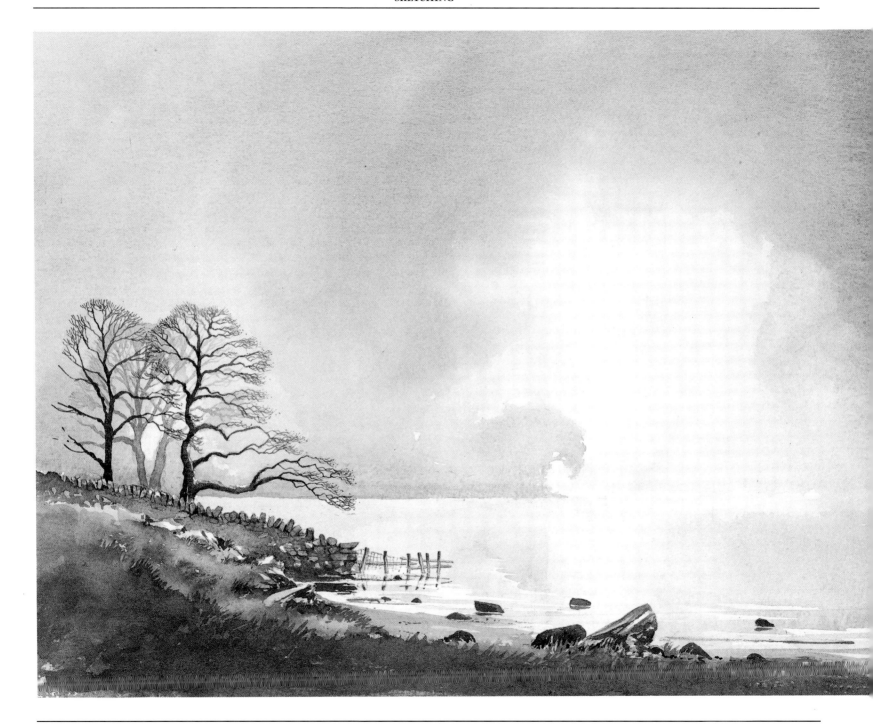

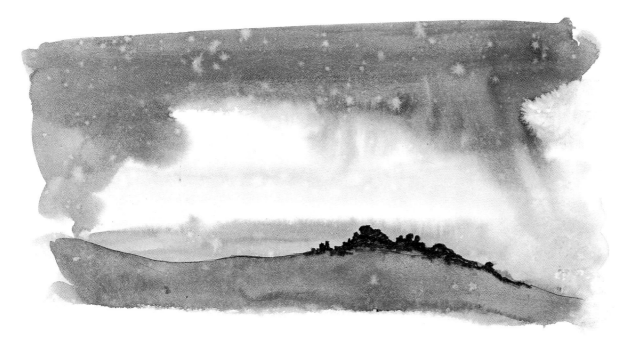

OPPOSITE:
RYDAL WATER
This was a winter morning when the drizzle fell so finely that I was unaware of it as I sketched. When it came to packing away the original sketch I suddenly realized the darker washes had taken on a mottled effect: so fine was the drizzle.

LEFT:
WILD WEATHER OVER HOUND TOR (Sketch)
This was carried out during a violent April shower. The rainstorm swept across the moor totally blotting out the tor for a few minutes. It was so dark that it seemed as though the sun had been switched off. Rainspots are clearly visible, for I could not shield it completely behind the rock against which I was leaning.

RAIN AND MIST

Rain on a sketch can be exasperating, but the paper can be shielded by the body to a certain extent. Some artists use umbrellas but I have only found them to be a liability, and would be a positive nuisance as well as a source of ridicule, for instance, on the Crib Goch ridge. Anyway, with watercolour pencils there is no need to go to great lengths to protect the work. There is little point in waiting for washes to dry so work quickly, accepting a messy result and use a watercolour pencil to draw into the wet paper. If you do need to wait for the wash to dry why not do another sketch from a slightly different angle? At times beautiful accidents will occur. Even the bad passages, when seen next day in the studio seem all the more worth the effort. You will have achieved spontaneity. After rain, painting in mist holds no problems, except that of slow drying. Provided a suitable subject presents itself, painting in mist can be extremely rewarding. There is greater unity as tones and colours are simplified. By ensuring there is a prominent foreground feature such as a tree, wall, gatepost or similar solid object, the work will have a feeling of depth as other features recede into the mist and simply become blurred areas of tone. Intermittent mist swirling in between crags can highlight features which for most of the time may be hidden in a mass of detail on a large mountain face.

SNOW

Falling snow presents much the same problems as rain, with the added disadvantage that flakes falling on your palette can soon transform it into something resembling multicoloured sago pudding. It then becomes tragicomic as you dip the brush into what you hope is burnt umber only to find an enormous blob the size of an egg attach itself to the brush. So try to keep the palette under cover if possible. Large snowflakes can be irritating on the sketch. The only answer is to work rapidly and shield it as far as possible. Working in

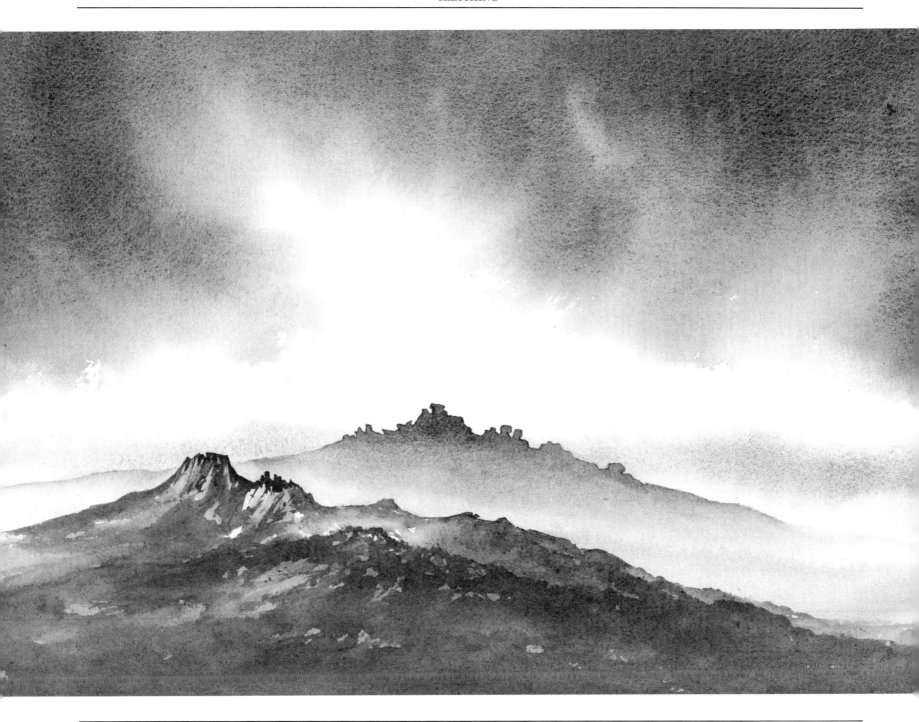

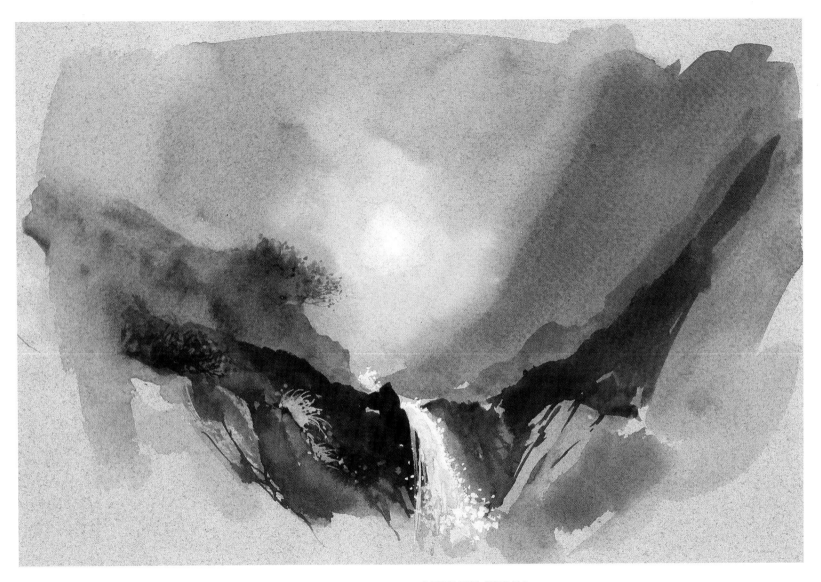

OPPOSITE:
WILD WEATHER OVER HOUND TOR
 (Painting)
*Painted from the sketch plus additional
material, as I have added Greator Rocks
in on the left.*

LAKELAND STREAM
*I painted this on grey-blue Canson paper,
more commonly used for pastels. It is
worth taking some tinted paper along.
Here I painted the falling water with
white gouache, emphasizing the misty
atmosphere with powerful dark tones in
the foreground.*

fierce blizzards can be exhilarating and frightening at the same time, but that is something best left until you are sure of your abilities to cope with all the problems. With spindrift and chunks of ice battering you, cagoule toggles lashing face and wet sketch, and the paper tearing, a distinct sense of humour is required. Snow in combination with sunshine can cause intense glare, and here sun-glasses or skiing goggles are the only answer.

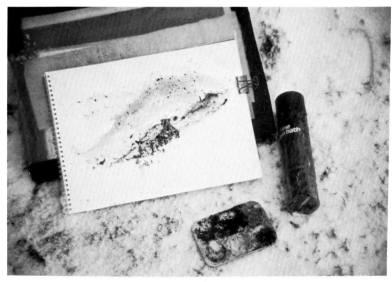

LAIRIG LEACACH BOTHY
A photograph of the sketch (shown on page 30) and equipment shortly after *finishing it, showing dark blobs of melting snowflakes.*

ICE AND INTENSE COLD

Coping with really intense cold can be dreadful. The trouble is that under these conditions you often find the most beautiful and unusual subjects: crisp, clear air, fantastic ice formations and sparkling light on crystal-clear ice. If you are well wrapped up in your thermals, several layers of sweaters, gloves, boots and a woollen hat it is normally possible to sketch for a few minutes even in exceptional coldness, especially if you have been walking for twenty minutes or so. Work rapidly on the essentials. With a complicated subject

I've even walked round in circles at the same spot to generate heat for a further five minutes of sketching. Keeping the water-bottle upside-down helps to ensure that there is unfrozen water by the cap when needed, and a lacing of gin acts as an antifreeze. Be prepared to use each brush for one stroke only before it freezes to a blob of coloured ice on the tip. It helps to have several brushes available. Defreeze them in your armpits if you can stand the discomfort. There are a variety of body-warmers on the market, but a flask of hot soup works wonders. If you are right-handed, though, keep the cup to your left, otherwise the brush will inevitably end up in the soup. As with all outdoor sketching situations equipment and procedures should be prepared in advance to make life easier.

SKETCHING AT NIGHT-TIME

Obviously a certain amount of moonlight is necessary for this, but a good time to get night-time scenes is before darkness is absolute. Usually the moon is still quite low in the sky then, which means it can easily be included in the work. Knowing the sketching location by day helps a lot, if only to prevent you from plunging down an open mine-shaft. Sometimes it is a good idea roughly to plot the moon positions at certain times on the previous night, so that you know almost exactly where it will be at a given time. A head-torch is a useful accessory as it leaves your hands free for painting, and you can actually see what colours you are using! Try as far as possible to manage without one if you can, as after torchlight your eyes will take time to adjust to a moonlight scene. Moonlight unifies everything, causes fine detail to be lost, and pervades a scene with powerful atmosphere. Snow on the peaks is quite magical by moonlight.

BAD-WEATHER ALTERNATIVES

In really bad weather, lasting several days, not everyone wants to carry on sketching regardless. Of course, it is quite feasible to work from inside a car, to a certain extent. As in planning walks, it pays dividends to study the map for

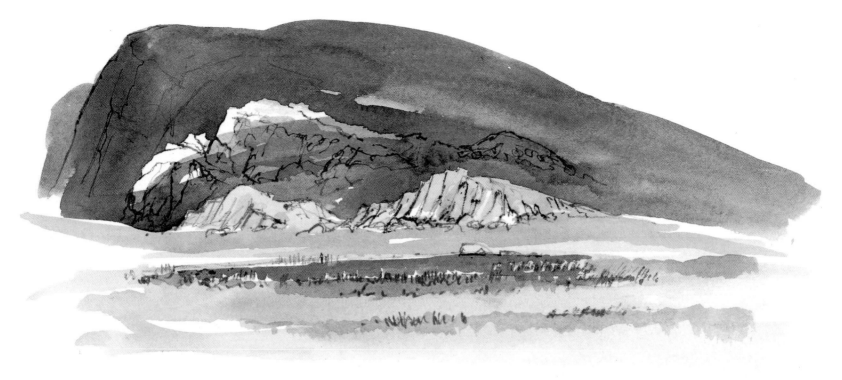

DALE HEAD TARN
Another Lake District scene done on a bright, cloudy day which caused incredible problems as cloud shadows continually moved across the landscape, *totally changing the lighting on the crags every few seconds. It really was a case of looking at a crag and then painting it in completely before taking another look.*

potential sketching targets. Streams, rivers, cottages and farms can make excellent low-level, bad-weather subjects, so follow roads—especially the unfenced variety—beside streams, particularly where bridges might be well positioned as a subject.

Without a car you are reliant on some kind of shelter in the form of barns, bothies, trees, buildings, walls, or even pitching a tent before a subject. In the mid-nineteenth century the artist P G Hamerton used a tent modified with a large window for painting in the Highlands. A survival bag or groundsheet held in place by rocks can provide a quick and adequate shelter. I've even spent nights in them during winter. I usually work out bad-weather alternatives two or

three days in advance, but even then get caught on the hop. This is certainly something that should be taken into account before a trip, so that appropriate gear can be taken and routes planned effectively.

STUDIES OF LANDSCAPE FEATURES
It is of great value to make detailed studies of features that normally support the main subject of a painting, such as rocks, walls, gates, hedges, briars, undergrowth, and even mud. These can be introduced into paintings time and time again, and are especially useful if you find, when doing a large watercolour, you haven't enough detail in the sketch from which to work. This is the sort of subject you can fall

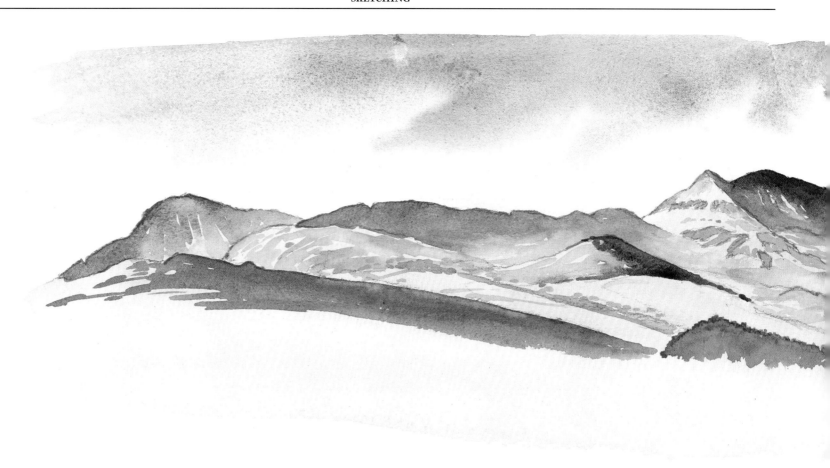

back on if you have failed to find a full composition that satisfies you, so there is really no excuse for returning home with no sketches.

COMPLETED PAINTINGS
Some artists like to do completed paintings out of doors, rather than just sketches, because they feel their work loses some spontaneity when trying to reproduce the sketch in the studio. There are arguments both ways. Find out what works best for you by trying each method initially. The old masters used both methods. There will, however, not always be time to carry out a finished painting, so the ability to

sketch rapidly is essential for the landscape artist. It also means that you take more scenes home with you, something which you should especially bear in mind when on holiday in distant parts. Unlike a sketch which you might use many times, if you sell a painting done outside it is gone forever, so think carefully about your approach to working outside.

COMPANIONS
Having companions around when you wish to sketch can be rather tricky, especially as they murmur mutinously whilst you sit sketching in a cloudburst, totally oblivious of their protestations. It might help to arrange for lunch-breaks or

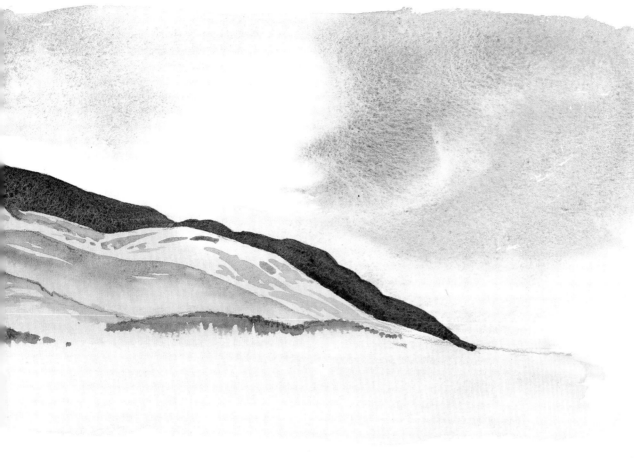

ARENIG FAWR PANORAMA
I usually take along a few sheets of watercolour paper about eighteen inches long in the rucksack for the sole purpose of painting panoramas. In this case I began by pencilling in the main masses, and then painted the washes from top to bottom without getting bogged down in detail. Dark cloud above Arenig Fawr itself has caused the mountain to appear dark and so come forward in the sketch.

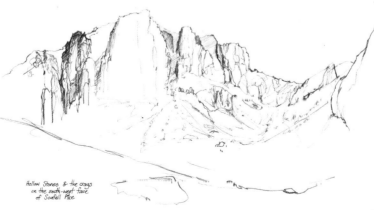

Hollow Stones & the crags
on the south-west face
of Scafell Pike

HOLLOW STONES
A detailed pencil sketch, describing the features of the crags below the summit of Scafell Pike.

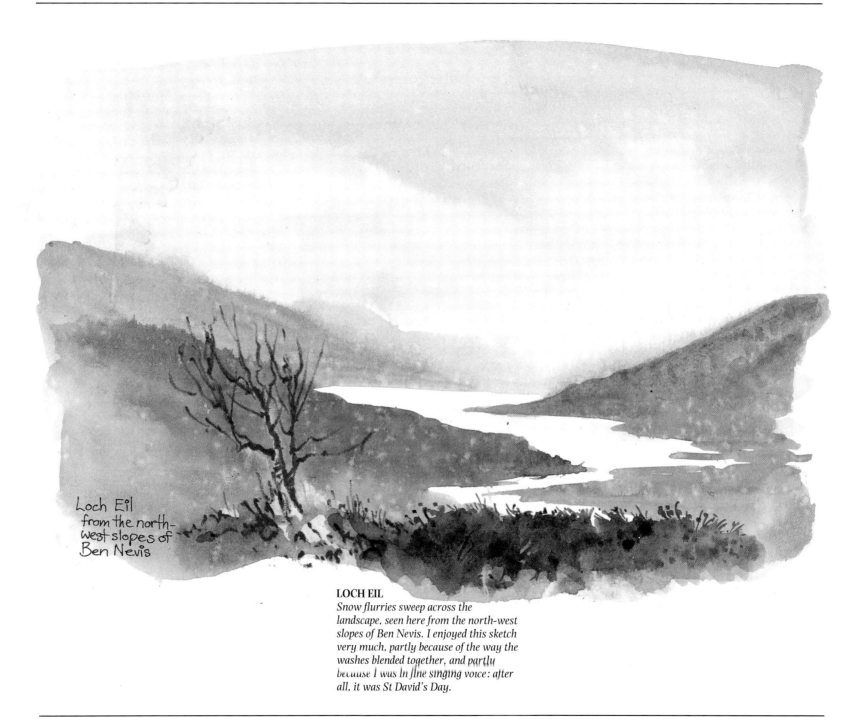

Loch Eil
from the north-
west slopes of
Ben Nevis

LOCH EIL
*Snow flurries sweep across the
landscape, seen here from the north-west
slopes of Ben Nevis. I enjoyed this sketch
very much, partly because of the way the
washes blended together, and partly
because I was in fine singing voice: after
all, it was St David's Day.*

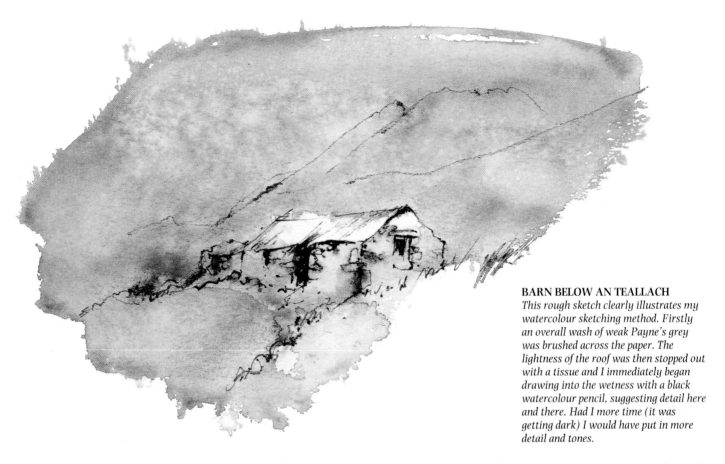

BARN BELOW AN TEALLACH
This rough sketch clearly illustrates my watercolour sketching method. Firstly an overall wash of weak Payne's grey was brushed across the paper. The lightness of the roof was then stopped out with a tissue and I immediately began drawing into the wetness with a black watercolour pencil, suggesting detail here and there. Had I more time (it was getting dark) I would have put in more detail and tones.

rests to fall in places where you plan to paint. As you speed up your technique the situation should improve, but still needs tactful handling. Maybe your companions can be persuaded to stand in front of a scene: a mountain for example. Include them in the sketch to give some idea of scale.

Sketching outdoors can be one of the most therapeutic pursuits. Don't allow yourself to be bogged down by rules, just get out and enjoy yourself. And do make an effort to take advantage of any really dreadful weather to capture those incredibly atmospheric scenes. With time you may even enjoy working on wild days. When sitting amidst the natural environment we are probably at our most receptive, though this might not be readily apparent as you slowly become saturated in a deluge. There is no such thing as a day impossible for sketching. Getting out is the only way of attaining a truly original landscape painting. Try painting a watercolour under a waterfall—not right under, of course: stand a little way back and let the ultra-fine misty spray fall on your sketch. Its effect is magical, especially on the dark washes. This is but one example of the many exciting scenes that await the artist in the mountains. Tiredness, danger, heat and thirst may stifle the urge to sketch, but in the hills a flash of light may be all that is needed to send creative inspiration coursing through our veins.

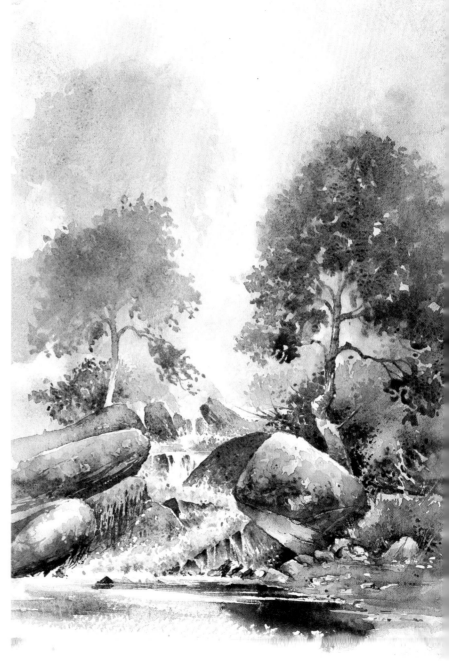

ABOVE:

CASCADE NEAR WATERSMEET, EXMOOR (Sketch)

This is on a tributary of the East Lynn river not far from Watersmeet. On a very wet day I followed the path alongside the river, and when they parted company I scrambled, jumped and splashed my way upriver to this cascade. Unfortunately the only decent position was actually in the river, so I sketched from that extremely uncomfortable position, the drizzle adding to the sombre mood of both subject and artist.

RIGHT:

CASCADE NEAR WATERSMEET, EXMOOR (Painting)

Full use has been made of the misty background and I have laid on colour, rubbed it off with a sponge here and there, then replaced it in parts. My main aim was to capture the bubbling, churning effect of the tumbling water by placing soft and hard edges where water turned to froth and water contrasted rock. The large foreground rock on the right revealed strong reflected light underneath, from the frothy foaming water.

From the collection of Miss Sybil Garrett

4
WORKING FROM
SKETCHES

Light is the first of painters.
There is no object so foul that
intense light will not make it beautiful

R W EMMERSON

Translating the sketch into a finished painting needs careful planning and consideration. Should the mood of the sketch be emphasized, or changed? What aspect of the scene should become the focal point? In most cases you will be working on a larger scale and so will need sufficient detail from which to work. Some artists like to use a squaring up method— overlaying both sketch and painting with a light pencil grid to provide reference points. This may be fine on a complicated architectural subject or cliff face, but to me it seems laborious and can give the work a stiff and overworked appearance. I much prefer to follow the sketch in a loose manner, in places perhaps 'improving' the composition. Often a number of thumbnail sketches help to decide on a composition where several possibilities present themselves, or if the subject is complicated. These sketches can be simple pencil outlines or blocks of tones using conte, charcoal, coloured pencils or watercolour pencils.

COMPOSITION

A successful composition involves arranging all the elements of the painting in a harmonious manner. Unless the picture has a centre of interest the eye crosses and recrosses it restlessly, and the painting exudes the appeal of a stuffed kipper. In a classical composition the eye is led to this point of interest by some feature such as a lane, stream, wall, hedgerow or similar device. Certain things detract from a good composition: walls or fences across the foreground block the viewer off from the focal point; a tree in the dead centre would cut the painting in half, as would the horizon halfway up the work; people or animals near the edge of a painting looking or walking out from it; and when the right-hand side of the painting is the exact mirror image of the left-hand side. I once came across an African painting of two mud huts in precisely regular positions equidistant from the sides, each with a palm tree of similar size on either side. In front of each stood a girl with a pot on her head. There were a further six copies of this painting stacked up behind it, production-line fashion. However, all these points have been successfully broken in the past, so perhaps we should not be too rigid with our work.

The centre of interest can be a house, bridge, tree, patch of light on land, water or between clouds, or anything that

THUMBNAIL SKETCHES FOR HINDSCARTH
Three quick drawings done to help decide on the composition: the left drawing showed the climbers' hut too small for my liking; the vertical format of the centre one did not work, partly because the composition fell away to the bottom-right; the chosen one is far right, which shows enough detail on the hut to add interest.

OPPOSITE
HINDSCARTH
I wanted to create a light patch in the centre of the picture, so I flooded the area with lemon yellow once the crags had been rendered. This seemed to help the arrangement by not allowing the eye to fall away to the bottom-right. The trees were painted in a deep tone to bring them forward.

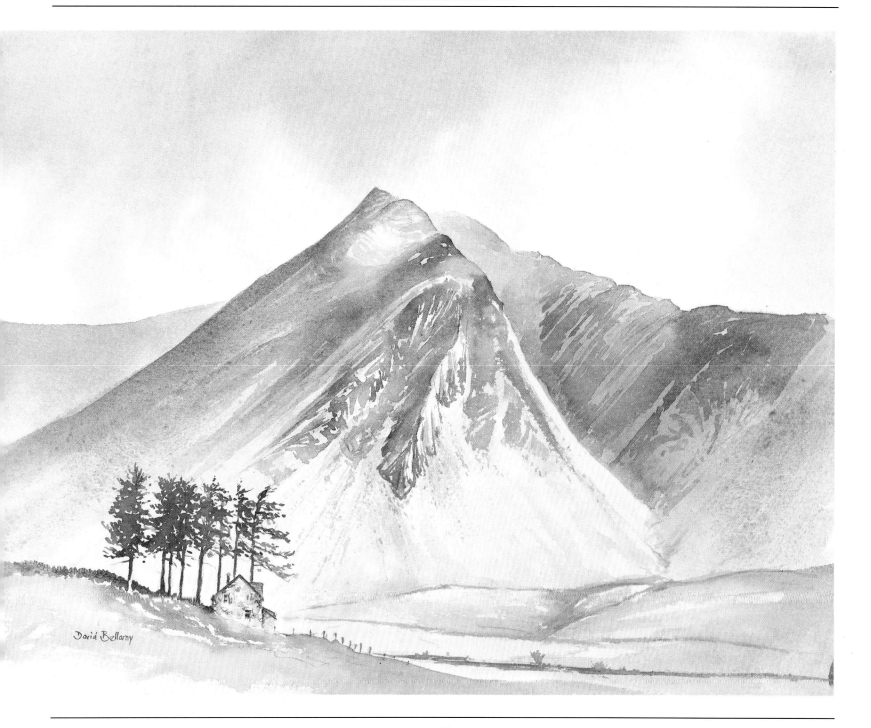

David Bellamy

COMPOSITIONAL DIAGRAMS

These are four examples of poor and improved compositions, shown in pairs. The left-hand diagrams represent poor compositions whilst each partner on the right indicates a better composition, though not necessarily the best.

The picture falls away to the right causing an overbalanced effect common in mountain scenes.

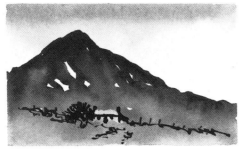

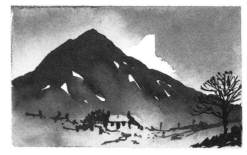

A tree has been added to balance the work, and the fence in the mid-distance rises out of the picture.

Too many horizontals, and the horizon is more or less cutting the painting in half.

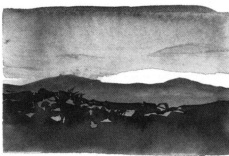

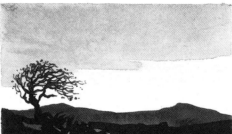

The horizon has been lowered and a tree included to break up the horizontal lines.

The stream is too far to the right, almost leaving the picture.

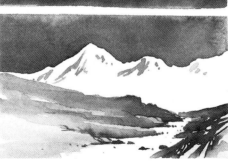

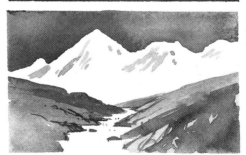

Here the stream has been centred to lead into the main mountain peak.

Two focal points distract, even more so when they are of more or less equal size.

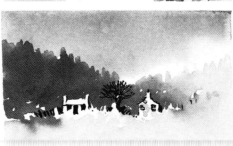

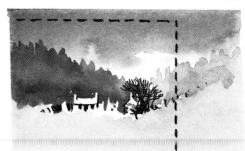

The right-hand cottage has been covered to a large extent by the tree, and also has been pushed slightly closer to the first. An alternative would be to cut out part of the painting.

relieves the uniformity of the surrounding passages. There really should only be one such point in a painting, otherwise competing influences distract the viewer. If you like a scene and there is no specific focal point, then create one by the judicious positioning of lighting, clouds or by emphasizing tones of definite features. Including a figure or an animal in the right place may sometimes be all that is needed. A common device used in the eighteenth century was to have figures in the scene actually pointing to the centre of interest. These days this would be regarded as stating the obvious.

A compositional hazard prevalent in painting mountain scenery is where the slope or ridge falls away to one side and out of the picture. Somehow this should be arrested by the inclusion of trees, rocks, buildings or something in the foreground, or simply by the use of strong cloud formations in the appropriate position. Don't forget the sky is very much part of the composition and can be arranged to improve the balance of the work. In general, where you have a complicated landscape the sky should be kept simple, and vice versa. Remember, composition embraces not just shapes, but colour and tone as well, so take care when considering these elements.

PREPARING TO PAINT

The type of watercolour paper used often depends on the subject. I use rough paper to create sparkle on water using a dry-brush technique for example, or to accentuate the fascinating granulations of French ultramarine. Often it does not matter whether NOT or rough paper is used. For large paintings 140lb to 300lb weight of paper is advisable. Even 140lb paper is best stretched, though this is really only necessary if you are painting on half-imperial size or larger. The 90lb paper should always be stretched. The first procedure is lightly to draw in the main features in pencil with as much economy of line as possible. Too much pencil work can give the finished painting a tired look and encourage slavish copying at the painting stage. Try to avoid using an eraser as far as possible: over-enthusiasm here can spoil the surface of the paper. Then the paper is totally

immersed in water and held up by one corner to allow the excess water to run off. The damp paper is then placed flat on a drawing board and the edges stuck down with wetted gummed tape. Do not keep the paper immersed too long as this will often cause undue strain on the gummed strips during the drying process and tear them badly, causing cockles on the paper. Have all the gummed strips cut ready to size beforehand and work quickly, otherwise cockles will cause problems in sticking down the tape. I dislike smoothing these out as this can cause pencil graphite marks to be spread across the paper, and again might harm the surface. If this happens I lift the paper up, flatten it back on the board and finish off sticking down the gummed tape. Stretched paper is as tight as a drumskin, a lovely surface to paint on. It should then be left until completely dry.

BASIC PAINTING TECHNIQUE

It is now time to begin painting: an exciting moment, but fraught with dangers. Before touching a brush you should think about a number of points. From which direction is the light coming? Is the overall effect to be warm or cool? What sort of mood is to be portrayed? How dark is the distant range of mountains in relation to the sky and middle distance? What sort of treatment is best for the sky? Are there any points that should be emphasized? How is the centre of interest to be highlighted? Work out your answers to these questions before you start, to avoid last-minute panics.

Normal practice in watercolour is to paint in the lighter colours first and gradually work in the darker ones. Paint in the darkest last. As watercolours are transparent we cannot successfully paint a light colour over a dark one, but there are times when we need to work in lighter colours after placing some darks, so keep an open mind in this respect. It may sometimes be necessary to paint in dark tones at an early stage in the development of a painting to give an idea of value relationships. For instance, where several quite dark tones are required and you need to see the effect of your darkest dark. Additionally, work from top to bottom as far as possible. Laying and controlling a wash are the most

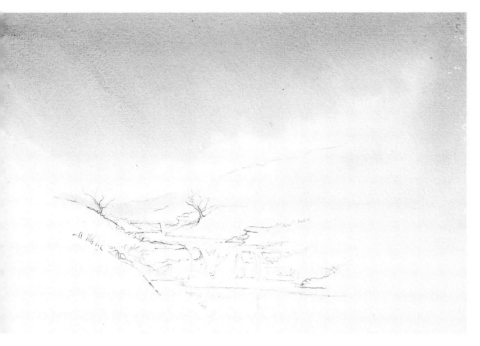

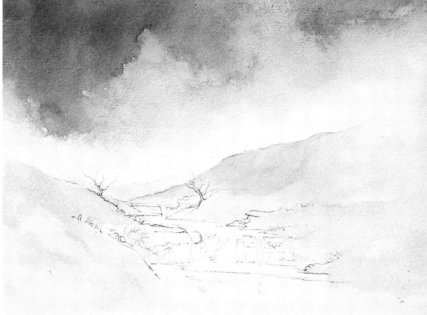

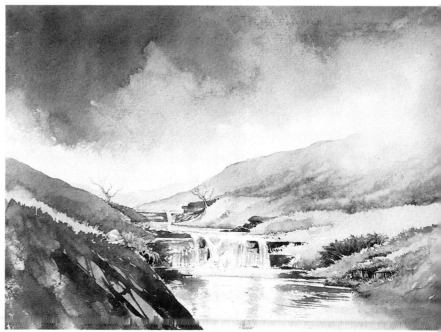

ABOVE LEFT:
GRWYNE FAWR Stage 1
This stream is seen here in its upper reaches in the Black Mountains. I began by laying in a wash of Prussian blue mixed with burnt umber in the sky, using a one-and-a-half-inch flat brush and then faintly entered the distant hill.

ABOVE RIGHT:
GRWYNE FAWR Stage 2
Having waited for the first wash to dry, I laid a stronger version of the same mixture over the top part of the sky to indicate threatening clouds. Then the hillside was indicated with a wash of Prussian blue and raw sienna, fading the hill away with the side of the brush as it disappeared into the mist on the right. Then I painted in the foreground grass by introducing lemon yellow into the mixture.

RIGHT:
GRWYNE FAWR Stage 3
With some light red I brushed in the warm areas denoting bracken, dropping in some cadmium yellow into the foreground bracken and making the further bracken duller with a drop of Prussian blue. Using the same blue I began work on the stream, and when this was dry detailed in some of the rocks. I also put in a splash of cadmium yellow to liven up the left-hand bank.

OPPOSITE:
GRWYNE FAWR Stage 4
The trees were painted in with a rigger for the branches and a number eight sable for the foliage, and finally I added some more splashes and ripples to the stream, again with a mixture of Prussian blue and burnt umber, mainly using the number eight sable. I have tried to capture the character of the rock structure by indicating the horizontal slabby manner in which they lie.

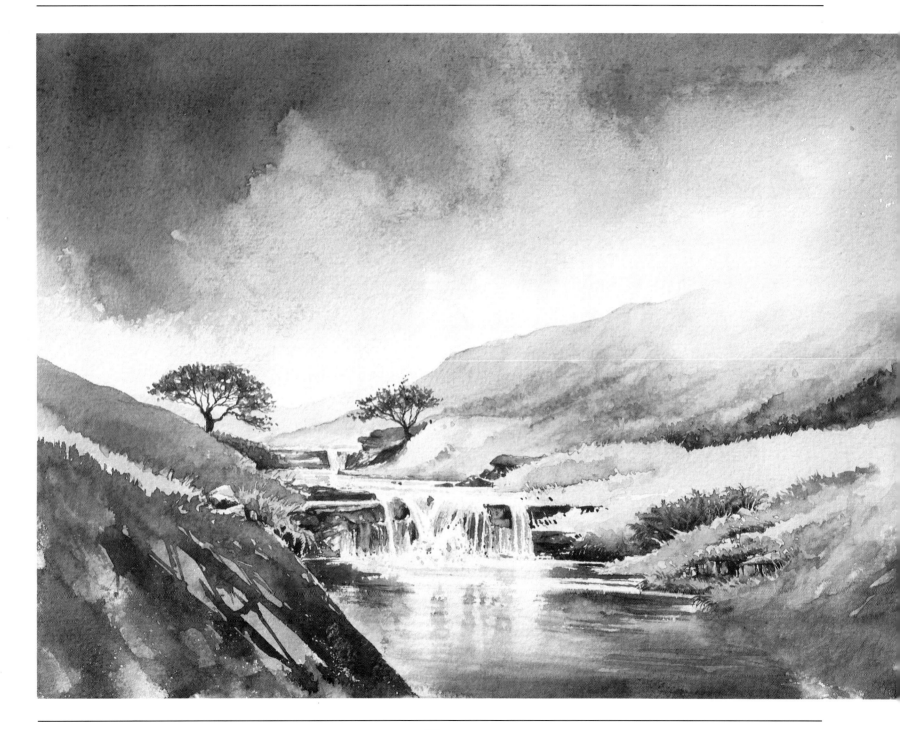

TECHNIQUES FOR USING THE BRUSH

Using a flat brush to create a horizontal white line—here a damp brush is being dragged from left to right in a wet wash.

Using a flat brush to create a dry-brush effect, by dragging a brush loaded with almost dry paint across a rough surface.

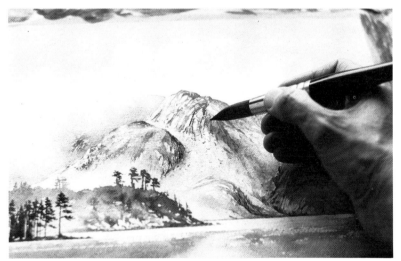

Using a large number twenty round brush for broader washes.

Using a large number twenty round brush for detail work.

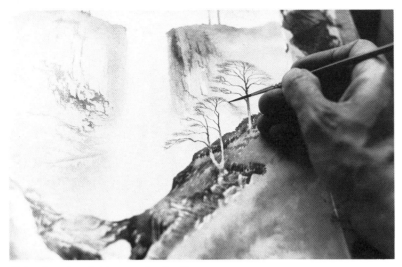

Using the point of a rigger on fine detail.

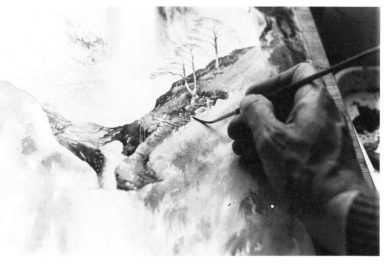

Using the side of a rigger when combining large areas with fine detail.

The general painting area set-up.

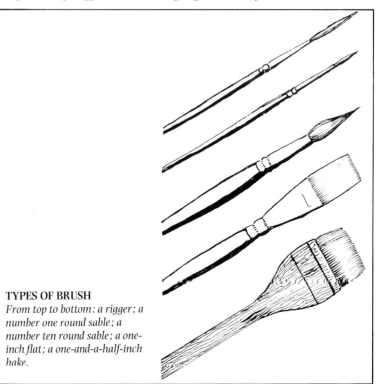

TYPES OF BRUSH
From top to bottom: a rigger; a number one round sable; a number ten round sable; a one-inch flat; a one-and-a-half-inch hake.

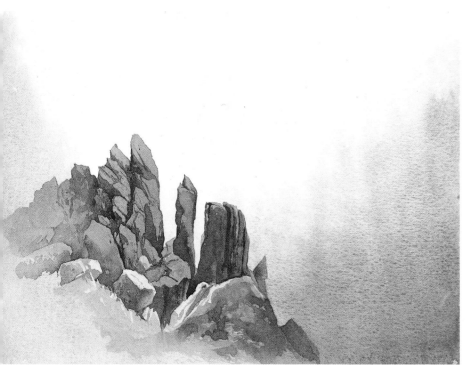

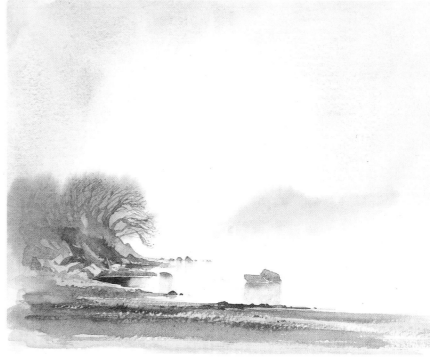

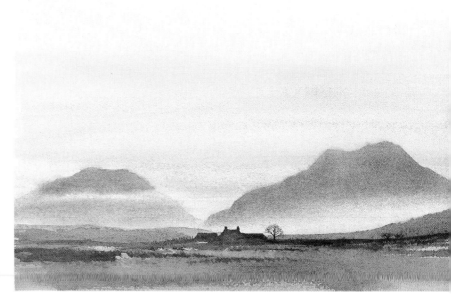

MOUNTAIN IMAGES
This is a series of four paintings, all of which have been kept very simple, a useful exercise for any watercolourist, however experienced.

ABOVE:
ROCKS ON CARN MEINI
Considerable licence has been taken here, not with the rocks, but with the atmosphere. It was a hazy summer day and the rocks can only be viewed from this angle by looking southwards, so there was no warm evening light as is suggested by the treatment. Much simplification has been done to create more of an image than a full painting, and this is something worth trying out, especially in the early days when the less complicated scenes make life easier. The overall wash of French ultramarine mixed with alizarin crimson has been
gradated to imply the presence of a hill to the bottom right: this was in fact the lower slopes of Carnbica. Much of the rocky clitter surrounding the main rocks has been eliminated, but the important rocks retain their general outline and character, which did not need emphasis to create drama.*

ABOVE RIGHT:
MIST ON DERWENTWATER
This 'mountain image' again shows considerable simplification, this time using the wet-in-wet technique described in chapter six.

RIGHT:
RHINOG FACH AND RHINOG FAWR
This is an evening scene where colour and details have been muted, the farm in silhouette, which adds drama and human element to a rather desolate subject.

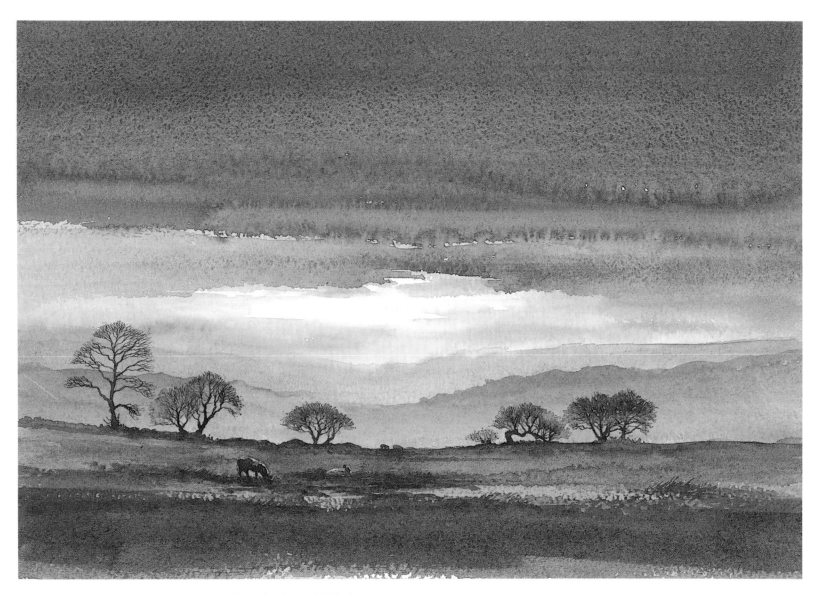

EVENING, PANTYGASSEG

Initially weak washes of French ultramarine and crimson alizarin were brushed over most of the paper, leaving the light centre part where some cadmium yellow was introduced. Gradually stronger tones were built up with the same colours and some raw umber was included in the foreground mixture. Finally the trees were drawn in with a rigger as stark silhouettes.

important aspects of watercolour painting. To lay a wash a reservoir of liquid colour is needed at the correct strength, or tone. You must therefore produce a mixture with the right amount of water. The mixture has to be strong enough in tone for the task, bearing in mind that watercolour lightens slightly with drying. Gauging this precisely mainly depends on experience. Use a large water pot, so that the water takes longer to become dirty—half a gallon size is fine. A second pot could be used simply for cleaning brushes, and is certainly useful if you are working in a room without a tap. Mix the colours on a large palette, white shallow tray or saucer, working the mixture into a pool of liquid. Do not mix more than two colours whilst you are still learning the rudiments. Later on try three, but beyond that all you will produce is mud.

Before touching your painting it is wise to test the strength of the tone and colour on a piece of scrap paper. This is also good practice prior to trying out any new techniques. For large washes you need a fairly large brush: a one-and-a-half-inch or at least a one-inch flat brush, or a wide hake is fine. Working with too small a brush may well reveal nasty ridges in the final wash when dry. Then, with the painting at an angle of about thirty degrees—books are ideal to prop up the drawing board so that it slopes comfortably towards you—lay in the wash. Boldly taking a brush full of colour lay it across the top of the area to be covered and immediately bring it down the paper with further strokes, not allowing the bottom edge to dry until the wash is complete. Always use as large a brush as you can get away with. If you wish to gradate the wash—make it lighter towards the bottom, for instance—gradually introduce more water into the subsequent lower strokes. Any excess liquid colour at the bottom of the wash can be soaked up into a damp brush. Try not to go over areas again, but leave the work to dry out completely before painting over it or any adjacent passages. In later chapters I shall discuss wet-in-wet techniques, but for the moment try to keep everything simple. The drying process can be quickened by the use of a hair drier, fan heater or perhaps placing the work in a sunny window, but I usually work on another painting whilst the first dries. It is particularly important to grasp this 'no-fiddling-with-it-whilst-it's-wet' idea, unless you deliberately want run-backs and merging colours.

To familiarize yourself totally with colours practise mixing in a methodical way rather than with one or two colours at random. Take a large sheet of watercolour paper and paint a pure blob of each colour along the top, and again with the same colours down the left-hand side. Then mix little blobs of each pair of colours, placing the mixed blob where the two colours intersect. You may find it easier to draw a grid in pencil beforehand, with each section about an inch or so square. Doing it this way ensures that you don't miss any combinations out. It is extremely valuable to see what greens you can produce, for example. Later on a third colour can be introduced into each mixture. Do experiment with colours.

Many students are apt to overdo the detail and make the painting more difficult than it need be. As I approach the latter stages of a painting I work less on large washes and more on detailed areas. When a fine point is needed on a brush for intricate work, load it with paint and drag it across a piece of scrap paper—I often use the margin of the painting—and at the same time twirl it between thumb and forefinger. Do this until the point is as fine as you require. Complicated subjects confuse unless you are experienced, so start with simple washes and little detail. Compositions similiar to my 'mountain images' series of simple paintings, will give you experience in laying washes without over-working the picture. In the 'mountain image' paintings you will see that the tones have been simplified and balance is maintained by the use of strong tones next to light ones. These tonal relationships are important and help define the shapes more subtly, without the need to draw outlines around everything. Colour alone cannot always effectively define shapes, and without variations in tone the painting can look lost when viewed from beyond four or five feet.

Tones are also the chief means of indicating recession. Colour certainly helps where cooler colours, such as blues,

PERSPECTIVE DIAGRAMS

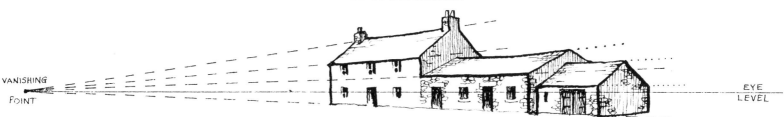

You may feel that this diagram is about as exciting as an architect's slide rule, but its value is in showing you the way in which horizontal lines appear on a building. The eye-level line indicates your eye-level, which will change if say you climb a ladder. All horizontal lines above this eye-level will slope downwards into the distance as they recede, whilst all lines below your eye-level will slope upwards as they recede. All these lines meet at an imaginary vanishing point, usually somewhere off your paper, but we don't go drawing these in unless we are drawing an incredibly complicated architectural subject.

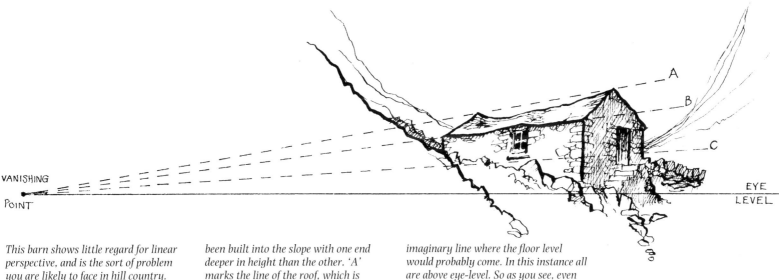

This barn shows little regard for linear perspective, and is the sort of problem you are likely to face in hill country. Here you have to imagine where the horizontal lines go, as the building has been built into the slope with one end deeper in height than the other. 'A' marks the line of the roof, which is sagging with age; 'B' indicates the horizontal line at the eaves; and 'C' is the imaginary line where the floor level would probably come. In this instance all are above eye-level. So as you see, even when linear perspective presents a chaotic facade, there are ways round it, once you have learnt the basic laws of the horizontal lines.

are introduced as the painting recedes into the distance, but the use of darker tones on mountain ridges as they get closer is a superlative example of aerial perspective. Dark foreground objects set against a lighter background is the most straightforward and effective way of creating a feeling of depth in a painting. Don't include much detail on distant mountains as the more detail the closer the area is brought to the foreground. When working from a sketch watch the critical edges where, say, middle distance and far distance meet; it is often a good idea to emphasize one or the other in order to make the change more apparent.

PERSPECTIVE

We have already covered aerial perspective, which is the

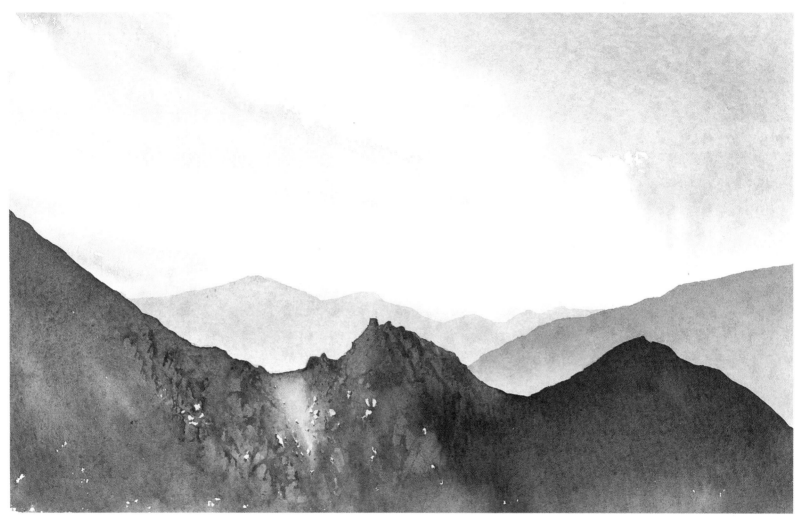

ABOVE:
AERIAL PERSPECTIVE
This view of Cofa Pike, a rocky appendix to Fairfield in the Lake District, gives an idea of aerial perspective, showing the mountain ridges getting lighter as they recede. Only Cofa Pike has any detail.

OPPOSITE:
CRIB GOCH FROM CWM GLAS
Crib Goch presents a complicated face from this angle, and even by putting in much detail the feeling of sunlight has been achieved by the use of deep shadows and contrast in tones between immediate foreground and the light screes below the rocks. The intricate rock fractures were carried out mainly with a rigger, and the overall colour betrays the name of the peak: the Red Comb in English.

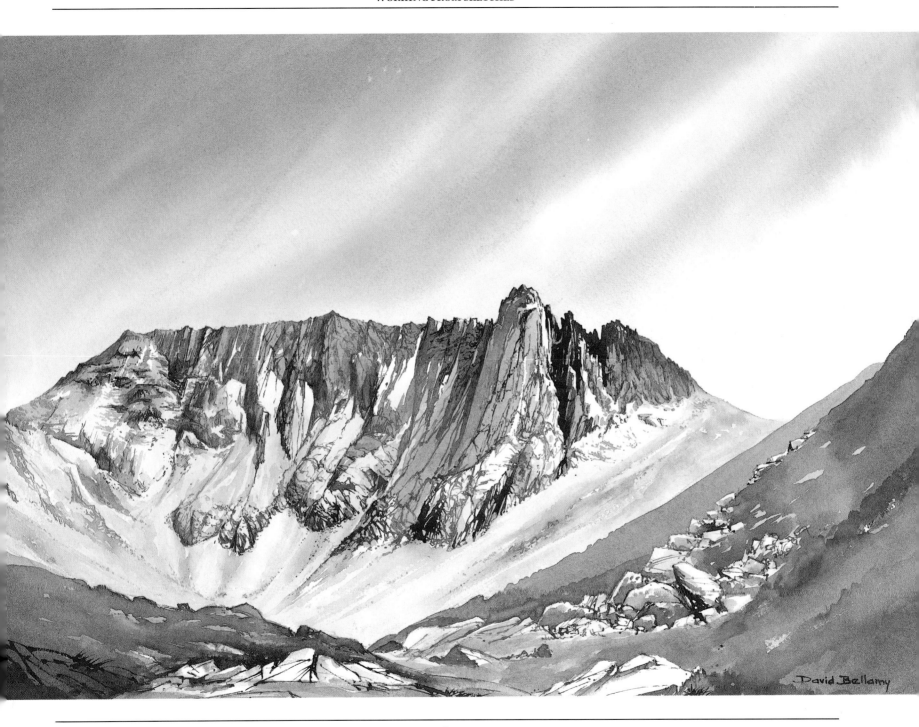

portrayal of recession. Linear perspective, however, is a subject that many artists find troublesome. Happily, in open mountain country linear perspective is not often apparent. Perspective is the science of making the structure appear to be solidly correct from any angle. The key to successful rendering of perspective lies in accurate observation of the subject, but it helps to be aware of the ground rules. Take a building as an example: basically all the horizontal lines above eye-level slope downwards into the distance, and those below eye-level slope upwards as they recede. This occurs whatever your eye-level, whether standing, sitting, or climbing a rock face. Most of us, however, have probably come across those lovely old tumbledown barns and ancient cottages that defy all the laws of perspective. What do you do then? Students complain that they don't wish to appear silly by drawing the subject exactly as it stands. My answer is to exaggerate the kinky bits that break those laws to an extent that they are incredibly obvious, even to the most myopic viewer, on the pretext that no artist would make such an outrageous error. It also adds character and interest at the

USING A CUT MOUNT ON A PAINTING
As you approach the final stages in a painting lay a cut mount over the work. This will highlight any problems, bring parts of the painting that need further work to your attention and help you decide when to stop.

same time. As an aid to working out these relationships use the thumb-to-pencil method described earlier.

Perspective peculiar to painting in the mountains usually concerns steep slopes, when looking up or down. Because of the indefinite structure of broken terrain this is rarely a problem, but how do you make it appear that you are actually looking up or down a gully? Introducing a figure immediately gets over this problem, as it becomes quite obvious that you are looking downwards if it's on the top of someone's head. Another method is to indicate strongly the direction of the source of light, by including the sky, or a stream at the bottom. The closer you get to an object the more distorted becomes the perspective and the relative sizes of various objects. To obtain the optimum viewpoint for giving the most faithful representation of its size and shape, it is normally best to climb up the mountain opposite until you are roughly at the altitude level with halfway up the mountain being viewed. Closer features exert undue prominence of course.

FINISHING THE PAINTING

When you are near to completing the painting drop a cut mount over the work to see how it is shaping up. This need only be an old mount of approximately the right size. It is amazing how suddenly the painting leaps out at you and improves considerably. Mistakes and incomplete passages also become more apparent, and you can concentrate on these now, rather than notice them for the first time when the painting comes back from the framer. Knowing when to stop vexes us all. It is so easy to mess the whole painting up by overdoing things at the end. Here the mount will help, and if you are still unsure it may be advisable to put the paints away and reappraise the painting after a day or two. If there's any doubt, leave it alone.

STYLE

Some artists produce highly stylized landscapes, almost to the degree whereby the subject seems subservient to the strong style. An example of this would be where perhaps trees of all types were simply reproduced in one style or format without consideration being given to their individual characteristics. If this is what you wish to achieve, go ahead, but I would warn against slavishly copying the dominant style of an artist. Try to forget about style whilst you are learning. Concentrate on producing competent paintings and your style will develop alongside. Later on you may wish to explore this aspect further, but my own attitude is that the subject comes first and I respond to that, allowing at times a powerful emotional release to guide me. Some subjects call for a different approach, so I like to remain open-minded when confronted with a new subject. As George Santayana once said, 'Nothing is so poor and melancholy as art that is interested in itself and not in its subject'.

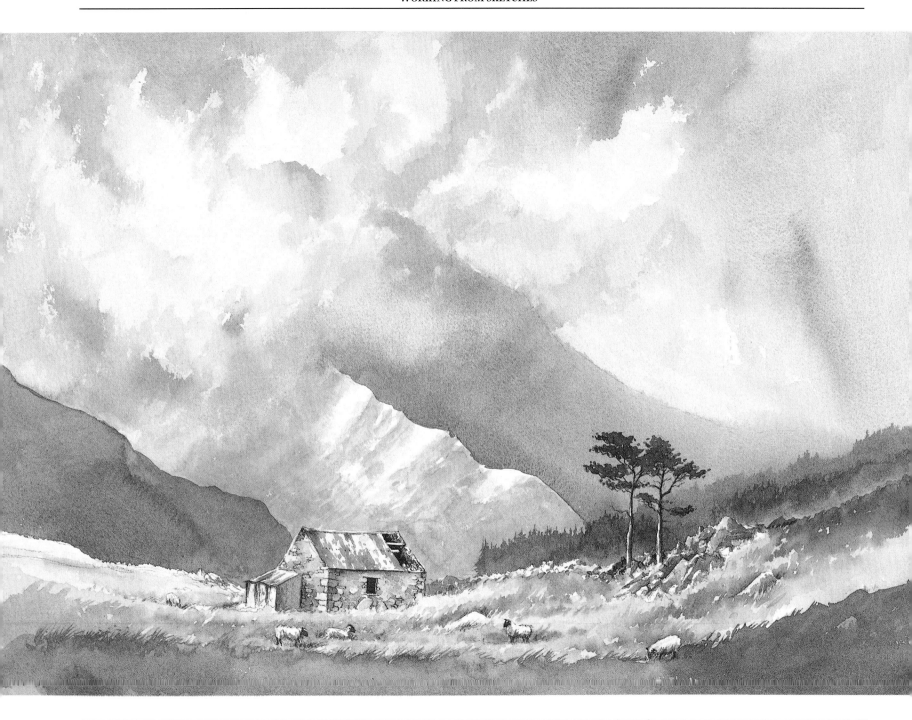

5
CREATIVITY IN A WATERCOLOUR

*. . . these are the works of the mind which I consider
very far before portraits of places*

DAVID COX

OLD BARN, GLEN SPEAN
*This scene held my interest, with the
wild elements contrasting the sturdy old
building.*

The secret of true creativity is having the courage to destroy something beautiful in order to turn it into the sublime. In this chapter we explore possibilities for rearranging the elements of a composition to suit our needs, and find ways to improve the pictorial qualities of a scene. During the eighteenth century the Rev William Gilpin held the opinion that it would be propitious to take a sledgehammer and 'improve' the aesthetic qualities of Tintern Abbey by knocking it about a bit. My approach is a little less drastic.

Ever since landscape painting began, artists have taken liberties in rendering the topography, and at times changing it out of all recognition. 'How far can we go in changing a scene?' is a question that often arises. Moving the odd tree, fence, boulder, recalcitrant sheep and even cottage about may be perfectly acceptable, but what happens when it comes to mountains and crags? Mountaineers, climbers and those who live in the mountains know immediately when liberties have been taken here—sometimes even to a mere crack in a crag. My own view is that, in painting a particular mountain I am creating a portrait and the overall effect of the mountain should therefore be reasonably faithful. It is not necessary to include every feature and it still leaves ample opportunity for creative exploration, but the general character should be obvious. Mountains cannot be moved about in relation to one another and neither can any be left out without good reason. If, however, the scene is not of any particular mountain and is to be entitled something vague such as *Mountain Snows* then feel free to let your imagination run riot.

Trees, rocks, walls, boulders, gateways, bushes and similar features are fair game, to be moved in order to improve your composition. Examples of this treatment would be to adjust the position of a gateway so that it leads you into the picture; replace a bush or tree to balance the composition on one side; remove some boulders from a mountain stream so that more water can be seen; heightening a tree so that it rises above the horizon and therefore breaks up monotonous horizontal lines. Lighting and sky treatment can naturally be changed to suit your needs.

SIMPLIFYING DETAIL

There are a numerous ways in which to simplify the detail of a complicated scene. Don't feel that you have to cover every square inch, as sometimes what you leave out matters more than what is included. Paintings need quiet passages where little is happening. One way to get around the problem where there are large areas of repetitious foreground detail is to vignette the painting—allowing the outer regions to bleed away into a weak plain wash, or simply untouched paper. This is done to a limited extent in many of my paintings, for I rarely put much, if any, detail into any of the corners. Washes of broken colour are another means of suggesting texture on the hillside, rather than painting in every single feature. This can often be done to advantage with the side of the brush, and especially when used in conjunction with rough paper, where the surface texture will cause the brush to leave patches of white or a previous wash to show through.

Another method of simplification within the detail itself is the 'lost and found' technique. A good example of this might be a foreground feature such as a drystone wall, which would need a considerable amount of working to show every stone. Even by bringing up the grasses and undergrowth to cover much of the wall, there would still be a large number of stones showing. And naturally too much undergrowth means more complications there. So cut out a lot of the stones. Put in the more important ones—usually those on top of the wall or beside a gateway, and blend in the rest. Suggest rather than define objects and textures. This can be done with broken colour washes and different colours. Not all walls are a dull grey. A splash of bright colour here and there can breathe life into a painting, but don't overdo it, otherwise the work will begin to look disjointed.

SCALE

Scale needs careful forethought and is often something that is taken for granted. How do we give some idea of the size of a mountain or crag, or the spaciousness of open moorland?

SCALE DIAGRAMS

A view of Tophet Bastion, Great Gable showing a climber just topping the crest. I was considerably higher and have tried to give the impression of looking down on the crag. The figure lends a sense of scale to the illustration.

The south peak of the Cobbler, a crag affectionately known as Jean by climbers. On the col below the two climbers give an impression of the size of the peak.

Three dot-like climbers in Central Trinity on Snowdon. It would be hard to make the dots any smaller without losing them totally, but it does indicate the immense face of part of Clogwyn y Garnedd, just below the summit of Snowdon.

The true size of a mountain is only evident from a distance where the perspective is truer. Closer in there are too many distortions. Likewise, if we place a building, tree or rock, say, too close to the foreground it may well dominate the mountain beyond, something we normally wish to avoid. Including a figure, animal, building or tree automatically gives a sense of scale, but by altering the object's size we can make the scenery appear on a grander or lesser scale. Turner often included lilliputian people in his paintings to exaggerate the immense and sublime quality of the background scenery. Again, refrain from putting figures or animals in the immediate foreground if you wish to convey a sense of scale.

COUNTERCHANGE

Counterchange is something we should be aware of and observe whilst sketching. It can be altered to suit our needs during the final painting. This is most evident, perhaps, when looking at a light-coloured telegraph pole 'growing' out of a hedgerow. The base of the pole may well be lighter

than the surrounding grass and foliage, but up above against the sky it is usually dark and almost a silhouette. The change in tone is often gradual and it pays to observe these points. Counterchange can be useful when depicting a tree and stops the objects becoming totally lost in one part of the scene.

CHIAROSCURO

This involves our arrangement of light and shade. Many times I have puzzled my walking companions, as I squint and hold my head on one side and stare into the bushes. Usually I'm just fascinated by the chiaroscuro effect caused by strong light seen through a framework of branches or stems. In a painting we create this effect by firstly laying on a wash of warm, light colour, and, when dry, delineating the darks. As with splashes of bright colour, it is best not to overdo this effect, which can, in fact, provide a centre of interest in itself.

FOREGROUNDS

Poor foregrounds can ruin a picture. In a watercolour, if working in the normal way from top to bottom, they are usually the last part of the painting to be done. Some artists keep their foregrounds simple, some make them almost an abstract, whilst others include a lot of detail. I feel it depends very much on the subject and don't like to enslave myself to any one formula. You will see examples of all types of

LEFT:
COUNTERCHANGE
In this one illustration there are several examples of counterchange. Firstly, on the mountain peak white snow on the summit makes it stand out against a dark sky, whilst lower down on its right-hand flank the mountainside becomes dark against a light sky. Where the dark mountain comes up against the foreground rocks it emphasizes their lightness, but higher up against the sky they darken. And finally the trees grow from light trunks low down to dark ones against the sky.

OPPOSITE:
LANCET EDGE AND CULRA BOTHY
The bothy, located in one of the most remote parts of the Central Highlands, affords a sense of scale and isolation, feelings which would not be so strong without the building. The composition follows the classic lines with the stream leading the viewer into the picture.

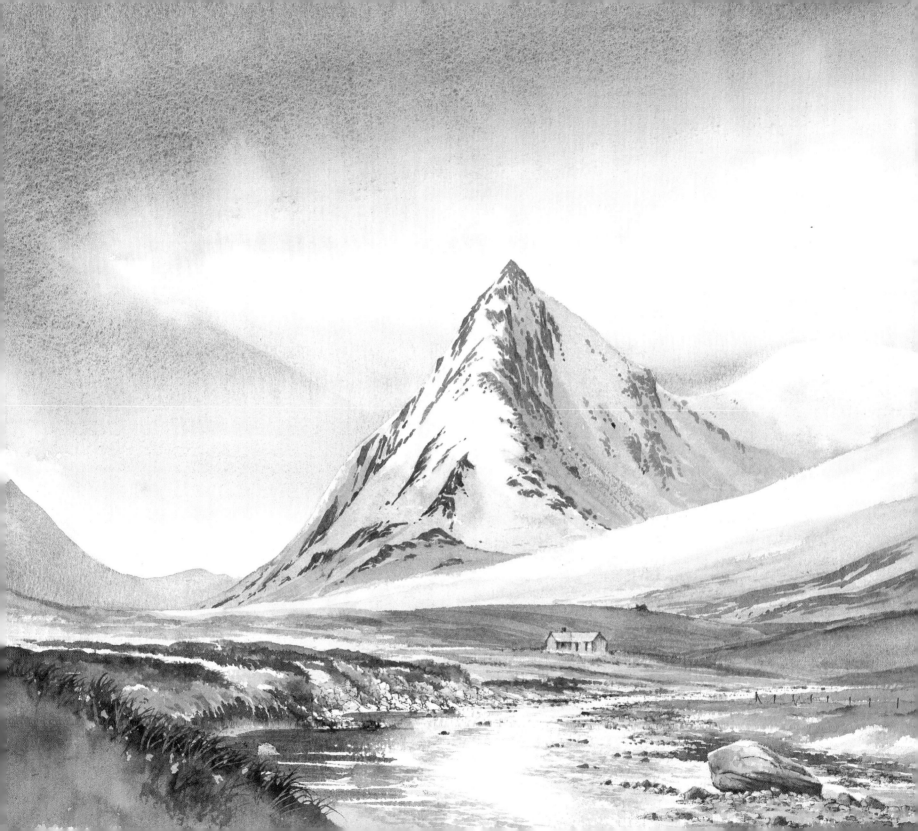

foreground in this book. In the main I prefer an uncluttered foreground unless it is an 'intimate' subject like a stream for example, where little is seen until it reaches the foreground, or a foggy scene, where most of the interest has to be in the foreground. On the whole, err on the side of simplification by suggestion rather than making too descriptive a statement. Sometimes a cast shadow, even from an 'out of sight' tree or building can provide a convincing lead-in to the picture.

IMPORTANCE OF WHITES

Take care in planning the darkest and lightest tones of all. Leaving the paper white will produce your lightest tone, and because there is no going back the whites have to be planned before putting brush to paper. Flecks of white enliven a painting and plenty of white areas should be left when depicting sunlight. The sun itself often confuses, especially late in the day as it sinks towards the horizon, glowing a fiery red. But even though it is red, it remains the brightest part of the sky. If you try to paint it red then everything else needs to be darker, otherwise you will run into problems, as red watercolour paint is far darker than the reddest of suns. So normally, if you include the sun, it is best kept as white paper. Try to keep your whites as clean paper—stopping out with sponges, tissues and the like, is a poor substitute, although these techniques have their value in softening or lightening passages. They cannot, however, compare with the pristine white of virgin paper.

INTRODUCING FIGURES AND ANIMALS

Many artists are wary of adding figures or animals to their landscapes, even if they were part of the original scene. Strangely enough, some of the most accomplished landscape painters have had problems here. Figures can give scale: a lone figure in a vast landscape can emphasize the loneliness, yet at times figures intrude. Also, as they are often added at the end of a painting, sometimes as an afterthought, they can mess up an otherwise competent painting if not carried out sympathetically. So how does one cope!

I don't include figures in a mountain scene unless there is good reason to do so: to provide a sense of scale if nothing else will suffice, to create a feeling of loneliness, or perhaps to depict a battle for survival in a blizzard or storm. A bent figure can put over a real sense of powerful winds. Draw them in lightly with a soft pencil first. When painting them in, ensure there is a sponge, tissue or clean, wet brush ready to lift out the figure immediately if it looks at all wrong. Figures are best doing things, reasonably logical things such as walking, climbing, etc, rather than simply posing on some wall in a rustic position. Any doubt about their inclusion and I leave them out.

Animals can take over a painting if they are drawn too large. Cattle are normally only found in the valleys or on the lower slopes, and are usually placed to advantage in the middle distance, suggested, rather than in great detail. According to Gilpin, in picturesque light the cow had undoubtedly the advantage over the horse, and was in every way better suited to receive the graces of the pencil. I gave up painting Highland cattle standing in lochs several years ago, after an argument with a large female (cow, that is!). By comparison, sheep are fairly simple to portray and more in evidence. They are also easier to turn into boulders should they go wrong. When I first painted some sheep in Snowdonia they resembled hippos, so the boulder trick was quickly utilized. Look carefully at sheep though, as breeds can vary enormously. There's quite a difference between a Derbyshire ram and a Welsh Mountain sheep. I once came across a field of enormous, fierce-looking rams with massive

DEER HERD, AONACH BEAG

The deer stood frozen against the snowslopes of Aonach Beag, which lay like some monstrous sleeping snow-leopard. I deliberately kept the background uncluttered so that the animals would stand out. Some of these red deer herds are quite large and it is not easy to get really close to them, as they have a very keen sense of smell and are timid creatures, unlike the reindeer found in the Cairngorms. A scene like this does not present too many difficulties, as the deer will often stand for ages watching you at a distance, ample time to sketch quite a few. Concentrate on the deer first, as you can always fill in the scenery afterwards at leisure. A pair of binoculars will help with detail. If you wish to work at a closer range approach them from downwind. Stalkers take great pains to close in, spending ages on their hands and knees. It goes without saying that you should keep clear of red deer during the stalking season.

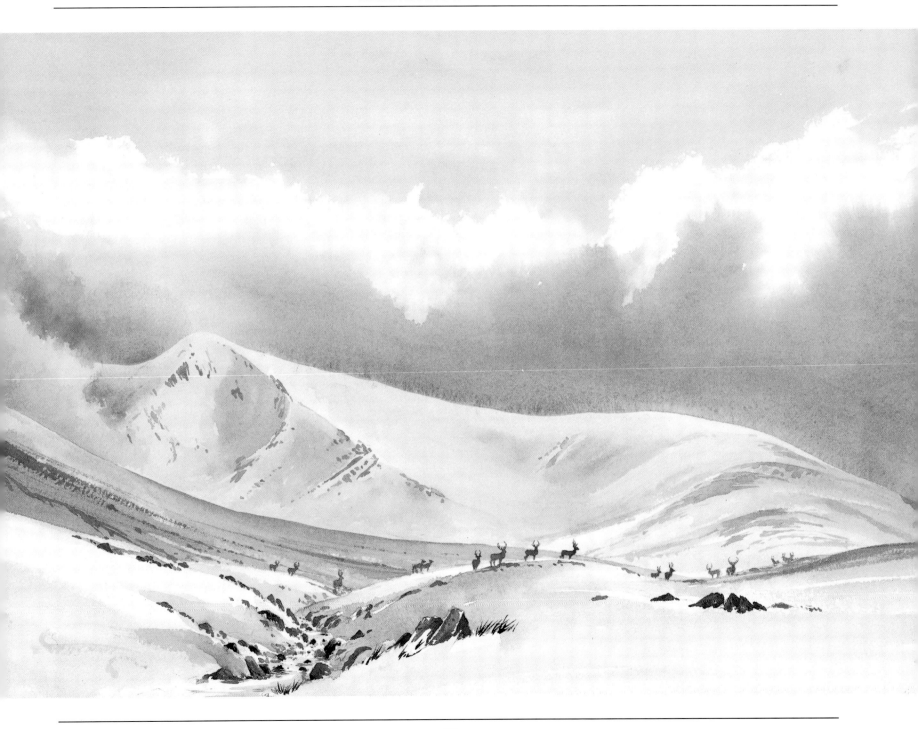

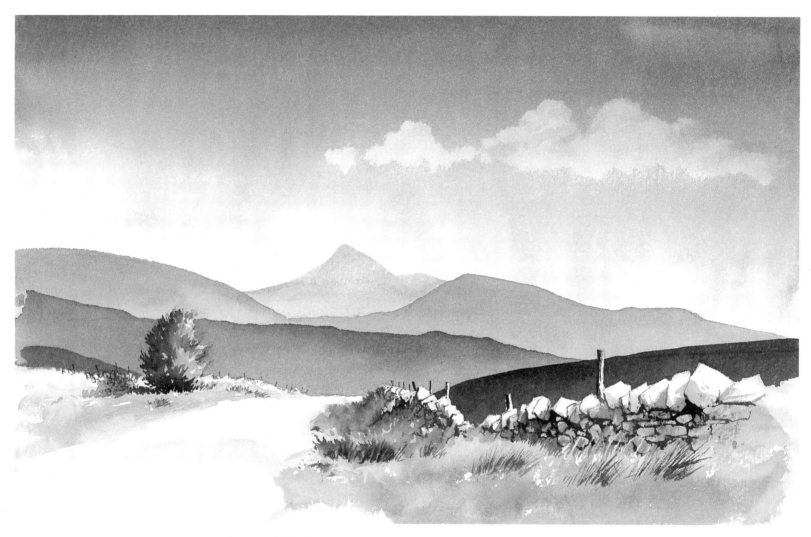

ABOVE:
HIGH WHEELDON, Peak District
This is one of the few actual peaks of the Peak District. I have painted it entirely with indigo. Doing a monochrome in this way is an extremely useful exercise as it concentrates your mind on working out the tones without the added confusion of introducing colour. I began with the lightest area in the painting and gradually worked in the darker areas, ending up with the darkest of all. Try a few of these and you will soon see your work improving, because you are having to concentrate on the relationships between each part of the composition, and defining critical areas with tone alone.

OPPOSITE:
LOCHAN NA H-ACHLAISE
An example of the use of a limited palette. Most of the painting has been executed with just French ultramarine and burnt sienna, with a touch of Naples yellow to warm up the sky.

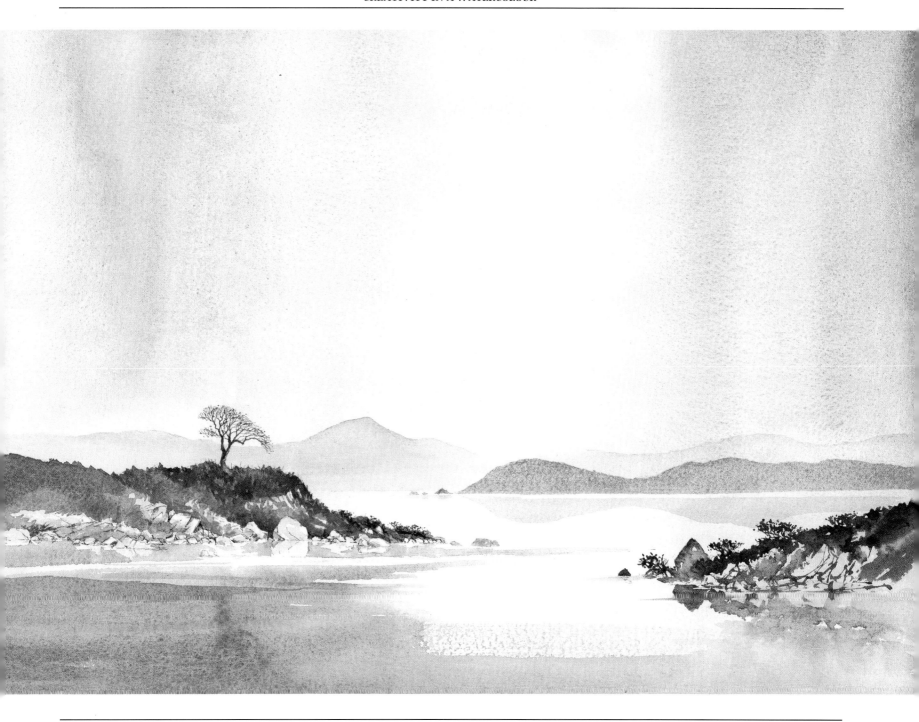

shoulders, which, had I seen in a painting would have assumed some licence taken. In art assumptions can be dangerous. Red deer are usually seen in herds, and difficult to approach before they flee. Where there are herds or flocks avoid the scattered look, with one animal to every two square inches. Bunch them with one or two strays, otherwise the effect can be distracting. Before placing figures and animals in a painting try out the colour and attitude of the figure on scrap paper.

COLOURS: THE LIMITED PALETTE

Too many different colours create a restless effect. I rarely use more than five or six in a painting, despite the large range available in the paintbox. I would suggest that you try a monochrome study, using either Paynes grey, burnt umber, indigo or sepia, as any of these will give a good range of tones from very dark to the weakest light wash. This is an excellent exercise to familiarize yourself with tonal values. Try a number of these one-colour paintings.

Having tried a monochrome painting take a second, lighter colour and just use the two colours to produce another painting. Try several paintings using only French ultramarine, burnt umber and raw sienna or yellow ochre. Afterwards compare the results with paintings you have done using many colours. It can be an extremely enlightening exercise. Then do further paintings, gradually building up the number of colours used, until you have tried a painting with five or six. These exercises will certainly help you achieve harmony in your work, as well as give you a better appreciation of tones.

Summer greens eternally vex the artist. It helps if you reduce the number to one, two or three greens at most. I don't generally use the ready-made greens, as these can be garish and in the main are staining pigments, so are difficult, if not impossible, to remove, if things go wrong. On most occasions I prefer to mix my own greens. Creativity with colour involves selecting and changing the original colours of a scene to suit your overall design. Try changing that cloudless blue sky to orange, and you will see what I mean.

DRYSTONE WALLS
These walls give some idea of the character of the area.

1
This is a Pembrokeshire hedge-wall—a pretty solid structure made up of stone layers sandwiched between earth and turf, capped with the occasional clump of gorse or wind-swept thorn-bush. Make full use of the lost and found effect offered by the stones appearing here and there.

1

2
These north Staffordshire walls are in places perhaps the most regular and intact of drystone walls on the hills, and at times seem like those of a model farm. The sandstone can appear both rounded and sharp-angled.

3
Limestone wall near Peak Forest, depicting the light colour and angular character of limestone, which has been accentuated by the dark background.

4
A Dartmoor wall contrasts the limestone with its darker, more rounded granite stones, which are much more varied in size. In places you will see where massive boulders have been utilized in the foundations of the wall.

5
A Pennine gritstone wall, tumbledown in places and generally of a darker colour. Use the gaps in the wall to create interest, breaking up the monotonous regularity and also to lead the eye through to a centre of interest.

2

6
A Lakeland wall in Upper Eskdale. Here the stones are well rounded, and the wall hardly much higher than the tallest grasses. In other parts of Lakeland, however, the walls are much higher, the stones more angular. In places these walls are an intense green colour and give the impression that they actually grow out of the ground, rather than having been built.

CAPTURING THE CHARACTER OF AN AREA

When painting a particular scene, whether in Scotland, the Pennines, Dartmoor, or wherever, it gives a marvellous boost to confidence to hear someone say, 'That's a typical Yorkshire Dale'. So we should strive to put over the

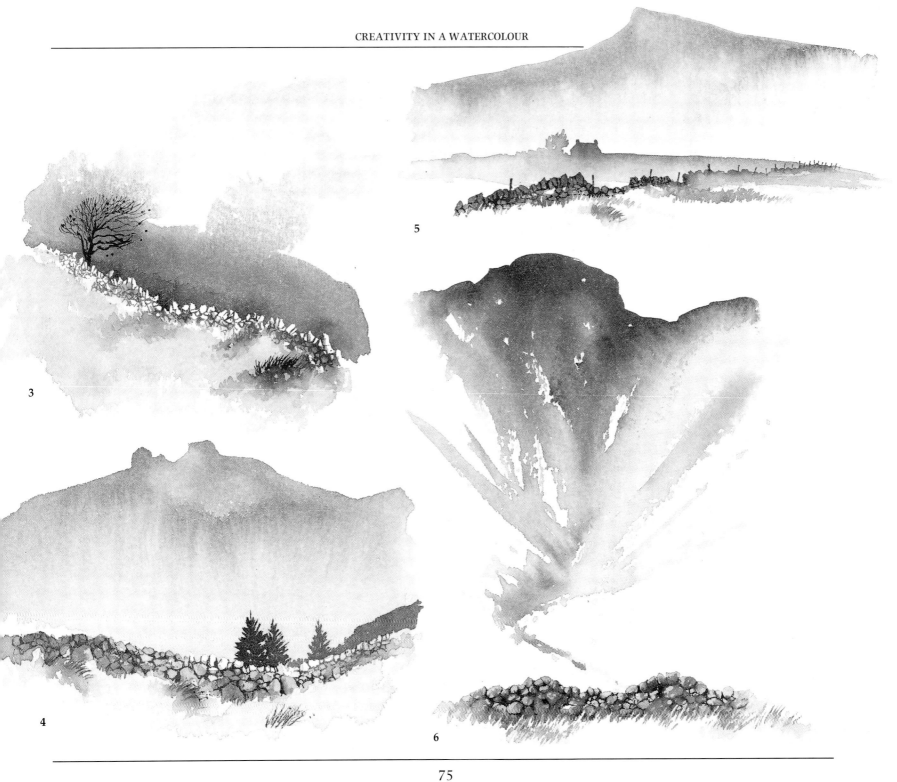

3

4

5

6

MINING BUILDING, Coniston Coppermines

Stage 1: here I have simply laid on the masking fluid over the building with an old brush, as I wanted clearly-defined edges on the roof.

Stage 2: I began the sky with a weak wash of Naples yellow running diagonally from the top right, and immediately brushed in some French ultramarine, allowing the two colours to fuse into each other where they met. Then I introduced the shadow area on the left and the shadows cast by the rocks caught in sunlight with French ultramarine, brushing over the masking fluid.

Stage 3: at this stage I decided that the sky where it met the mountain on the right needed more definition, so introduced a stronger tone of French ultramarine. The warm tones on the rocks came next, using raw sienna with a hint of cadmium red. I worked on the walls of the building with raw sienna and French ultramarine, and then the darker rocks with much the same mixture. Next I began to put in more detail on the rocks caught in the sunlight.

Stage 4: I finished off the sunlit rocks and finally added in the dark detail of the foreground rocks, stones and building.

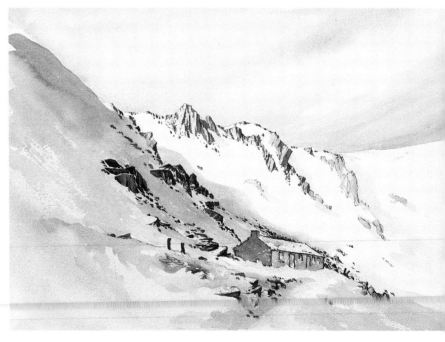

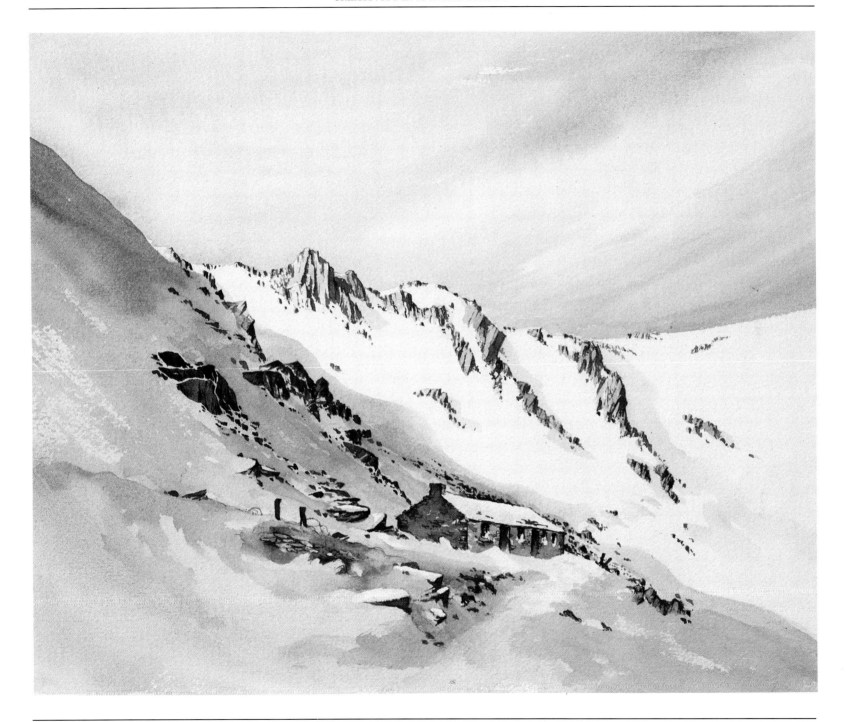

MOUNTAINSIDES

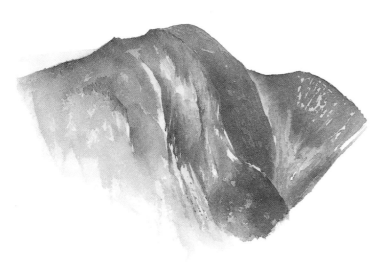

Scree slopes at Wastwater, done with a dry-brush dragged diagonally.

Jagged rocks on Bristly Ridge of Glyder Fach painted with a fine sable.

Glistening boiler-plate slabs on the notorious A'Chir ridge on Arran, again done with a fine sable brush.

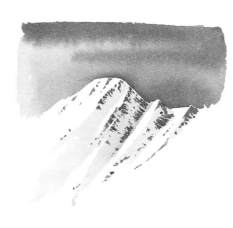

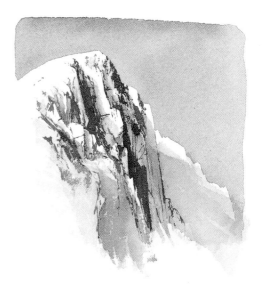

Indefinite forms on the side of Dollywaggon Pike brought out with changes of tone. A large round sable was useful here.

Snow-grouted ridges and gullies on the Aonachs. The shadow areas were painted first with a large sable, then when this was dry the dark rocks entered, following the line of the strata.

Craggy face on Cadair Idris achieved with a rigger and number eight sable.

TREES COMMON TO HILL COUNTRY

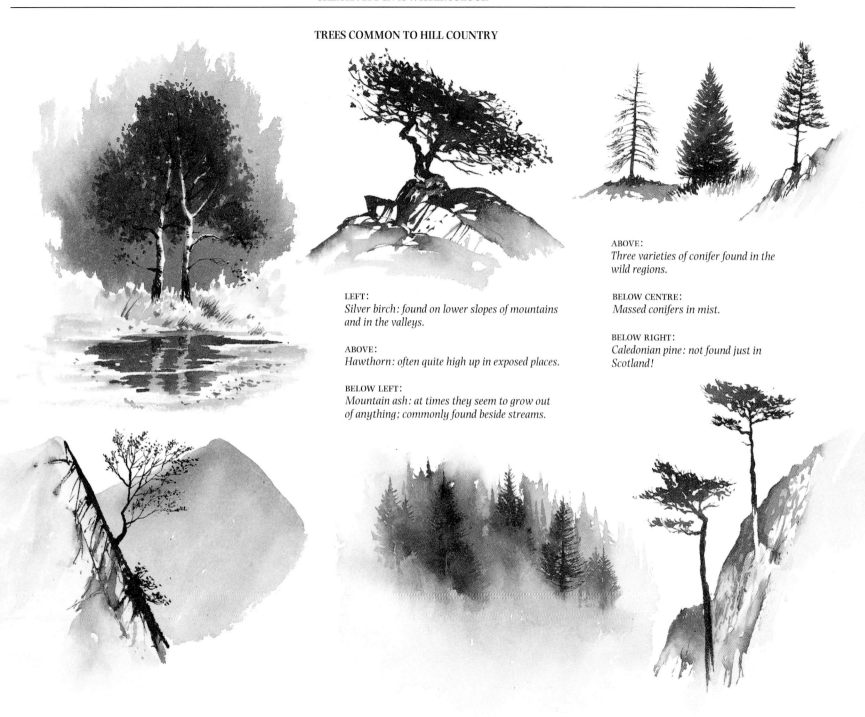

LEFT:
Silver birch: found on lower slopes of mountains and in the valleys.

ABOVE:
Hawthorn: often quite high up in exposed places.

BELOW LEFT:
Mountain ash: at times they seem to grow out of anything; commonly found beside streams.

ABOVE:
Three varieties of conifer found in the wild regions.

BELOW CENTRE:
Massed conifers in mist.

BELOW RIGHT:
Caledonian pine: not found just in Scotland!

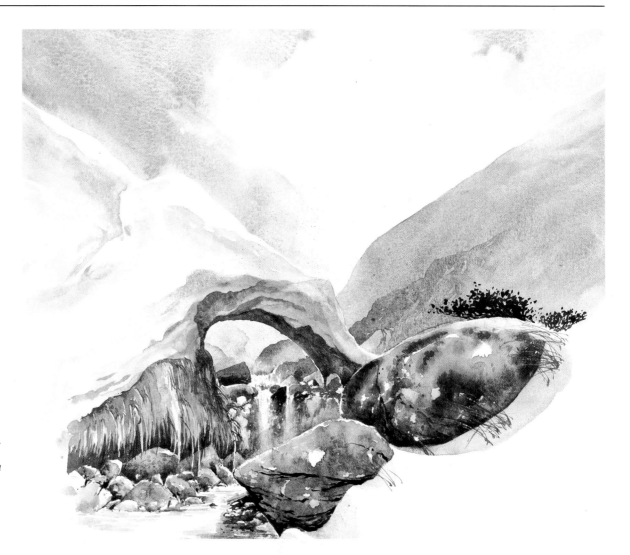

SNOW ARCH
This is an example of an unusual subject. Keep your eyes open for new ideas and experiences in subject material, and with a creative approach you may well find yourself responding well to these. Often places such as stream beds can yield interesting mini-subjects, complete in themselves.

character of a place in our paintings. Naturally, it must begin with the outdoor sketch, observing all the features that make it a 'Dales' scene, for example. In the final painting we can bring to bear observations from a number of sketches and photographs, some of which might show strong characteristics. So what should we look for in seeking out this elusive quality?

Firstly, the most obvious aspect is the geology. We don't have to be experts to observe the different appearance of gritstone and limestone. This is readily apparent in the rock structures, textures and colours, the characteristics of drystone walls, and is reflected in the vernacular architecture. Granite and sandstone are more rounded than the angular quality of limestone, which is much lighter in tone and colour when compared with the other two. Note the Welsh slate roofs in Snowdonia, whilst in the Pennine

HOW TO CATCH A CHARGING OTTER

This double-sketch done rapidly with a wash of Payne's grey shows at the top the otter caught at the start of an exuberant charge: it was actually charging back into the river to catch another fish, not at me! Animals like this found out in the wilds are best watched for a few minutes before doing any sketching. Unlike a cow or sheep they leap about like a frenzied jack-rabbit, making sketching rather a challenge. Wait until they are about to change direction or attitude, and as they pause quickly get down the general pose, as I have done here with watercolour. Loss of absolute accuracy has been accepted in exchange for a more dynamic portrait. Watercolour pencil has been used to add detail.

In the lower study it does rather look as though the otter is pawing the ground ready for the charge, but in fact it was just playing in the grass. The same technique was used as above, though the pose is a little ungainly, especially with the rear right leg.

moorlands many roofs comprise enormous thick, flat sandstone slabs of much lighter colour. The traditional Pembrokeshire cottage has a light-coloured roof with no slates showing beneath the slurried mortar. In the south Pennines much of the stonework on buildings is blackened, with light mortar in between the regular stonework. Barns in the Yorkshire Dales feature extruding stones at regular intervals along the sides, whilst the traditional bank barns in the Lake District have a storage area upstairs and a stable or cowshed below. The barns were built into a bank so that carts could have easy access to the upper part. The overall shape of the hills can also betray their situation: the Torridon Hills are distinctive, yet so are the Brecon Beacons, which are quite different. These are some of the points to watch for when seeking the character of an area, a few of the many intricacies you can find to spice up your paintings.

ORIGINALITY

Creativity also involves seeking out unusual and new types of subject—perhaps never considered before—and seeing more common subjects in a new light. Popular subjects turn up frequently at exhibitions, and if you suddenly find yourself in front of a well-known scene, such as Ashness Bridge in the Lake District, consider how you can render it in a more original way, whilst retaining its form and character. It can be quite a challenge. Be aware though, that originality for its own sake can result in a contrived or stylized work devoid of feeling.

Copying the scene before us into the final painting in a photographic manner can exude all the excitement of a London telephone directory. We need to put our own stamp on it; to improve the composition; emphasize the atmosphere, the remoteness of a scene, perhaps; we want to use colours to achieve this overall feeling, of unity, or even of discord between foreground sunlight and distant storm. Don't be afraid to experiment—stuff the mango chutney into the sago pudding, as it were, if it adds vigour to your skies. Be prepared to throw away a lot of work that 'didn't come off' just to get one superb effort. And it's a marvellous way to cast aside those painting blues that affect us all at some stage.

6

EMPHASIZING MOOD
AND DRAMA

Each purple peak, each flinty spire
Was bathed in floods of living fire

SIR WALTER SCOTT

The painting of a mountain scene devoid of atmosphere is like a curry without the rice. It just doesn't look right. In the mountains atmosphere seems far more accentuated. How do we capture this special quality, and conjure it up when it is not apparent? The key to mood is in the sky and lighting, which can evoke a strong influence on our feelings and emotions. Treatment of skies is paramount here, for a good sky can make an indifferent painting superb. Skies are a fascinating subject in themselves and there is much more to them than a couple of wet-in-wet strokes with a three-inch paintbrush. The wet-in-wet technique, described in this chapter, is excellent for skies, but is perhaps used too often, when a little thought might produce a more interesting effect. You do not have to walk for long in the hills to see some marvellous sky-scapes.

Lighting creates the overall atmosphere in a scene. Warm evening summer sunshine is vastly different from a pale mellowing February sun shimmering through a vapoury haze. Note how the evening light catches rocks and hillsides and transforms the local colour. Or how a patch of light shining through a gap in the clouds can isolate and accentuate a focal point. Strong directional lighting creates intensely dark shadows and, when low, throws them across a scene, which by their horizontal nature gives a pleasing sense of peace and tranquillity. Backlighting accentuates aerial perspective—see how the hills lose their detail as you look into the sun, and how the mountain ridges become more clearly defined. Note also the phenomenon of how in this lighting the ridge tops are clearly darker in tone than they are lower down, the change being barely perceptible. This feature can be exaggerated and put to good use in a similar way to normal counterchange.

How do you capture these moods? Firstly, limit drastically the number of colours you use in a painting. Whilst you can use bright colours for a high-key subject with warm lighting, in the main you will probably use the less bright end of the palette. Restricting yourself to about four colours will help. Avoid discord by carefully selecting those that complement each other. Simplify the colours, tones and shapes.

In addition to limiting the colour range, you can achieve unity in a painting by keeping to one base colour. By this I mean that you use, for example, French ultramarine as the blue with which to mix the sky colours, for the green leaves and grasses when mixed with, say yellows, and in the water, and so on. This will immediately lend itself to a more harmonious picture. Another technique is to introduce a glaze, which is a colour washed over a previously painted area that has dried. Care is needed in choosing the right colour for glazing; the more transparent pigments such as crimson alizarin or French ultramarine should be used. Manufacturers often indicate the degree of transparency on their paints, but it is as well to do some tests on scrap paper before committing your masterpiece to such treatment. The smoother the paper, the more likely that a glaze will become muddy, as then the first wash is more likely to be disturbed.

OPPOSITE:
STONE CIRCLE, DARTMOOR
Approaching rain seems to intensify the feeling of brooding stones, evoking a strong sense of the past. My first action in this painting was to paint in the distant hill, and then straight away wash on a very wet sky, beginning with raw sienna, into which I then brushed a mixture of French ultramarine and burnt sienna. With the drawing board at quite a steep angle I allowed the whole wash to run down the paper, in part blotting out the distant hill. When all this was dry I painted in the slopes on either side, using raw sienna, burnt sienna and a touch of French ultramarine. Again the painting had to be left to dry before the foreground was executed with the same colours. Finally I introduced the stone circle.

OVERLEAF, LEFT:
TRYFAN FROM TAL Y BRAICH
Early morning sunlight has caught the upper reaches of the mountain: a time when they are at their most magical, but which I rarely capture when not using the tent.

OVERLEAF, RIGHT:
STOB GHABHAR
Here I was captivated by the large coire, and how the sunlight seemed to gouge out the gullies by casting shadows across them. After painting in the sky and leaving a crisp definition between sky and snow-covered peak I then painted in the bare rock outcrops. When all these were dry I glazed the areas to be kept in shadow with pure French ultramarine. In places the glaze has caused the dark rock shapes to blur slightly, but this has been kept to a minimum by laying on the glaze decisively with one stroke. Going over it again would have fatally blurred the rock areas. Pure, clean French ultramarine has a crispness about it which I rather like. Of course, the glaze could have been applied as an initial wash and the rock outcrops painted in afterwards, but I felt more in control of it by doing it this way.

David Bellamy

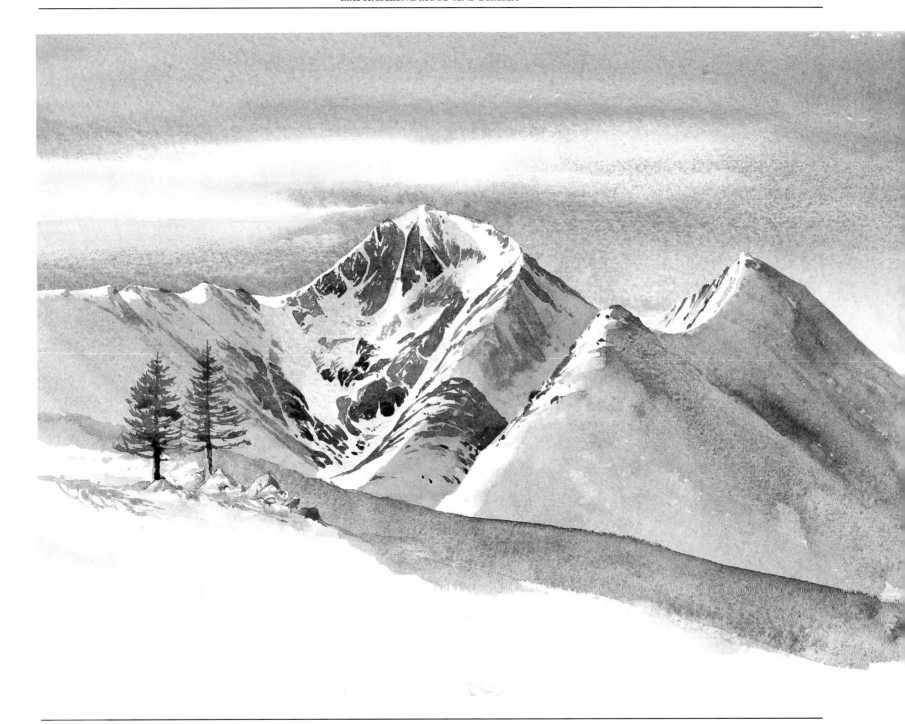

Mud is not easy to shift! A transparent glaze will allow the original wash to show through, and has the effect of unifying the whole area. This is particularly advantageous in creating shadows. So often I see students painting the shadow side of a wall and its cast shadow as two totally different colours, thus dividing it into two discordant zones. This usually looks disconcerting, when all that might be required is a glaze over both areas to unify them.

The placing of tones and colours in the sky to indicate clouds, light and the direction of light can suggest peace, strong winds, wild storm clouds or approaching rain. It helps to pin-point the exact position of the sun or even include it in the painting. Think about colour temperature in relation to the mood of the moment, before choosing colours.

WET-IN-WET

In watercolour, the wet-in-wet technique is one of the most powerful ways of creating mood. Basically it involves dropping or blending another colour into a wash that has already been laid and is still wet. The main problem is one of timing and this only comes with experience. It is not too difficult, but if you have not tried it before practice the method first on cheap watercolour paper until you are more familiar with the way of working. Try boldly applying dark colour into a lighter wash that is still wet, but be very sparing with water when dropping in the second wash, otherwise the effect will be diluted. The steeper the angle of your drawing board, the more dramatic the result. The technique is useful for mists, skies, blending in soft tones and creating gradual changes. The real 'secret' in achieving pleasing wet-in-wet effects is in having a confident, bold approach to the technique. After all, if you are painting in the sky first with this method, then you will not have much to lose if you make a mess; it's not as though you've spent an hour or two on the painting already and just messed it up at the last hurdle. Again, experiment on small areas to begin with.

RAIN

Any attempt to paint rainfall with deliberate diagonal brushstrokes for each individual drop of rain is likely to end in disaster. An overall effect can be achieved by a broad-brush approach to suggest a mass of falling rain, but I usually prefer to wet the surface first with clear water and then, with the board at a fairly steep angle, lay on strong washes at the top of the paper. I then allow the washes to run down the paper, sometimes tilting the board to right or left to give the impression of wind blowing the rain across the landscape. Try painting in the distant hills first and allow the 'falling rain' to run down over the hills, losing them here and there, so creating a natural veil of falling rain. This can be done with the hills dry or still wet. However, this method may not work every time if painting over wet hills, so practice beforehand is essential.

The effect of rain can be further enhanced by painting wet roofs, puddles and reflections on rocks, roads and hard surfaces. This wetness is achieved by keeping the area light in tone and creating reflections using a limited wet-in-wet technique. Sometimes it is better to re-wet the area first with clean water, then brush in the reflection, thus creating a soft effect. Leave some small patches of white in the areas you want to appear wet in order to give sparkle. Sometimes it is worth contriving a bright-coloured or quite dark reflection to emphasize the dampness or wet conditions, but this naturally depends on your overall plan for the painting.

MIST

This is generally done using the wet-in-wet method mentioned earlier, so that everything blends in softly. Don't fiddle too much once the wash has been laid, as things can go terribly wrong. You can always wait until it is completely dry, re-wet the area with pure water, and then blend in a colour wash. Strong, crisp shapes are needed in the foreground to help accentuate the impression of a misty day. Mist unifies colours which are normally in strength only in the foreground, so use a very limited palette. Background mist can be useful to isolate objects or diffuse a complicated passage, and also to eliminate irrelevant features.

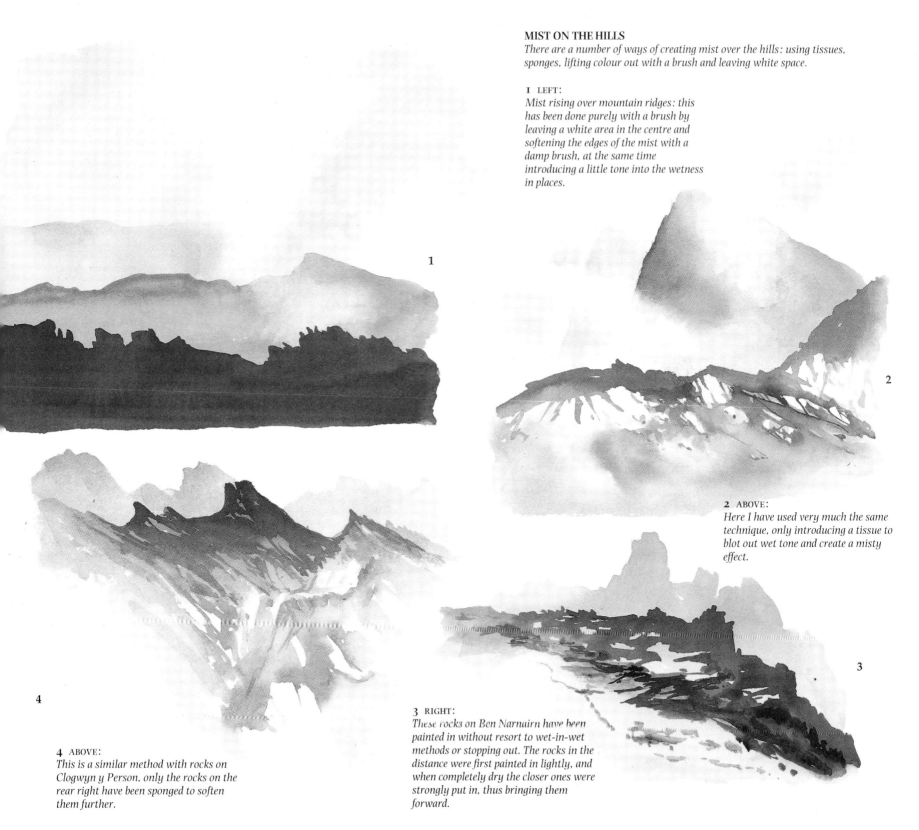

MIST ON THE HILLS

There are a number of ways of creating mist over the hills: using tissues, sponges, lifting colour out with a brush and leaving white space.

I LEFT:
Mist rising over mountain ridges: this has been done purely with a brush by leaving a white area in the centre and softening the edges of the mist with a damp brush, at the same time introducing a little tone into the wetness in places.

1

2

2 ABOVE:
Here I have used very much the same technique, only introducing a tissue to blot out wet tone and create a misty effect.

3

3 RIGHT:
These rocks on Ben Narnairn have been painted in without resort to wet-in-wet methods or stopping out. The rocks in the distance were first painted in lightly, and when completely dry the closer ones were strongly put in, thus bringing them forward.

4

4 ABOVE:
This is a similar method with rocks on Clogwyn y Person, only the rocks on the rear right have been sponged to soften them further.

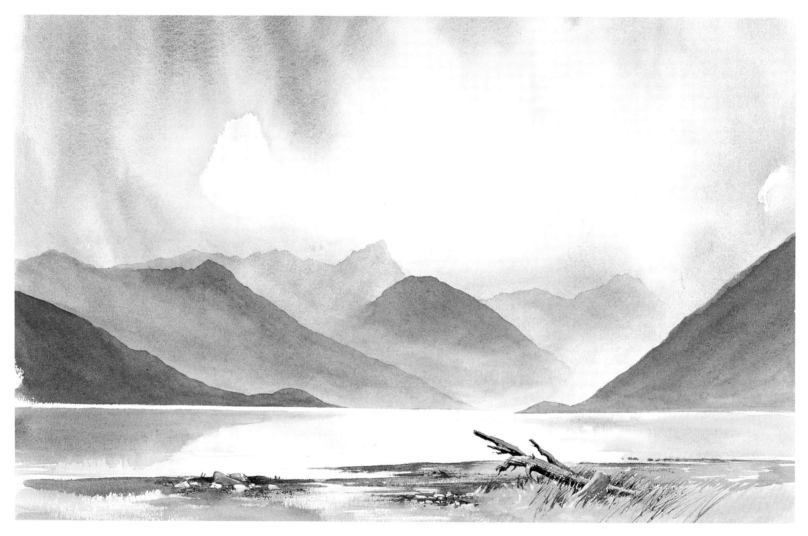

ABOVE:

WINTER LIGHT, LOCH QUOICH

Overall use of a mixture of crimson alizarin and French ultramarine has created a warm mood of expectancy over the loch: hardly a thunderstorm in February, but perhaps a hint of impending snowfall. The misty atmosphere amongst the mountains adds to the sense of mystery.

RIGHT:

PENNINE FARM IN DRIZZLE

How I love some of these gloomy days in the Pennines, when the drizzle often seems to wake me up and freshen the landscape, sharpen images and increase the feeling of unity. Make the most of reflections on these days. In this composition the puddle and chimney reflecting on the wet roof put over a feeling of a rainy day.

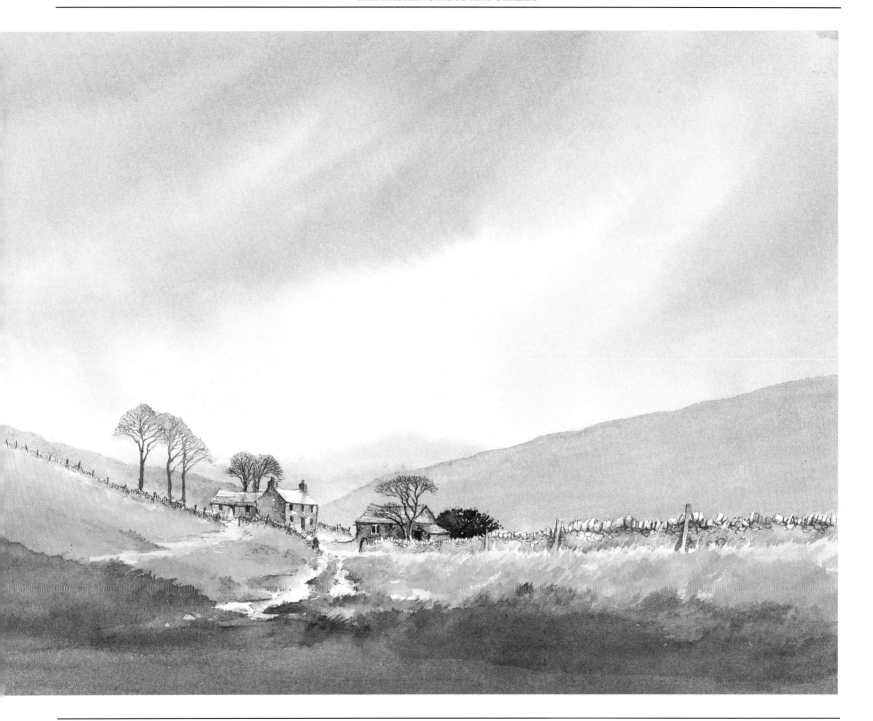

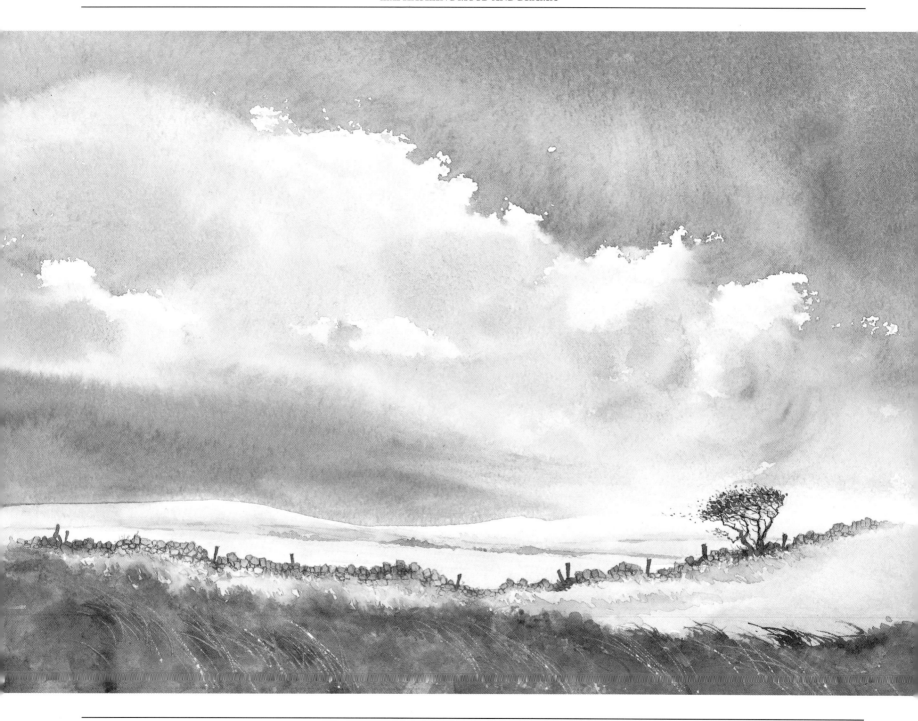

WIND

Wind can be depicted without resorting to the 'inside-out umbrella' trick. Bent figures, animals, branches and grasses can of course be effective, as well as leaves departing from a tree. Rippled water on a lake and a wild sky with clouds ragged at the edges, also suggest a blustery day. Position the clouds diagonally across the sky to give a dynamic appearance, implying movement. At the same time make sure that the sky is in keeping with the landscape: a tranquil lake with a storm-tossed sky would be glaringly inconsistent. Try large, sweeping brush-strokes when painting in cumulus clouds. The ultimate in this would be the vortex effect, rather like a whirlwind. David Cox (1783–1859), the Birmingham watercolourist who did so much work in North Wales, was supreme in depicting wind, and his work is worth studying for this alone.

SUNLIGHT

The effect of sunlight can be increased by darkening shadows and putting less detail into the sunlit areas. Too much working there will destroy any feeling of strong light. Use cast shadows if possible and keep the direction of light consistent. Cool shadows add warmth to the sunlit areas, so judicious placing of warm and cool colours can accentuate the degree of temperature. Flecks of white should be left in the sunlit area to suggest light catching objects. Don't forget that evening and early morning light is much warmer than midday, at times turning the hills quite red. This colouring is more pronounced on hard, rocky surfaces, so that mountains like the Cuillins of Skye which are very rocky, tend to reflect strong changes of colour, sometimes quite intense. I have seen them change from almost black to light pink within an hour, without any help from the local whisky! On a fiery evening Seat Sandal in the Lake District, turns quite red when seen from Grisedale Tarn, even though from this angle the flanks are predominantly grassy.

OPPOSITE:
NORTH YORK MOORS
My intention here was to give the impression of strong winds, by bending the tree and detaching some leaf-like shapes from the branches, by emphasizing the bent grass, and also by creating a diagonal cloud effect across the sky. This latter effect conveys a restless, wind-torn feeling to the sky. The passage beyond the tree I have played down, both to allow the tree to stand out, and to give a feeling that 'something is brewing, yonder'.

ABOVE:
LLIWEDD FROM GRIBIN
 (Photograph)
This shows the actual scene with back-lighting and the foreground snow in sunlight. I sketched in strong sunlight in an exposed position high above Glaslyn. My right crampon had just broken on the climb up awkward mixed rock, ice and snow. I sat sketching, not knowing whether or not I would get back down in one piece, quite sure that this would probably be the last sketch I would ever do. But somehow I made it

OVERLEAF:
LLIWEDD FROM GRIBIN
This is the finished painting produced from the sketch, photograph and other sketches of the sky on a previous trip on the Snowdon Horseshoe. I have actually flattened out the foreground to show a little more of the snow and jagged rocks which were missed by the photograph. Here the mist is rising out of Cwm Dyli: it's quite a place for this effect.

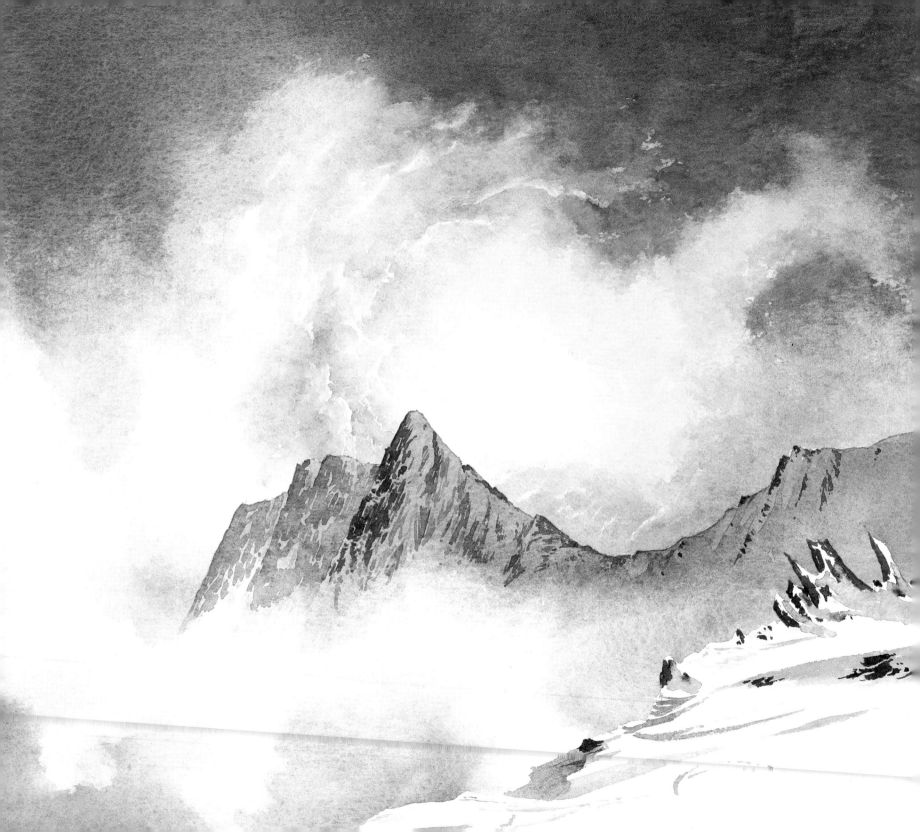

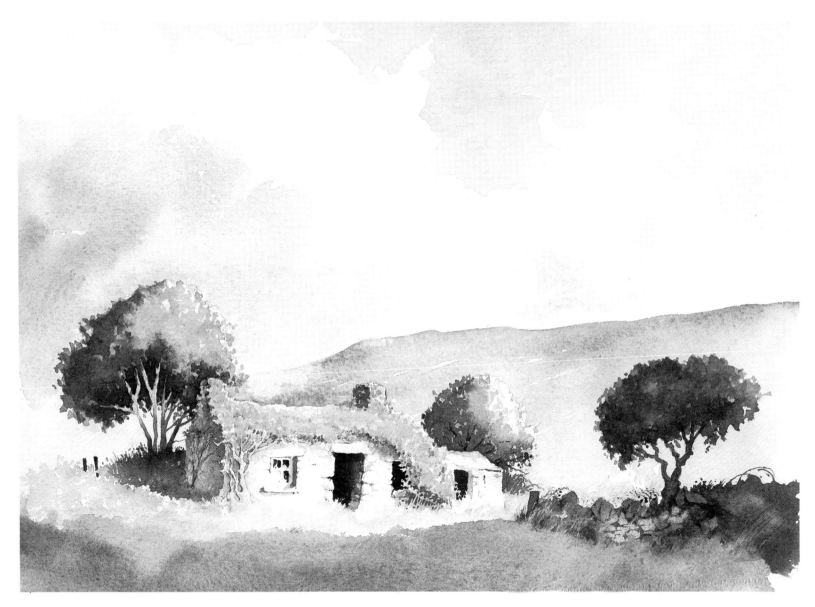

ABOVE:
ANGLESEY COTTAGE
I came across this abandoned old ruin when glorious evening sunshine illuminated the warm stonework, and here I have tried to convey this sense of strong light on a building. The stonework, a marvellous subject in itself, has been made subservient to the sunlight—it was so tempting to introduce more stones and really enjoy the stone textures, but I managed to restrain myself. This was also the case with the ivy. With the left-hand side of the cottage I have indicated a hint of light reflected from the sunlit ground by darkening the adjacent patch under the tree. The wall was actually on the left hand side of the cottage, but in that position it created a barrier for the eye so I decided to move it over to the other side. A deep tone cast across the foreground also helps to add a sunlit feeling to the building.

SUNSETS

Don't let the prettiness of sunsets put you off painting them, for most are not blatantly so. Sunsets demand considerable control of washes and speed of handling in watercolour, so the secret again, is to keep it simple. They need not be deep reds and purples: some subtle and interesting effects can be obtained with yellows and blues. The upper area of the sky I generally keep almost a plain wash, and concentrate the actual sunset in the middle horizontal band of the picture. I prefer not to put any preliminary pencil work in the sky, even with complicated cloud formations. In the main it is a question of getting a hard edge on one side of the cloud (normally on top) and a soft edge on the other side, by blending with a damp brush. Quite often it can be more beneficial to work on a small area at a time, as it is virtually impossible to keep several areas wet at once whilst working on them.

STORMS AND BLIZZARDS

Techniques for storms can be the same as for sunsets, only using more sombre tones and colours, or, with the simpler type of stormy sky, try broad washes of colour with as large a brush as possible. A sunlit foreground can accentuate an approaching storm in a striking manner, and a storm over a brightly lit field of rape can be quite a sight. Sometimes wetting the paper first before introducing colour can work extremely well. Brushwork is important in depicting wild stormy contortions. Brush positively in the direction of the sweep in the main cloud formations. Confidence in brushwork is essential in watercolour painting: when depicting skies this is even more vital.

LOW-KEY SUBJECTS

Working at dusk, night-time, in a dark wood, pothole or cave can produce some challenging low-key subjects, which are particularly effective when there is just a single source of light. This is where tinted papers come into their own. The composition is automatically simplified for you, and colours few, almost a monochrome. Joseph Wright of Derby

(1734–1797) produced many night-time subjects that demanded a low-key approach and his work makes a fascinating study for the use of controlled and single-source lighting. You may find it advantageous to lay a preliminary wash over most of the paper before getting down to details.

HEIGHTENING THE DRAMA

Early artists working in the mountains took some amazing liberties with the topography—perhaps because in those days few people would see the actual subject. Today you have to be a little more careful, and even if you have captured the scenery exactly as it is in real life, someone may well argue with you. So think twice when making slopes steeper than they actually are, or peaks sharper. I was once criticized for moving a tree (in a painting I hasten to add) twenty yards along the shores of Loch Leven. There are a lot of trees on the shores of Loch Leven!

Drama is increased by bold use of colours and tones, with strong contrasts between each; by strong directional lighting; and by fierce jagged shapes of crags and rocks. The introduction of wild weather can also increase the feeling of drama. By painting a building, tree or person smaller than real life, the height of the mountain or crag beyond is increased, and likewise if you wish to give the effect of a very steep and far drop to the valley below. A single shaft of light, illuminating part of a painting, can act like a floodlight in a

BLIZZARD, LAIRIG LEACACH

This was a February day when I suffered a tremendous battering in this long pass between Spean Bridge and Loch Treig. The elements tossed me about like a pea in a boiling cauldron, and it seemed as though half the mountain was being tossed about with me. My large rucksack exacerbated matters, causing me to be twirled around like a reluctant Catherine wheel. Sketching became a nightmare, but that was what I was there for, and only by jamming myself against cold, sodden rocks could I achieve anything, although a rousing, but crude rendering *of 'Men of Harlech' worked wonders for morale. The foreground rocks had a distinctive layered character, accentuated when covered in snow, and it was this I wanted to bring out as the key to the foreground. All other detail was swamped by the ferociously driven snow, into which it was impossible to look or breathe, as the breath was simply flattened back down the throat. The figure, which in fact was supposed to be myself, adds not only to the loneliness of the scene, but accentuates the driven snow.*

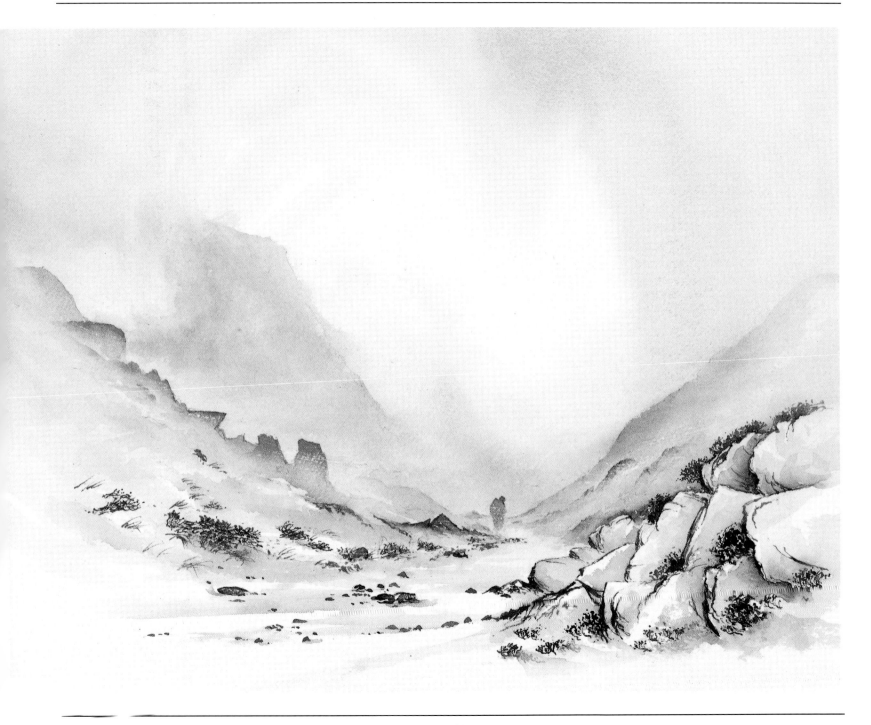

theatre. If you wish to create dramatic effects in a painting this should be planned before you even begin drawing in the pencil stage. Consider trying a vertical format painting rather than the more usual landscape format. Do several different thumb-nail sketches, using tone as well as line to indicate roughly the main masses.

Capturing mood, therefore, demands careful observation during the outdoor sketching sessions, when working in watercolour brings tremendous advantages. Then you need to concentrate on the atmosphere, almost to the exclusion of the topography. Getting out when the weather is moody is essential if you wish to master nature's moods. This usually involves very early morning excursions, or evening ones, for these are the times when the atmosphere is at its most magical, and is one reason why I prefer to camp high whatever the weather or season. Back at home you can experiment in translating these moods into the final paintings. For me, this is one of the most exciting aspects of creating a landscape painting.

LEFT:
PISTYLL RHAEADR
This is the highest waterfall in Wales, and when the stream is in spate it is quite a sight. Much of the detail of the upper reaches of the cliffs was obscured by the fine spray thrown up by the waterfall, and this suited my purpose in losing a lot of the detail in order to accentuate the falling water. In the centre the rock window forms a natural focal point. I spent quite a bit of time painting in detail, and then deliberately sub-fusing it with a sponge. This was a painting I kept on the board for several days, as I did not want to finish it, being such a fascinating, yet challenging subject. The vertical format added drama and it is good to attempt completely different sizes and formats from time to time—but could it have been painted effectively in another format? Probably!

RIGHT:
PISTYLL RHAEADR (Detail)
This close-up of the centre of the painting gives a better idea of how I have tackled the falling water, rocks and vegetation. The painting was done on Saunders Waterford NOT paper of 140lb weight, an excellent paper for this sort of treatment: painting detail, scrubbing it out and then going over certain parts again.

TREATMENT OF WATER

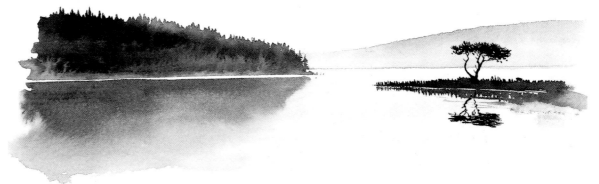

Calm water done with the wet-in-wet technique on the left and a 'dry' technique on the right.

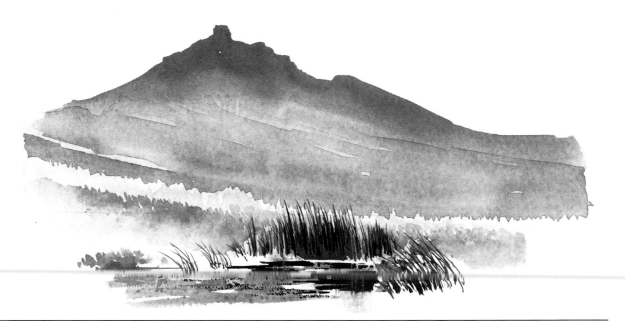

Still water with vegetation in a Dartmoor bog.

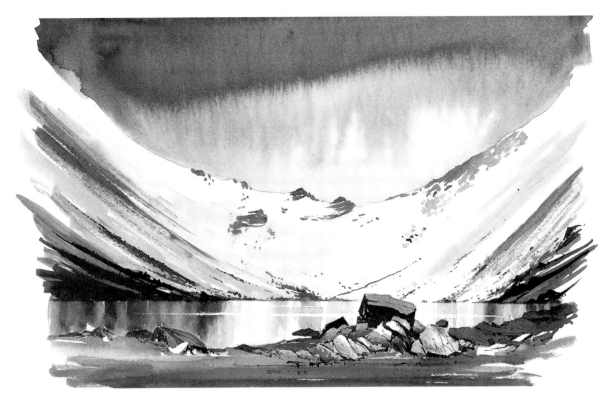

LEFT:
A frozen tarn—Goats Water in the Lake District—showing how downward strokes of the brush to delineate reflections create the sensation of ice.

BELOW:
Treatment of cascading water with reflected light on the rocks to the left of the upper fall.

BELOW:
Use of the dry-brush technique to create sparkle on water.

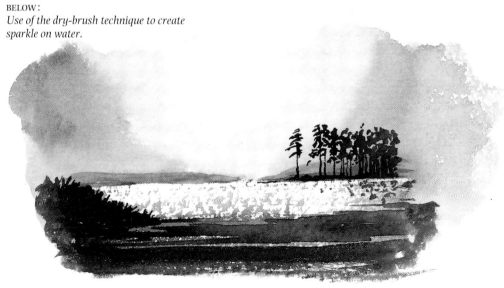

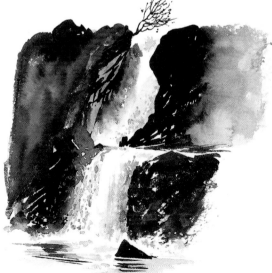

7
FURTHER TECHNIQUES

*White does not exist in nature. Nature knows only
colours . . . white and black are not colours*

AUGUSTE RENOIR

FARM, CWM CYWARCH
I am not a great user of masking fluid if I can achieve the effect by more traditional methods, but there are times when I find it useful, such as on the roofs of buildings when set against a dark background. This painting is one such example. I began by painting on the fluid over the buildings and letting it dry completely before laying in the first background wash, which I allowed to come down to the level of the farm. Suggestions of the massive crags of Craig Cywarch were put in immediately, before the initial wash had time to dry, and also some of the misty effects of vague tree outlines were introduced at this stage. In one or two places I splashed in some brighter cadmium yellow to relieve the more neutral colouring. The work was then left to dry totally before any further painting was carried out. Gradually I worked downwards to the farm, which was then rendered in the strongest detail in the picture, and finally suggesting the foreground.

Now that you have been introduced to the basic watercolour methods we can take a look at some of those techniques that are useful on certain occasions. What do we do if a watercolour goes wrong? What alternatives are there for creating white areas? What are negative spaces? How and when should we vignette a work? Working on a full imperial painting. Working to a theme. And much more.

HOW TO RESCUE A WATERCOLOUR

Everyone knows that sinking feeling when a watercolour starts to go wrong. It is even worse if most of the painting has been completed to our satisfaction and suddenly all the effort seems to have been in vain. Unlike an oil painting it is not just a case of laying on another coat of paint until it is correct. But it is well worthwhile attempting to rescue any watercolour, and some of my better works have been rescued ones. Firstly, there are two points worth noting about the materials being used: many greens are staining colours and therefore almost impossible to remove entirely, even when mixed with other colours; and the heavier the paper being used, the more punishment it will take. So if you are prone to mistakes in your watercolours it may be as well to restrict use of the ready-bought greens and paint on at least 140lb paper.

My most usual method of retrieving a watercolour is to sponge it down, sometimes in the bath or sink, then dry it off by dabbing with tissues. When sponging, make sure that the water is absolutely clean. If colours run and cause ugly run-back marks let them dry out completely before sponging gently. Sometimes only the sponging is necessary, sometimes a further watercolour glaze is needed. Occasionally I leave the marks if they fit in without being intrusive. With delicate parts needing treatment the area not being sponged can be masked off, either with paper or low-tack masking film cut to the right shape. Sponge lightly at first, only increasing any vigour if absolutely necessary, as this will affect the surface of the paper, making it problematical for any subsequent wash.

There will no doubt be occasions when, having com-

CREATING WHITE AREAS

Painting the negative shapes: in this study of summer trees I have created the trunks and branches by painting around them in dark tones, that is, painting in the negative spaces in order to delineate the positive. This was much more commonly used before the advent of masking fluid, but is a method I enjoy using. Naturally you need a fine-pointed brush, preferably a sable. Often a rigger can be effective for this sort of work.

pleted a painting, you put it away in a folder, not entirely satisfied with the result. You may visualize new ideas later, on seeing it afresh. Perhaps you consider laying another wash over part of the picture. The watercolour can be re-stretched in the normal way, but try not to agitate the water as you soak it, otherwise this action might remove some pigment. After leaving it to dry out thoroughly it is ready for painting. I once received a half-imperial watercolour back from the printer with a ghastly fold mark right across the lightest part of the sky in the centre of the picture. As the painting belonged to friends I was horrified. I could think of only one thing to do: stick it in a bath of water and re-stretch it. Imagine my relief when the re-stretched painting ended up with a surface as tight as a drumskin, the awful mark having completely disappeared.

Where there are minor blemishes these can often be removed or subdued by scrubbing with an old brush, using clear water. Sometimes a bristle brush as used for oil painting can be more effective. If this only works to a certain extent then load some weak colour onto the brush and try blending it in to minimize the effect of the blemish. Otherwise consider painting some feature over it: if it is in the sky add a pair of wings or extend a tree; if in water add a rock, ripple or

This illustrates the use of masking fluid on the trunk of a birch tree. On the left is the image of the tree-trunk covered in masking fluid, applied with an old brush. The fluid has been rubbed off in the centre tree, leaving a stark, white area with hard edges. Some detail has been added to this in the final stage on the right-hand tree-trunk, to give it the character of the birch.

This is not a twin-headed worm that has just seen a ghost, but is the first stage of a painting of willow trees. Here masking fluid has been dropped in a very liquid pool on to the paper and from this reservoir it has been pushed outwards with a matchstick to create a filigree of fine branches. The next stage would be to add in detail.

Again, masking fluid has been painted over the cottage and a first wash applied over sky and mountain.

This is the next stage of the cottage composition, where a second, darker wash has been brushed over the mountain, and when this is dry the masking fluid is removed. Finally some features have been included to round off the work.

reed. With a mark by the waterline of a lake this can normally be corrected by scratching along the top of the waterline with a razor or sharp knife. Scratching, however, should be done sensitively as it is a pretty drastic solution. Finally, consider cutting off the offending part of the picture if all else fails. For this a cut mount or two large 'L' shaped pieces of card are indispensable, enabling you to visualize how the re-shaped painting will appear. Quite often this can be resolved by changing the format of a painting from the horizontal to the vertical.

WHITE SPACES

Creating white passages in a watercolour is one of the most challenging aspects of the medium. My own preference is to leave the surface white, painting around the area concerned if possible. This involves working with negative spaces and needs careful planning, but is certainly worth practicing. Masking fluid is a popular way of getting around this problem. Brush on the fluid at the beginning of the painting, covering the areas you wish to leave white. Use an old brush and rinse it out in soapy water immediately afterwards, as the fluid is harmful to the brush hairs. However, if you need to mask strand-like areas, such as twigs, try using a matchstick or mapping pen to apply the fluid, as they can produce some interesting results. Experiment first on scrap paper. Allow the fluid to set completely before starting to paint. This only takes a few minutes. You can then paint over it without having to be careful about the surrounding washes. Remove the fluid only when the surrounding paint is dry, either with a finger or an eraser. Note that the fluid, as it comes off, will remove most of any pencil lines or underlying wash that it has covered. Do not leave it on the painting more than two or three days at the most, otherwise it may be extremely difficult to remove. Never leave any on the paper. Personally I use masking fluid very sparingly, as it creates a hard, artificial edge, and whilst this is fine on a building or perhaps a rock, it can look gimmicky on the branches of a tree. Having said that, I know many artists seem to use it on all manner of features in a painting, so

experiment with the fluid to see what can be achieved. Some papers do not respond well to the fluid, so test it on a small sample first. I once used some fluid during a demonstration on watercolour paper that I'd used many times before. To the amazement of the class, when I removed the fluid I took away half the background mountain with it. Maybe the sizing was not quite right on that particular sheet. It proved quite a challenge to correct that one.

Resists in the form of a white wax crayon or candle are other ways of achieving white areas, although personally I rarely use them. They are particularly effective in creating sparkle on water or the rough bark of a tree for example, especially when combined with rough watercolour paper. Firstly the crayon or candle is dragged across the area to be left white, and then a wash is applied over it. The wax will prevent the paint reaching the paper. I once used wax to indicate the sun, set in a dramatic sky, and as I had not quite got it right ended up with a square sun: it's not easy to discern white wax on white paper!

For large areas of white a low-tack film normally used by draughtsmen and illustrators can be useful, especially where you wish to depict a large area of snow-covered mountain against a dark sky. The film, manufactured by Frisk Products, can be bought with gloss and matt surfaces. It is

BEN ALDER

This is one of the most isolated mountains in central Scotland, and here is seen from the east, probably the optimum viewpoint. From this angle the great corries are evident, caught between the horns of the Leachas, the two ridges descending from the main ridge. It was a cloudy February day, with threatening dark clouds hanging over the mountain, the edges of the main ridge caught in sharp sunlight at times. I wanted to capture the brilliant whiteness of the snowy mountain against this dark sky, but it was too large an area to use masking fluid effectively. In these situations I prefer to use Frisk low-tack masking film, as it is cleaner, less messy and very suitable for large areas. When the paper was dry after stretching I laid the film with its backing over the mountain and drew the outline lightly in pencil. The next step was to cut out the outline with scissors, peel off the backing and carefully position the film over the mountain. Because it is low-tack it can easily be readjusted, but it is a good idea to ensure the edges are properly stuck down. Using a paper with a NOT surface reduced the possibility of seepage, although this cannot be totally ruled out. I then laid in the washes in the sky with a powerful mixture of Payne's grey.

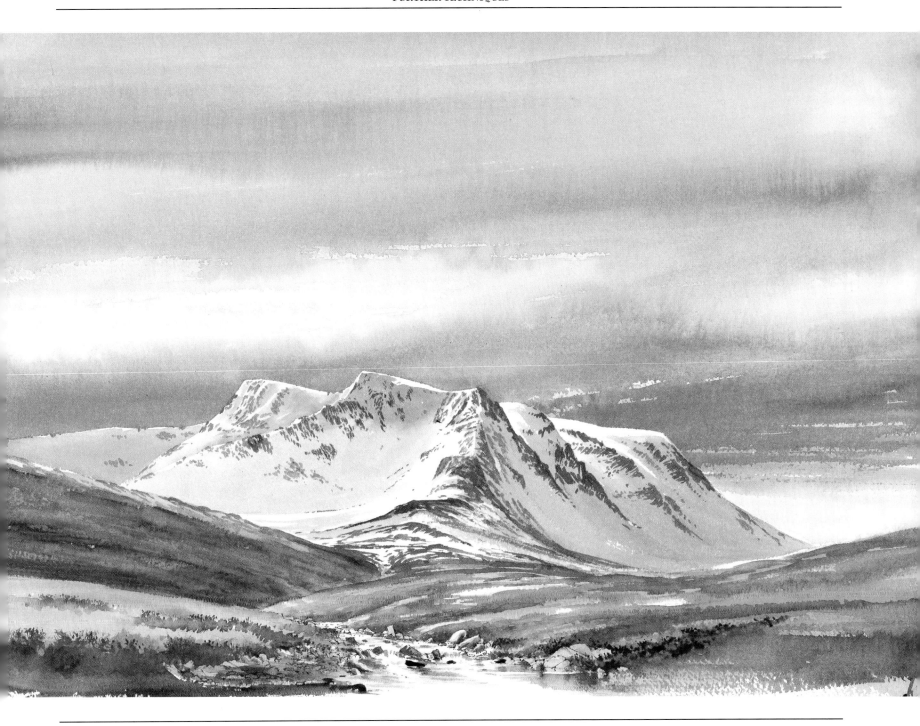

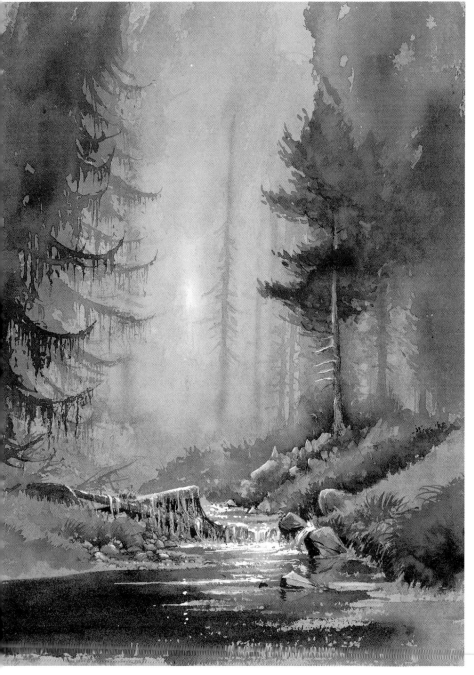

easy to draw on the matt surface when outlining the area to be masked. The film has a backing and the image required can be traced through both layers with a pencil. Next cut the shape required, peel off the backing layer and position the mask on the paper. It is however, more effective with NOT or hot pressed papers, as some seepage is likely to occur at the edges if rough paper is used. The film can also be used to mask off light, horizontal areas of water on a lake, for example, or for creating ice patterns, snow cornices, or just to protect a large white area at the bottom of the painting which you may wish to leave as pure white.

Indefinite areas such as clouds, or possibly light boulders, can be stopped out using tissues, rags or a sponge whilst the local paint is still wet. You need to work quickly and it is as well to practice the technique on scrap paper first until you are confident. Again, this is a method I use sparingly: it rarely produces the whitest of whites. Finally there is scratching out. This is really a last-resort technique, often applied to add interest to calm water on a lake. In this case do ensure that it is horizontal and restrain the urge to scratch all over the place. Leave it to the very end, as any wet watercolour over it can produce catastrophic results.

Watercolour purists shun the use of white opaque paint in a watercolour, yet many of the old masters, including

LEFT:
LOCHNAGAR STREAM
This painting was done on De Wint 90lb paper, so rough that it is classified as 'rugged'. Unfortunately it is no longer manufactured, which is sad, as I did enjoy using it as a change from ordinary watercolour paper, particularly for low-key, moody scenes such as this. I began by putting in the misty background, suggesting some details before the paper cockled thus preventing further work until it dried out. This paper produces the most amazing cockles when wet. I slowly worked my way towards the foreground and at the end resisted the temptation to overdo the white gouache.

RIGHT:
WOODLAND STREAM
I have included some spots of white gouache on the surface of the water in this painting of a stream in the Brecon Beacons. Being tiny they do not seem to intrude on the work, as white gouache might do if applied in large doses. I had to stop when I realized that the stream looked as though it was beginning to suffer from an outbreak of measles. The whole painting has been vignetted by rubbing all around the edges with a wet sponge to create a soft transition to white paper.

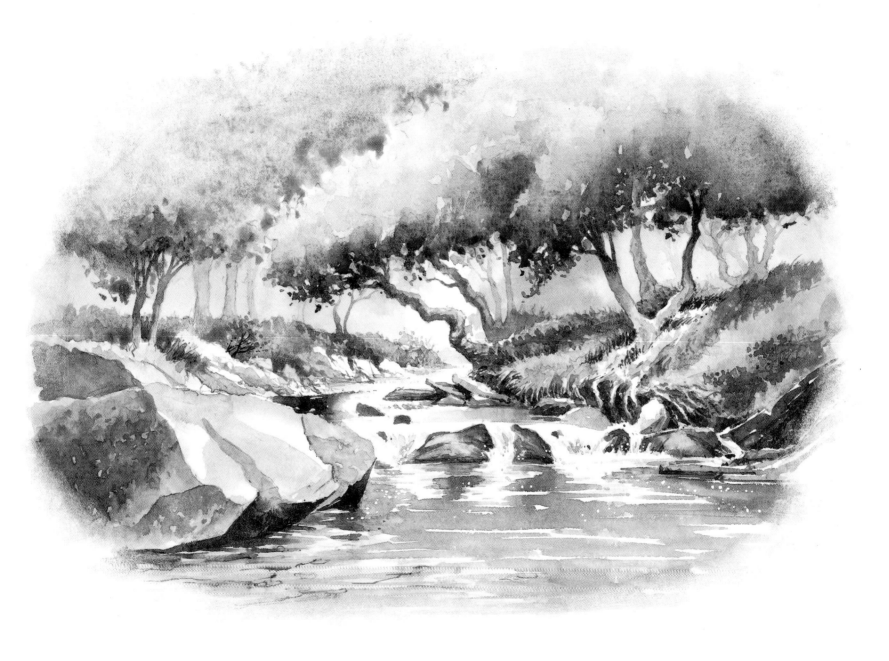

Turner used it extensively. Why not use it to create those white patches? Although I occasionally use white gouache to portray a seagull, fleck of white bog cotton or distant mast, I am not happy about introducing an opaque colour into the transparent medium of watercolour. In most cases it seems to intrude and is apparent on all but the smallest parts. I do however, use it on tinted papers where it is the only effective way of creating adequate highlights. On tinted papers it does not seem out of place.

TINTED PAPERS

It is an interesting exercise to work on tinted papers, particularly if you can get hold of some Turner Grey or De Wint handmade papers, which, sadly are no longer being manufactured. Two Rivers produce tinted papers, and the Canson and Ingres papers, though mainly designed for pastels, can be used for watercolours, if stretched. Painting in this way can provide a diversion during a bad patch in your work, or when inspiration has flown out of the window. The subjects which lend themselves best to tinted papers are those that include water: streams, lakes, and so on, where reflected light and sparkle can be introduced to create highlights. Leave the highlights to the end and be miserly with them. Don't scatter them all over the painting. Understatement has much more impact. Turner used a tinted sketchbook on occasion and produced some interesting vignettes with incredible economy of brush-strokes.

VIGNETTES

Vignettes are an excellent way of preventing the over-working of a painting. Normally the foreground is faded out, rather like the old Victorian sepia photographs, leaving the rest to the viewers' imagination. Where there is a mass of reeds, stones, or bricks in the foreground, such a mass can be pretty boring at times, both to paint and view. Simply paint in a few and suggest the others either by a wash of broken colour or by gradually 'losing' the detail towards the edges and corners of the paper. It also means the painting is finished earlier!

LARGE PAINTINGS

Perhaps at the opposite end of the scale is the full imperial watercolour, something which may not be an everyday occurrence for most watercolourists. I enjoy working on this size occasionally, but in the main only work on these for exhibitions. The sheer size is enough to put many off. Naturally you need a drawing board large enough to take the painting and a brush two or three inches wide to apply the larger washes. Paper should be at least 140lb weight, preferably 300lb. The temptation is to put in a tremendous amount of detail, but beware, for as with most paintings you need some quiet passages. Carry out the painting as for a normal size, though with some passages it can be a good idea to work on smaller areas at a time, though remaining conscious of the overall effect by standing back to check from time to time. Sometimes it is necessary to leave it for a few days before continuing, and possibly doing it piecemeal in this fashion makes it less daunting. However, I don't like paintings to be lying around in an unfinished state for too long, as they can go 'off the boil' and the initial inspiration and enthusiasm is lost.

INSPIRATION

Maintaining inspiration and enthusiasm is something for which you should always strive, whether to place your work on a higher plane or simply to get going again. It is no use waiting for inspiration to strike before getting out the paints:

RIVER DEE BY MOONLIGHT
A watercolour on Turner Grey tinted paper, with white gouache to bring out the highlights. Much detail of course has been suppressed, as at night-time the more general shapes are important, and I feel the emphasis should be on the mood rather than the topography. I started the painting with a weak lightening of the general area around the moon, using white gouache, immediately blending in some Naples yellow to add warmth. When this was dry I painted over a weak glaze of crimson alizarin to warm the sky even more, brushing in the darker parts of the sky with Prussian blue mixed with burnt umber whilst the alizarin glaze was still wet. Gradually I introduced the hills using Prussian blue and some Indian red, allowing them to dry before putting in the far tree-line. The foreground trees were made really dark to give the work some depth, and finally when the whole painting was perfectly dry I laid on the highlights with white gouache.

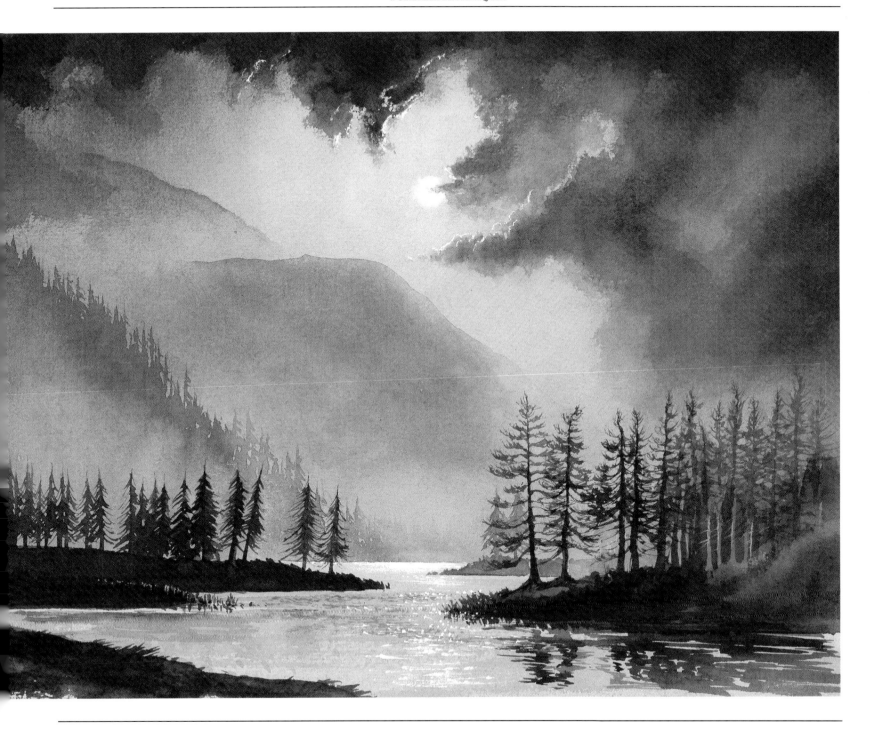

it will certainly strike at some stage, but you may have an awfully long wait. Expose yourself to new experiences: get out and do some sketching in new areas; visit an exhibition; read another illustrated book. If you are really in a rut try to see a demonstration or attend a painting course. Introducing new elements or continually trying new ideas is a way of keeping the spark alive. Working on different sizes and formats of paintings helps in this respect, as does tinted papers, mentioned above. Another method is by working to a theme for a while. Set yourself a target of around six or ten paintings all on the same theme: farms, bridges, misty scenes, winter scenes, or perhaps of a particular place. Subjects found along a particular river is another example. This not only gives you a specific objective to work towards, but provides added interest if you exhibit your work in public. It can be a rewarding exercise to set projects of this type, and can get you out of the 'what subject next?' problem, which many artists find is a block to progress. One thing is sure: if you paint the same type of subject using the same methods all the time your work is bound to grow stale, so constantly be alert for new subject material and ways of working, without totally throwing everything out of the window.

Another way of getting over the block is to copy the work of a first-class artist. This should only be done as an educational exercise, and not as a means of producing pictures for sale. Over the centuries it has been a common device employed by professional artists in teaching people to paint. Paintings by the masters were hired out for the express purpose of copying. Slavish copying should be avoided, the object being to determine how certain effects were achieved. Degas was a great one for making copies of the work of the old masters.

THE CAMERA

These days few artists seem to be without a camera. Photography is a quick and effective way of obtaining subject material, capturing an amazing amount of detail in less than a second. In the mountains it is especially of value

in recording distant hills before they are blotted out by an approaching rainstorm, or a complicated cliff face, or a scene from a position that might be just about to avalanche and you don't wish to hang around to watch the fun. A camera also helps to check angles, slopes and relative shapes and sizes of peaks, crags and the like, provided the perspective is not distorted by the use of extreme wide-angle lenses or by a foreshortened viewpoint. I find a camera useful to back up my sketches, but as the latitude of the film is restricting it cannot record the subtleties in the sky on the same frame as well-defined detail on the ground. If you expose for the ground, the sky usually becomes a white glare in the photograph. Also, you cannot get that profoundly inspirational feeling into a photograph that you can achieve in a sketch. No photograph can compare with a rain-spattered sketch, for in addition to the sketch the scene is etched in your mind: a quickly taken photograph does not give your brain time to absorb much of the subject. With thought, though, a combination of sketches and photographs can work extremely well.

Care should be taken with the techniques outlined in this chapter. If they become over-used they are then simply crutches for poor technique. By all means experiment with them, and discard those that do not suit you: all artists are different and have their own favourite methods. You have to find out which techniques suit you best by trying out all the ways of achieving your goal. It can be great fun, but introduce them gradually, otherwise you are unlikely to realize the full benefit of each technique. And please don't try putting them all into the same painting at once!

DOLWYDDELAN CASTLE
These remote castles perched high on a crag exude a romantic air, at its best when the sky beyond adds to the mood. Castles as subjects lend themselves very well to working to a theme, and half the fun is finding out about the history of the place, which these days is fairly easy with such a lot of books on the subject. The path leads down into the picture, then actually goes round the castle hill to the left. I've tried to suggest a lead-up to the castle by including a light patch just above the bend in the path.

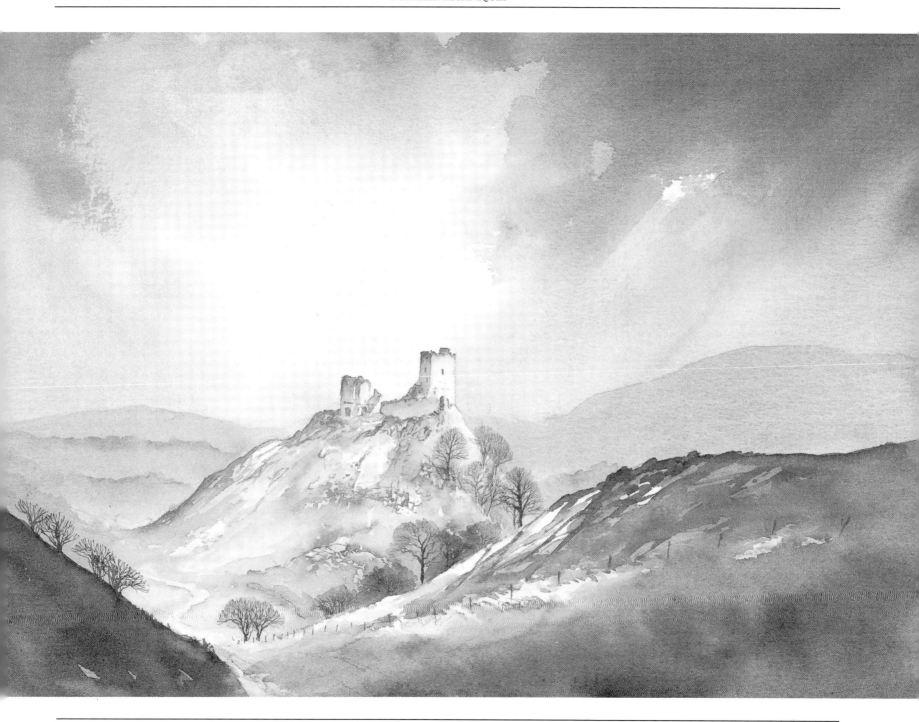

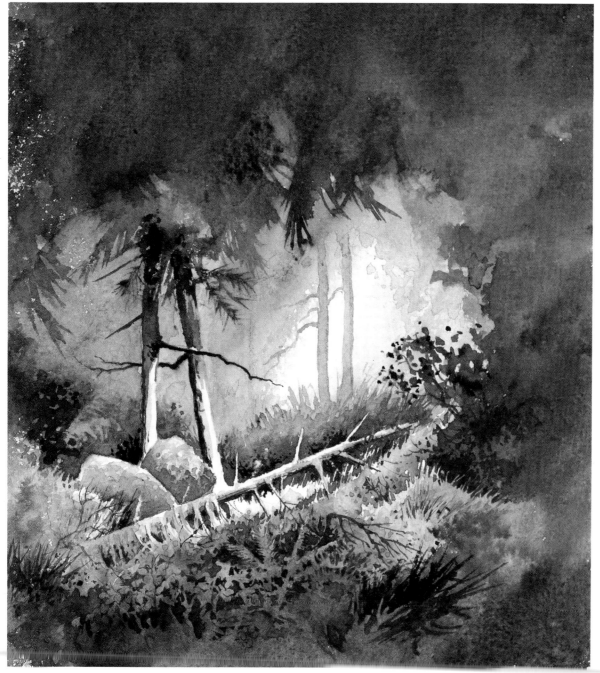

LEFT:

PINEWOODS NEAR RIVER BOVEY, DARTMOOR

Here I have turned upside down one of the 'rules' I spoke of earlier: that of creating a barrier between the eye of the viewer and the centre of interest. Both the thick undergrowth and the fallen, spiky tree combine to form hurdles over which the eye must jump to reach the focal point—the patch of distant light. This composition has perhaps worked because of the mysterious quality of misty pinewoods, and the hurdle helps to suggest the elusive nature of what is beyond the trees. Depth in the painting has been achieved by strong darks and splashes of warm colour in the foreground and cool blue washes in the distance.

RIGHT:

MOEL SIABOD AND AFON LLUGWY

This is an example of a large, complicated painting, in which there is more than the usual amount of detail. It began as a full imperial-size work, but I cut it down slightly when it became apparent that so many trees might overpower the real centre of interest: the mountain. Working on this scale needs careful planning for execution, and naturally there is more to lose if the painting develops problems towards the end of a marathon session. One of the biggest problems on a painting of this sort is the juxtaposition of tonal areas: that is, ensuring that certain parts of the picture do not become lost against a dark background, for example. This potential hazard has been resolved, for instance, by making the tops of the pine forest dark against the lighter mountain, but then fading them into mist further down the paper in preparation for the adding in of dark trees below.

From the collection of Mr and Mrs Michael Allfrey of Colwall

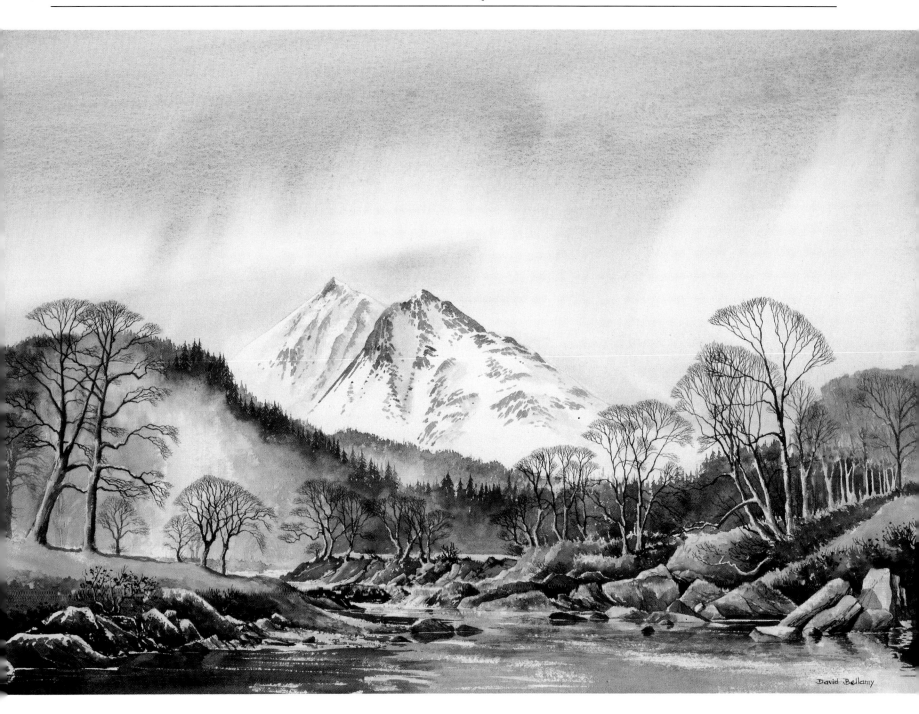

8

PRESENTATION AND
FURTHER DEVELOPMENT

*A good deal of labour and time is saved in frame-making
in consequence of the facility of procuring strips
of every variety of prepared mouldings*

EARLY TWENTIETH-CENTURY ADVICE ON FRAMING

LLYN Y SARNAU
*Light and mist effects through pinewoods
is a popular combination. If you have not
tried it yourself, or not been happy with
one that you have attempted, then at an
exhibition it is beneficial to study how
these problems have been overcome by
another artist.*

ABOVE:

ENNERDALE

There is no building, no definite mountain peak so what is the centre of interest? Has the painting worked, or does it need more of a focal point? How would you approach it? Improve it? Look at paintings critically in this way. My aim in this Lakeland scene was to create an air of mystery beyond the trees acting as sentinels on either side of the river in the middle distance. This, to me, is the centre of interest. The right-hand foreground has been deliberately left vague, with just an impression of fallen trees, trunks and the occasional boulder. Even the rocks below the foreground tree on the left have been understated, but some detail was needed in the tree itself, and this also helps to give depth to the work. The river has been rendered with a few dry-brush strokes, working horizontally.

RIGHT:

ENNERDALE (Detail)

This enlarged area gives a better idea of the positive-negative interplay on the middle-distance conifers. A fine sable brush was essential to enter accurately the intricate shapes, which after the initial wash was laid, were painted in darkly when the paper had dried. Whilst these dark areas were still wet I blended them in here and there with just water on a damp brush, thus losing detail in places and strengthening it in others. Painting all the trees in every detail would be like lining up a squad of soldiers, not quite the effect I envisaged for this beautiful valley.

Many amateurs have so little confidence in their work that they shy away from even framing a painting in a modest way to hang on their own wall. So the first essential is to believe in yourself. You have to start somewhere, and unless you are framing your work it is not being seen at its best. A good mount and frame can work wonders for a painting. But framing is not cheap and to frame several paintings might well prove prohibitively expensive. Going to a good framer is easily the best way of getting it done: don't be afraid to approach your local framer to ascertain what range of mouldings is available, and get a rough idea of the cost involved. If you explain that you are starting out you will probably find the framer extremely helpful. If you have a number of paintings to frame don't be afraid to ask for a discount.

Other sources of framing are art supply shops, where you can often buy frames 'off the peg', junk shops, gift shops that sell cheap prints in cheap frames (discard the print!), and of course there are frame kits. Some firms advertise in the art magazines, where for instance if you buy ten or so frames you get them cheaper, and some of the plain frames are quite cheap. If you are a practical person you can try making your own by simply buying the moulding, hardboard backing and glass. There are many excellent books available on the craft of making frames. However, should you be as competent as I am at cutting and sticking together the mouldings, you will wisely steer clear of this type of work. For paintings you will need two-ounce glass and thin hardboard. Unless a framer is doing the job for you, you will either have to buy a ready-cut mount from an art shop, or cut one yourself. Whilst you can cut the mount reasonably well with a Stanley knife, you do need a steady hand, especially if you wish to produce an accurate bevelled cut. Particular care is needed at the corners, and much practice is needed to cut a good mount. Alternatively, there are a number of mount-cutters on the market, from small hand-held ones to more sophisticated types mounted on straight-edges. These will certainly allow you to do a better, more professional job. Ready-cut mounts, of course, come only in certain sizes but are expensive

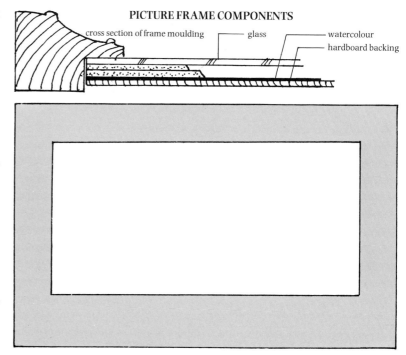

PICTURE FRAME COMPONENTS

cross section of frame moulding — glass — watercolour — hardboard backing

PICTURE MOUNT: LANDSCAPE FORMAT

The bottom section of the mount is slightly wider than the other three. In a painting of overall size around 16 × 12 in the difference would be about half an inch, progressing to about one inch for a full imperial picture.

PICTURE MOUNT: PORTRAIT FORMAT

Again the bottom section is wider than the others, and here a double mount has been cut, the difference in size between the inner and outer mounts being a uniform three-eighths to half-an-inch all round.

compared with the cost of cutting your own. Getting a framer to make the frames and cutting your own mounts is certainly one way of reducing costs. Keep watercolours away from the cutting area: I once cut one precisely in half.

Personally I prefer double mounts on my watercolours, as these give a rather pleasing lead-in to the painting. I use a standard system of a white inner mount, and an ivory (or cream) outer one which has a window about three-eighths of an inch larger all round than the inner mount. The advantages of this system is that it contributes a sense of unity to an exhibition, does not overpower the painting, and I don't spend ages trying to work out what is the most appropriate colour mount to go with each painting. It also helps if I need to reuse the frame for another painting. Occasionally I will try a coloured mount. With frames, despite there being a wide range from which to choose, I normally stick to just four or five styles of moulding. This again provides unity at an exhibition or in the house, and when customers buy a number of paintings they usually appreciate matching frames.

If you have not been painting for long I suggest you limit the sizes of your paintings to a quarter-imperial or half-imperial, and certainly for a while keep to these sizes. The reason is that by working to a standard size you are then able to swop paintings around in the frames. This is particularly beneficial if you don't want to buy a lot of frames and are not selling your work. The traditional way of sealing the backs of watercolours is by using gummed tape, but if you are constantly taking paintings in and out of frames you will probably find it easier to use masking tape instead.

EXHIBITING
Naturally it is best to start in a small way and gradually work towards something more ambitious as you gain confidence. Places to exhibit your work can include libraries, building society windows, hotels, pubs, theatre foyers, plus annual events such as the local show and of course your local art society exhibition. Craft shops often welcome artists to exhibit with them. One thing is clear, however. No one is going to come chasing after you whilst you are unknown, so you do need to get out and find suitable outlets for your work. Initially just look around to see what possibilities there are in your area. At this stage there is no need to state your intentions. Find out what hanging space is available. Is it in a good position for sales? Would you like to exhibit there? Having produced a list in order of preference you can then approach the proprietor. Take along some of your best work. You will need to agree the rate of commission, when and on what basis you are to be paid, how often you change the paintings around, and the situation as far as VAT is concerned.

Even with a solo show it is not necessary to have the exhibition at a proper gallery. You can hire a hall, room in a hotel, or even use your front room if you wish. Working to a theme for the exhibition will probably attract more attention, and a title like 'Lakeland Villages' is much more meaningful and attractive than 'Works on Paper' or 'Exhibition of Recent Work'. When I had my first 'Mountains and Moorlands' exhibition I abseiled off the roof of the gallery, but these days take private views a little more leisurely. If you are having a private view—and why not?—wine is usual, and of course you need to send out invitations to as many people as you can. Someone once suggested to me that to have a private view was elitist, which really amazed me: artists have enough problems without taking away one of their most potent sales events, and anyway it is a pleasure to be able to meet some of your customers, many of whom can become good friends. Galleries of course will do all that for you, but make sure you sort out the responsibilities, finances, and other details before agreeing to put on the show. You may even consider submitting work to the exhibitions of the Royal Institute of Painters in Watercolour in the Mall Galleries in London, or the Royal Watercolour Society in Bankside.

VISITING EXHIBITIONS
Try to see as many exhibitions of work that interests you. Don't dismiss small local exhibitions as simply means to find

out what prices other artists are charging or what sort of standard is on show, for you may find some real gems hidden away. It is probably best to have a quick look at all the exhibits, then return to those that really catch your eye, perhaps concentrating on two or three paintings only. Maybe the dramatic effect excited you, or the use of light or colour, or perhaps you cannot work out how a certain effect was achieved. Ask yourself these questions. How was that effect achieved? What is the work really about? What is the most significant part? What is the centre of interest? And so on. Ideally take down notes on the spot, or write them up quickly afterwards. These glimpses into how other people work can be educational, stimulate inspiration within you, and perhaps spark off new ideas. At times such ideas may not be directly related to what you have seen at the exhibition. Don't be afraid to ask about the artist and his or her work, even if you don't intend buying. Note any interesting aspects about the gallery, which might give you ideas for your own exhibitions. Whenever I visit London I seek out an exhibition, but the temptation is to visit as many galleries as can be covered in the day. This can be self-defeating as only so much can be absorbed at a time and trying to cram too much in will dilute the overall value.

DEVELOPMENT

With your painting, even if you only do it as a minor hobby, think about what you want to be doing in a year's time. Set yourself targets such as a number of paintings, and which exhibitions to which you would like to submit work or arrange yourself, and how in that time you can improve your standard of work. To improve standards you could perhaps attend workshops, courses or evening classes. Keep all your work, except that which you sell of course, including the awful ones, and every three to six months review them to see how far you have advanced. If you keep painting regularly you should see a steady improvement. Don't worry about the times when you find it difficult to paint: we all go through those, and although it may be a battle to shake off this period, it will eventually disappear. Most of all get out

and sketch, and if you don't enjoy doing this in winter make sure that by mid-autumn you have sufficient sketches and material to work from during the winter months.

ART GROUPS AND SOCIETIES

Seek out your nearest art group or society, for not only do they hold exhibitions, but offer advice, sometimes discounts on materials, demonstrations by visiting artists and you can work within a group. If your local library does not have details try *Leisure Painter* magazine. I have demonstrated to many societies, and can vouch for art groups being friendly and eager to welcome new members. Occasionally, with some of the larger societies, there has to be a waiting list, but I do know one enterprising lady who, on coming up against this, decided to form her own group. She explained the situation to me and asked if I would be their first demonstrator. When I arrived I was amazed to find around eighty people had turned up—not bad for a new group. So don't despair if there is no art group in your area. If you need help to form one, I am sure that the editor of *Leisure Painter* would be only too pleased to offer advice.

PAINTING COURSES AND CLASSES

You can learn a lot by attending a painting course, especially from watching demonstrations by an artist whose work you admire. Many ideas can also be gleaned from other students on the course. What should you look for in choosing a course or painting holiday? Obviously if you like the tutor's work it is a distinct advantage. You need to find out what the accommodation is like, including that in which you have to work. How many demonstrations are given? Will you be sketching outside or is the course mainly based indoors? Will art materials be available? And what equipment is needed? I feel that a painting course should be both educational and enjoyable, with a relaxed informal atmosphere that is conducive to bringing out the best in students. The tutor must be enthusiastic about his work. I limit the number of courses I run each year because I need to be out sketching in the hills and working for exhibitions. Then running a course

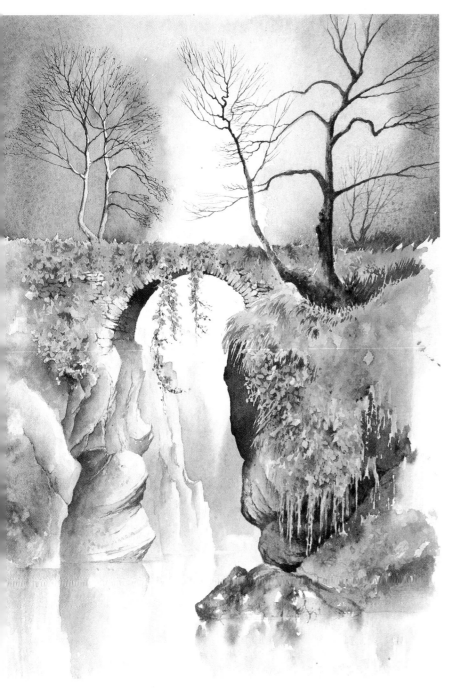

makes a marvellous change of pace. Meeting students is part of the enjoyment, and a complete contrast to working alone. One day I am up in the mountains, battling for survival in a fragile tent, the next maybe I'm running a course in supreme comfort in a three-star hotel. No two courses are alike. On one course in Herefordshire as I took a student across a field to set her up before a subject, I noticed a farmer over the hedge watching us. Setting the student up in a sketching position I returned to the main group, only to find that another girl wanted to paint across the field. Again the farmer was watching as we crossed his field half an hour after the first. By the time I walked past with the fourth girl he was staring and furiously scratching his head. On another course I crossed a field to where several pupils were grouped, only to find that they would not allow the farmer in his own ruts—the ladies had found some puddles in tractor-ruts so aesthetically inspiring that they had insisted the tractor keep well clear of the subject. Advertisements for courses and painting holidays can be found in the art magazines mentioned in chapter ten. From time to time *Leisure Painter* and *The Artist* publish complete supplements devoted to courses and painting holidays.

Attending regular evening classes is another way to improve your work. Life drawing classes from the nude model are particularly useful. Unfortunately, demonstrations do not seem to be so common in evening classes as they are on courses, so it is a good idea to ask about this aspect. Details of classes can usually be found in libraries, and in London the annual publication *Floodlight* contains a comprehensive listing.

PACKHORSE BRIDGE, SNOWDONIA

Did he have to use such an unusual background colour, and why has he not 'finished-off' the water? These are questions that might strike you immediately. Maybe he was having an off-day, I hear you say. The mixture of permanent blue and crimson alizarin has filled the scene with an almost mystical quality, and is a useful device for separating different planes, or, as in this case, for isolating the bridge. There are other ways, particularly with tones, but here I wanted to use colour to highlight the structure. The water was actually extremely dark, but with so much interest in the bridge above I wanted to play down the water and convey a more ethereal quality.

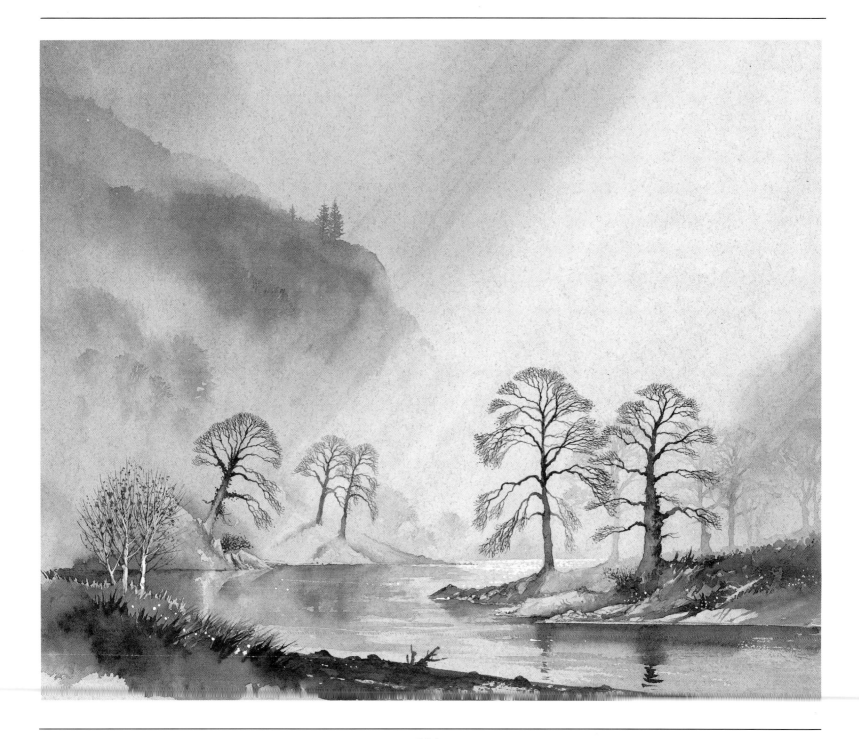

9
SHORT WALKS FOR THE ARTIST

I was tempted to visit this noted pass, and found the horror of it exceeding the most gloomy idea that could be conceived of it

THOMAS PENNANT

RIVER USK
Another painting done on Turner Grey tinted paper. Here the Usk flows through pleasant meadows between the Brecon Beacons and the Black Mountains. I have 'mistified' the background and thrown light diagonally across the scene.

The walks described in this chapter enable the artist to get in amongst some of the most beautiful scenery in Britain. They are mainly aimed at those new to mountains and those who cannot walk far from the car. Experienced walkers and mountaineers will no doubt be familiar with many of them, but might well find new material. Naturally, with so much to choose from I can barely scratch the surface, but at least it will provide a starting point. I am lucky in being able to climb mountains, and hope the pages that follow will give some guide and inspiration, particularly to those who are not so fortunate, but who still love the mountains and wish to paint in them, rather than from postcards. None of the walks is dangerous, but of course conditions can change rapidly on a mountain so ensure that you have adequate wet-weather clothing, footwear and keep within your limitations. During winter the most simple mountain walk can become extremely hazardous in worsening weather.

BRECON BEACONS AND BLACK MOUNTAINS

The distinctive profile of the Brecon Beacons can be viewed from many points of the compass, without even having to leave the car for much of the time: from the Mountain Centre west of Brecon; from the Eppynts to the north, particularly from near the Drovers' Arms; from the Hay Road and several points along the minor roads to the south of Brecon; from the dam at the southern end of Pontsticill Reservoir near Merthyr Tydfil; and from the Neuadd Reservoirs in the heart of these fascinating hills.

For walkers many routes lead to the summits, but artistically those from the north offer more subject material, via Cwm-llwch or Bryn-teg. However, for the walking artist the best part of the area is probably that around Ystradfellte. This is waterfall country with plenty of river walks, but take care in wet conditions, as getting into position to sketch some of the falls can be tricky on steep ground with severe drops in places. These are obvious, however. Try the walk south, beside the Afon Mellte, from Porth yr Ogof caves until it is joined by the Afon Hepste, and follow this until you reach Sgwd yr Eira fall, then turn northwards back,

eventually joining the original path. The Nedd Fechan and Afon Pyrddin also offer interesting walks through wooded scenery.

In the Black Mountains to the east, the valleys of the Grwyne Fawr and Grwyne Fechan are most attractive. In the Grwyne Fawr you can drive up to Blaen-y-cwm and then walk up the track to the reservoir. Two miles beyond this the track meets the northern escarpment where you can turn right and then turn south-eastwards down the ridge above Tarren yr Esgob, finally dropping down to Blaen-y-cwm. The Grwyne Fechan is especially interesting around Llanbedr, and includes two picturesque bridges. The two most shapely mountains are the Sugar Loaf and Ysgyryd Fawr, both viewed to good advantage from the River Usk just below Abergavenny.

DARTMOOR

For those who like painting tors there is a concentration of fine examples on the eastern moors, with Hay Tor the most popular; and Hound Tor perhaps the most dramatic, providing interesting profiles from Black Hill to the north of Hay Tor Down, and also from Hayne Down with its strange outcrop, the Bowerman's Nose. For those fit enough, these tors, taken in a circle, make an excellent round trip. Otherwise they can be individually climbed quite easily from the roadside. On the western part of the moor, Great Staple Tor, with its Collossii (best seen in strong evening sunlight), can be reached from the road near Merrivale with a little more effort than is required for the tors in the east. Across the valley stands Great Mis Tor, another of Dartmoor's most superb outcrops, and directly south of Great Staple Tor, the

PENBIRI HILL, PEMBROKESHIRE
I splashed quite a lot of cadmium yellow around in the foreground which has more detail than I usually paint in this position. The gap in the hedge-bank was not actually there, so I created it to lead into the painting, strategically placed in front of the cottage. The dark patch of undergrowth in the centre helps to push the cottage into the middle distance by creating strong contrast. The feeling of recession is accentuated by the warm colours of the foreground in comparison with the field beyond.

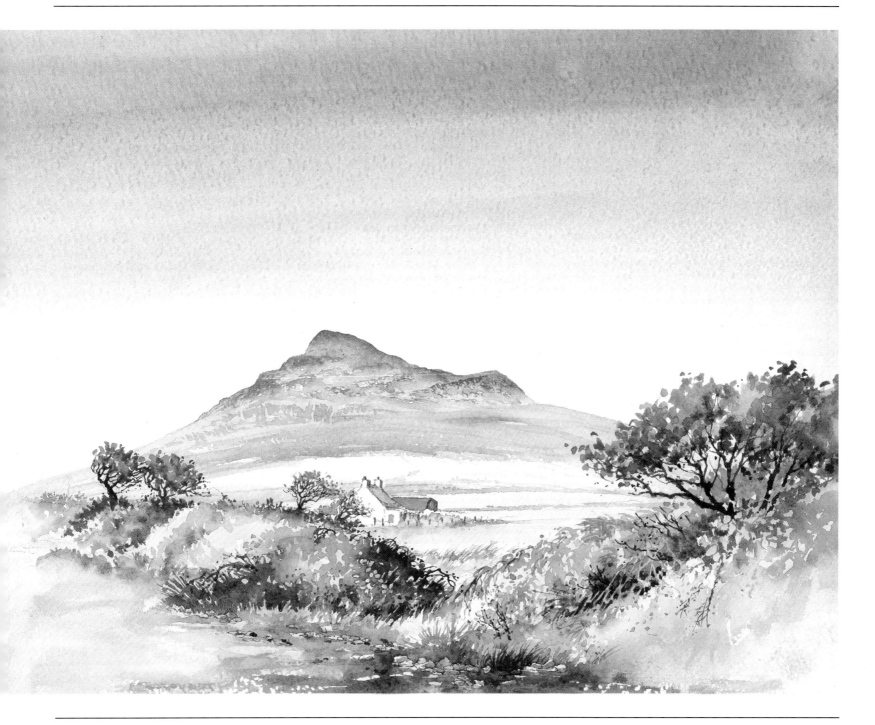

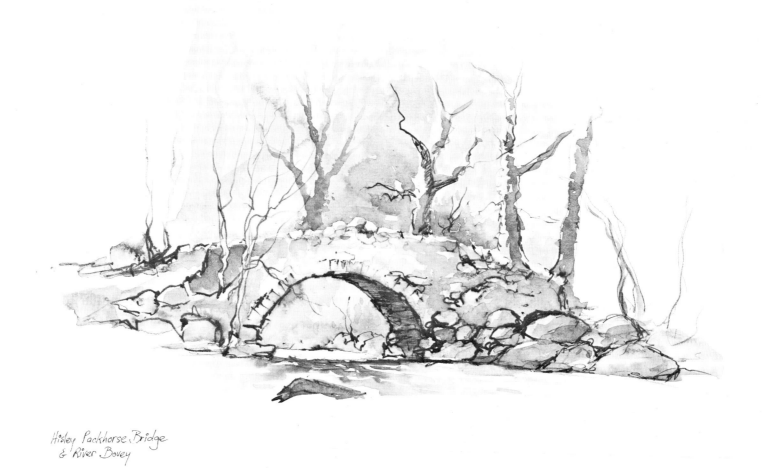

Hisley Packhorse Bridge
& River Bovey

9th April 198

upper ramparts of Vixen Tor are visible. But Vixen Tor is deceptive: most of it lies hidden from the north, and with little effort it is well worth exploring. Lether Tor and Sheepstor, on opposite sides of Burrator Reservoir, are both impressive. There are of course many other worthwhile tors, some well hidden within the inner reaches of the moor, whilst others can be viewed from the road.

Walks on to the moor perhaps offer more interest for the artist when following a river, which provides subject material as well as being a navigational aid. From Cadover Bridge south of Meavy there is an steady walk up the River Plym, a fine, sketchable river. After about two and a half miles the old cottage of Warren House comes into view, itself an interesting subject. A further mile brings you to Giant's Basin where standing stones punctuate the skyline. Either return the same way, or, from Warren House head along the south side of Gutter Tor to reach the road by Ringmoor Cottage, before heading back to Cadover Bridge. The East Dart river north from Postbridge provides another worthwhile excursion. Walking up the east bank it is a good three miles to Grey Wethers stone circles, the last part without the river. Another mile will bring you to the North Teign and the fine clapper bridge below Teignhead Farm, but this is only for strong walkers. Trying to attempt a circular walk would involve covering rough ground. One of my favourite river walks is up the River Tavy from near Wilsworthy north-west of Mary Tavy. This walk enters the impressive scenery of Tavy Cleave and into the heart of the northern moor. Go as far as you dare, but a rewarding circular walk can be obtained by a stiff climb up the flanks of Hare Tor then returning along the crests to your starting point, thus taking in both river and tor scenery.

Around the fringes of Dartmoor the wooded valleys, or cleaves, provide contrasting walking and sketching opportunities. Lustleigh Cleave and the River Bovey offer pleasant woodland walks and there are several tracks around the Hisley area with the delightful pack-saddle bridge over the Bovey. Further upstream, on Becka Brook is yet another charming old bridge. Whilst on the subject of interesting bridges, Fingle Bridge on the River Teign near Drewsteignton is a five-star affair for the artist, and there are pleasant walks through the wooded valley. On the western side of the moor the Lydford Gorge is worth a visit. Again, the Plym downstream from Cadover Bridge, takes on a wooded character, being particularly of note near Dewerstone Rock. Dartmoor, then, has much to offer, whatever your taste. If you stray far enough watch out for the red flags in the danger areas, but it is always advisable to enquire locally whether the army is on manoeuvres before venturing on to the moor.

THE LAKE DISTRICT

One of the most picturesque of the lakes is Ullswater with easy walks along the eastern shore away from the main road. For the more energetic Red Tarn (Helvellyn) can be reached from Glenridding by taking the lane directly westwards and up past the disused Greenside mine. Then the going becomes wilder and after about three and a half miles Red Tarn is found nestling below the massive cliffs of Helvellyn's east face. Height climbed is about 1800 feet. Return the same way. Nearly three miles south of Ullswater is Brothers Water affording an easy and pleasant stroll along the western shore.

In the Hawkshead area take the lane northwards out of Near Sawrey (of Beatrix Potter fame) to the three tarns: Moss Eccles Tarn, Three Dubs Tarn and Wise Een Tarn. The view from the latter is magnificent, with the Langdale Pikes in the distance. Either return the same way or take the longer route through the woods high above Windermere to the east. Tarn Hows is another scenic, if popular spot, but worth visiting off-season. It can be reached by taking the B5285 from Hawkshead to Coniston and taking a right turn after nearly

HISLEY PACK-SADDLE BRIDGE
This is a quick watercolour sketch with a black watercolour pencil used to define detail. Sunlight cascaded through the canopy of trees, catching the tops of the *parapets and rocks and causing a coruscating effect on the fast-flowing water. In this peaceful spot I could have sat, sketched and dreamed all day.*

two miles. The walk around Tarn Hows is a must.

The triangle roughly defined by Ambleside, Grasmere and Elterwater has a number of delightful walks, around Rydal Water, Loughrigg Tarn and along the River Brathay. From Skelwith Force on the Brathay take the path across the fields to Elterwater Lake—this is particularly beautiful on a tranquil evening.

Further south-west the Coniston area provides excursions for all tastes. From Coniston village the Walna Scar Track leads in a west-south-west direction, eventually ending up in Dunnerdale. As it turns the southern flanks of Coniston Old Man the scenery becomes progressively wilder. Cove Beck Bridge is crossed and the track climbs to the left of Brown Pike after about three and a half miles of walking. An excellent walk is then up Brown Pike and Dow Crag, but this is steep and Dow Crag stands at 2555 feet. Far easier is the alternative of taking a path to the right of the track before Cove Beck Bridge is reached—this leads you up to Goat's Water, a truly wild amphitheatre, the tarn dark and sombre beneath the intimidating crags of Dow Crag: one of Lakeland's most impressive corries. Some care is needed on the boulders as they are uneven. Return the same way. Another walk from Coniston is north-westwards beside Church Beck up to the Coppermines Valley. To reach the tarns of Low Water and Levers Water from here takes some stiff climbing.

Little Langdale has one or two interesting walks: cross the river east of Little Langdale Tarn by the quaint and sketchable Slaters' Bridge. Head south towards High Tilberthwaite, returning along one of the other paths through the woods. Blea Tarn can be easily reached from three directions. The view from the south end towards the Langdale Pikes is one of the classics of Lakeland. Further west over the appallingly steep, narrow and tortuous passes of Wrynose and Hardnott (not for the nervous), lies Eskdale. Upper Eskdale provides an interesting route into the recesses of Scafell Pike, the roof of England. Starting from the western foot of the Hardnott Pass the path climbs steadily north-west beside the River Esk, after two and a half miles coming to a

charming old packhorse bridge just below a waterfall. Here the river forks. To the right Lincove Beck heads for Bow Fell, but to the left we head for the Scafells. Once the first steep bit is past the going gets easier and after three-quarters of a mile the gradient is hardly noticeable. Eventually the fractured crags of Scafell and Scafell Pike come into view, impressive and well worth the effort. Return either the same way or around the flanks of High Scarth Crag.

Wastwater, with its famous screes and surrounding fells affords much sketching material. There is usually ample parking further up the valley near Wasdale Head, beyond which stands Great Gable. The path beside Lingmell Beck, below the south face of Great Gable leads up to Sty Head, taking you into the wild hub of Lakeland. At Sty Head is a stretcher box and mountain rescue kit, so it is a convenient place to faint. Sty Head can also be reached from Borrowdale, leaving the car at Seathwaite and climbing away to the right, once over rock-hung Stockley Bridge. After Styhead Tarn climb to Sty Head then turn left towards Sprinkling Tarn. A quarter of a mile past Sprinkling Tarn turn left down Grains Gill back towards Stockley Bridge. This is a superb circular walk, a little steep in places, but not dangerous. Doing it in the manner described is best as the view up towards Sty Head presents a wild prospect, whilst descending Grains Gill offers magnificent vistas of Borrowdale and Derwentwater. The shores of Derwentwater provide pleasant walks and scenic views, and can be combined with a trip across the lake by boat from Keswick. Some three miles south of Derwentwater is Watendlath with its tarn and packhorse bridge, well loved by artist and tourist.

From the village of Buttermere is a gentle stroll along the south shore of the lake. At the bottom tip either continue round the lake or the more adventurous can climb to the Scarth Gap Pass which gives good views of the head of Ennerdale, in particular Pillar Mountain across the valley and Great Gable at the head with the Black Sail Hut standing below. To the left Haystacks is a gem of a mountain: not high but alas, erosion has caused some problems and it takes a bit of a scramble to gain the top with its many tarns.

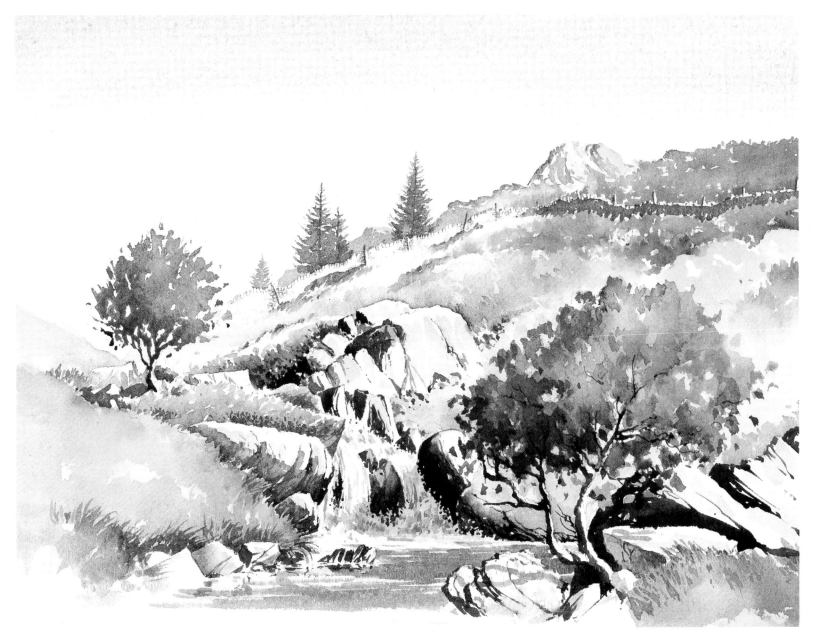

LAKELAND BECK
In this small painting I try to put over the feeling of hot sunshine in early autumn by the use of warm colours and dark shadows. Note the cast shadow falling across the bubbling waterfall.

THE PEAK DISTRICT

The Peak District offers a tremendous variety of scenery for the landscape artist. Perhaps the most famous part of the park is Dovedale. Visit it in winter when more can be seen as the trees are not hiding the fascinating rock shapes. An excellent two-day circular walk can be done by walking up Dovedale one day and back down the Manifold Valley to the west, the next, or the first walk can be cut short at Milldale. Near Hartington the valley opens out and becomes less dramatic until Parkhouse Hill is reached.

To the west of this area lies the North Staffordshire Moors, perhaps one of the least known parts of the Peak Park. This is gritstone country, quite different in character from the limestone of Dovedale. Lonely farmhouses and cottages cling to the contours of the bleak moors, scenery which I find particularly inspiring. The lanes are fairly quiet and you can capture much of the flavour of the area without even leaving the car. You do need, however, to get out to savour the Roaches and Ramshaw Rocks, two great outcrops that signify the start of the Pennine range. From the north end of the Roaches you can descend to Black Brook and then to the River Dane, which makes a fine excursion to Danebridge and then back to the Roaches by a circular route. Further north on the Dane, Three Shire Heads, with its two packhorse bridges, should not be missed. Several alternative routes converge on the scene, so take your choice. I last did it on an extremely wet, windy day, gloriously atmospheric: I sang most of the way.

Around the Bakewell area, in the heart of the White Peak are many classic walks of the park. Lathkill Dale should gladden the brush of many artists, though the river disappears in places. Monsal Dale has much to interest, including a viaduct. One of my favourite Dales is Millers Dale, going upstream from Cressbrook, and a circular walk can be worked out via Litton and Tideswell Dale.

Another excellent centre is Castleton, with its castle perched high above the village. A walk along Peakshole Water will reveal the fine prospect of Mam Tor, a good composition with the river in the foreground. In fact there are many possibilities of sketching the hill with various foregrounds, simply by exploring the valley. To the west of Castleton lies the Winnats Pass, which I saw at its most dramatic after a heavy rainstorm, a rainbow etched strongly against a dark sky, actually descending into the pass. If you climb the south side of Mam Tor, a circular route can be followed along the ridge crests to Lose Hill from where you can return to Castleton. Splendid views of Kinder Scout to the north from many points on the ridge.

Kinder Scout and Bleaklow are in the Dark Peak, where gritstone and heather moors give the landscape a different character. They are really only for the hardy walker. The going is tough and in bad conditions competent navigational skills are needed: I've probably met more lost souls to the inch on Kinder than anywhere else in the country. This is scenery which may well frustrate the neophyte painter, a haunting loneliness which seems to bring out a love-hate relationship with walkers. To savour some of this wilderness drive to the head of Derwent Reservoir and then walk upstream beside the River Derwent. Once out of the trees you find a rustic old bridge, before the scenery becomes increasingly wilder, with shattered trees in places giving a feeling of being in 'Deadman's Gulch' or some equally barren place. Eventually you will find yourself in the heart of Bleaklow, but unless you are experienced in bog-hopping it is wise to turn back and retrace your steps. The easiest way on to Bleaklow is from the summit of the Snake Pass, following the Pennine Way northwards. This certainly gives you a flavour of the wild mass of groughs and peat hags, with clinging black oozing mud. An experience you will not forget. Go no further than you feel is within your experience. Extracting paintings from this bleak moor is every bit as challenging as tripping across a field of bulls carrying your finest cabinet of china.

THE SCOTTISH HIGHLANDS

With so much marvellous mountain scenery to choose from it defies all the skills of a sardine-packer to cram so much detail into a few paragraphs. Starting in the southern

highlands the Trossachs are an obvious first-class attraction: the lochs present incredibly beautiful low-level subjects without any need to walk, climb or bog-trot far, yet there are mountain walks that are as challenging as you wish to make them. You only have to drive up the main road from Glasgow to Crianlarich to be aware of the beauty of Loch Lomond. Loch Katrine and Loch Lubnaig are also scenically mind-blowing, but one of my favourites is Loch Ard over which Ben Lomond rises. With loch-hugging morning mist this is rivetting stuff. Ben Lomond makes an excellent excursion in itself. However, the most striking mountain to climb in this part of Scotland is Ben Arthur, or the Cobbler, a relatively simple climb from the Arrochar side above Loch Long. One of the best views of the Arrochar Alps is from the road at the head of Glen Douglas, with the great trough of Loch Long in between, although from here you do not see the amazing profile of the three summits of the Cobbler.

Further north, as you approach Tyndrum, the large glen to the west leads up to Ben Lui, one of the most shapely mountains in the area. The walk up beside the River Cononish towards Ben Lui with the stream itself providing an excellent lead-in, presents a stunning composition. Here, mid-morning is the optimum sketching time, when sunlight falls across the flanks and casts shadows into the central gully. Before walking up the glen however, gaze back down Strath Fillan. On a clear day you can see the twin peaks of Ben More and Stobinian, preferably with the river in the foreground and framed by trees in true Gilpinesque manner. These peaks are at their finest under a coating of snow.

On the road to Oban, Loch Awe will excite the most doubting of tourists, with the spectacular ruin of Kilchurn Castle before a backdrop of Ben Cruachan. Not far away at Bridge of Orchy, stands Loch Tulla with several subject possibilities. On a calm day watch for Stob Ghabhar mirrored in the loch. From here is a five-star walk up one of the old military roads to Kingshouse, with the Blackmount to your left and the untamed vastness of Rannoch Moor to your right. The two backgrounds make fascinating and contrasting elements within paintings. Watch out for Ba Bridge with

the River Ba cascading over sharp angular rocks, and the mountains behind. Further along near Kingshouse, and reachable by road, stands Blackrock Cottage, an attractive composition with Buachaille Etive Mor rising beyond. Finally Kingshouse Hotel makes another fine centre of interest to a painting. Rannoch Moor itself is spangled with sketch-worthy lochs and lochans.

Kingshouse stands at the eastern end of Glencoe, which, if you are lucky will be in a sombre, foul mood. Don't just drive down it: get out, walk a few yards and savour its wildness and atmosphere. Use the River Coe as a lead-in to the mountains, as they close in threateningly on either side. Gaze up at the fearsome crags of the Aonach Eagach Ridge on the north side. Towards the bottom end of the glen is a visitor centre, and eventually the glen spills into Loch Leven, one of Scotland's beauties. Drive round to Kinlochleven and climb up the path towards Loch Eilde Mor. Not far up, the view down Loch Leven presents itself, and if you have timed it right you may witness a glorious sunset straight up the loch, with mountains falling down on either side, the whole spectacle framed by that classic tree, the Caledonian pine. It is too breathtaking to paint adequately. By all means carry on along the old military road to Loch Eilde Mor, if you have any breath left!

Fort William makes an excellent centre, even if you don't intend climbing Ben Nevis. Pictorially, the horrific, plunging cliffs on the north-east face of Ben Nevis, are a must for rock-

OVERLEAF, LEFT:
UPPER LOCH TORRIDON
It was a bitterly cold February evening when I sat beside the loch and sketched this scene. The line of clouds fascinated me, but what excited me most was the hard and soft edges formed by knife-edge rock against hazy background. I drew the tree higher than it appeared in order to break up all the horizontal lines and also give balance to the right-hand side of the picture. Note the aerial recession brought about by strong darks in the foreground.

OVERLEAF, RIGHT:
DEVIL'S POINT, CAIRNGORMS
What rivetted me to this scene was the great boiler-plate slabs of the peak and the wild situation of Corrour Bothy. I used a rigger for much of the intricate work on the mountain, and had to arrest the fall-away effect to the left by enlarging the two boulders.

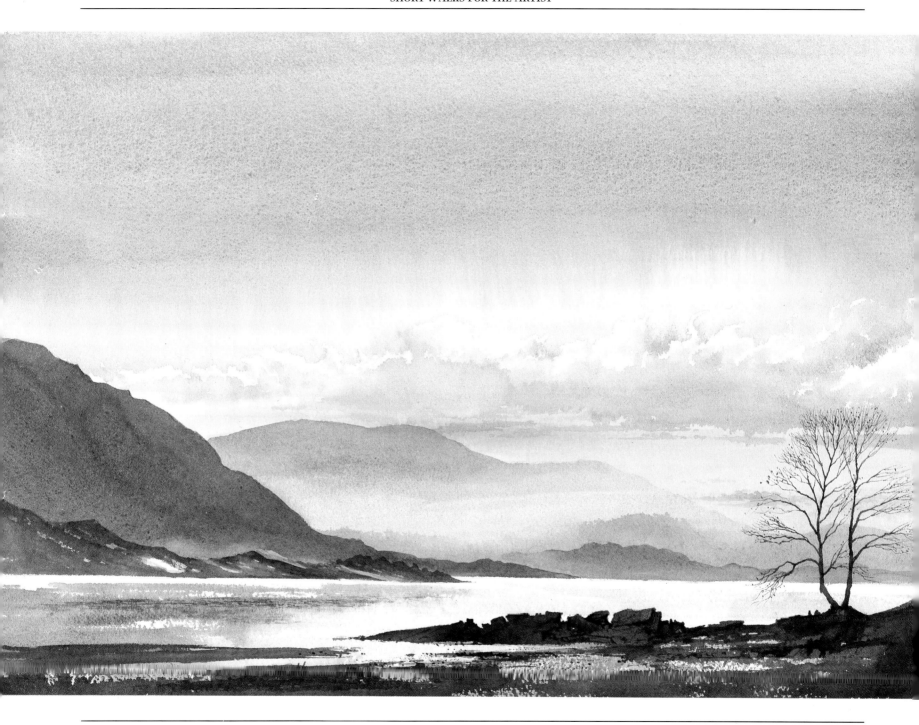

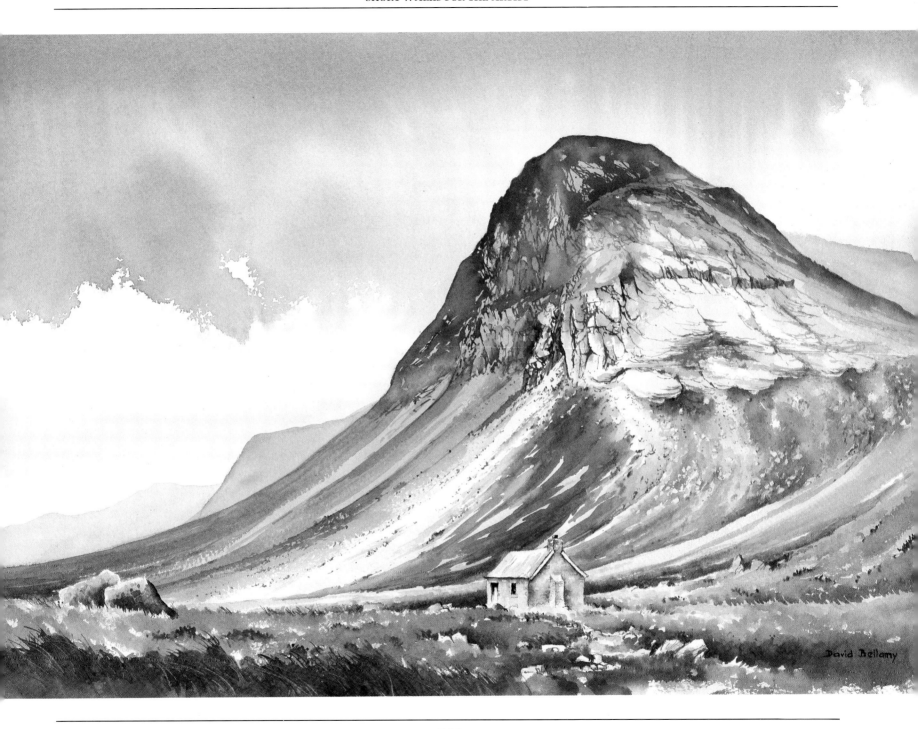

artists of all types. For the low-level artist it is hard to beat the glories of Glen Nevis. You can drive several miles up the glen to below the gorge, with a subject in every direction. Even the most recalcitrant subject-finder would be hard put to feel displeased here. Beyond the car park Water of Nevis plunges through a spectacular gorge. You need to take care in places, especially when wet underfoot. As you emerge at the top end of the gorge you are confronted by the magnificent cascade of Steall Waterfall.

From Fort William the drive to Mallaig, with Loch Shiel, Loch Ailort and Loch nan Uamh along the way is of particular interest. The western highlands, though extremely wet, exude a wild, romantic beauty, and if you can get into Knoydart, Loch Nevis, Loch Quoich and Loch Hourn you will be rewarded with some fascinating subjects. These places, however, should be left for those who are confident about going into remote mountains. The charms of Glen Shiel and Loch Duich on the other hand are close to the main road. Eilean Donan Castle provides a stunning subject without any need to leave the car. Further east Glen Affric is one of Scotland's most scenic glens.

Skye, from an artist's point of view, is very different from the mainland. The old thatched crofts offer new subjects, and the sea is never far away. The Black Cuillin take some getting used to, both from a mountaineering and artistic angle. Other than climbing the ridge, which in all but a few places is a forbidding scramble, the finest viewpoints are: from near the Sligachan Hotel, looking towards the peak of Sgurr nan Gillean; other points down Glen Sligachan; looking across Loch Slapin towards Blaven; from Loch Coruisk, which is probably the wildest loch in the country (this can be reached by boat from Elgol, otherwise it is quite an expedition); and finally by walking up the track from the Glen Brittle campsite towards Sgurr Alasdair, the reigning peak. The range can be viewed as a whole from a number of places on the island.

Then there are the northern highlands, with Glen Torridon, Loch Clair, Loch Coulin and Loch Maree especially outstanding. Further north comes Little Loch Broom, Stac Polly, Suilven and the stark landscape of Sutherland. An

Teallach is one of my favourite mountains, but a colossal undertaking if you are new to mountains. From Dundonnell, however, climb the track to Loch Toll an Lochain, which lies in the great corrie of An Teallach, in my view the most impressive corrie in Scotland. This is a walk through unsurpassed scenery with many subjects on the way; waterfalls, streams, pines and the mountain.

In the east lie the Cairngorms, the roof of Scotland. Most of these are great rounded masses, and much walking has to be done to reach some of the juicy bits. The Rothiemurchus Forest provides splendid woodland walks, and Loch Morlich makes a number of excellent compositions, especially with the Cairngorm ridge in the background. From the loch the Ryvoan Pass unfolds a variety of scenes—go as far as the bothy. If you return in the gloaming it is all the more romantic and beautiful. South-west of the Cairngorms lies Creag Meagaidh, where a bracing climb leads from Loch Laggan up steadily into Coire Ardair. When I last ascended to this savage corrie, Meggie, as the mountain is affectionately known to mountaineers, must have seen me coming: she put on a really spectacular show of sunlight and snowstorm.

SNOWDONIA

In much of the Snowdonia National Park mountain walks start from roads that are often 1000 feet high, and so there is less to climb than a mountain of equivalent size in parts of Scotland, for example. One of the most magnificent ranges in Snowdonia is the Glyders. There are several parking places beside Llyn Ogwen, the natural approach. At the western end of the lake the outgoing stream dives under the main road and then plunges down the Ogwen Falls, which is quite

LOCHAN NEAR FLODIGARRY, SKYE
Flora MacDonald was born near here, so the scene induced a romantic background. The mist has been accentuated and I have reversed the normal process of painting more detail on hills that are closer, by suggesting it on the far distance mountain which is bathed in sunlight. It has worked because of the dark tone of the left-hand hill, the excuse for no detail there being that the hill was in shadow. It's great fun when you break the rules of painting and get away with it!

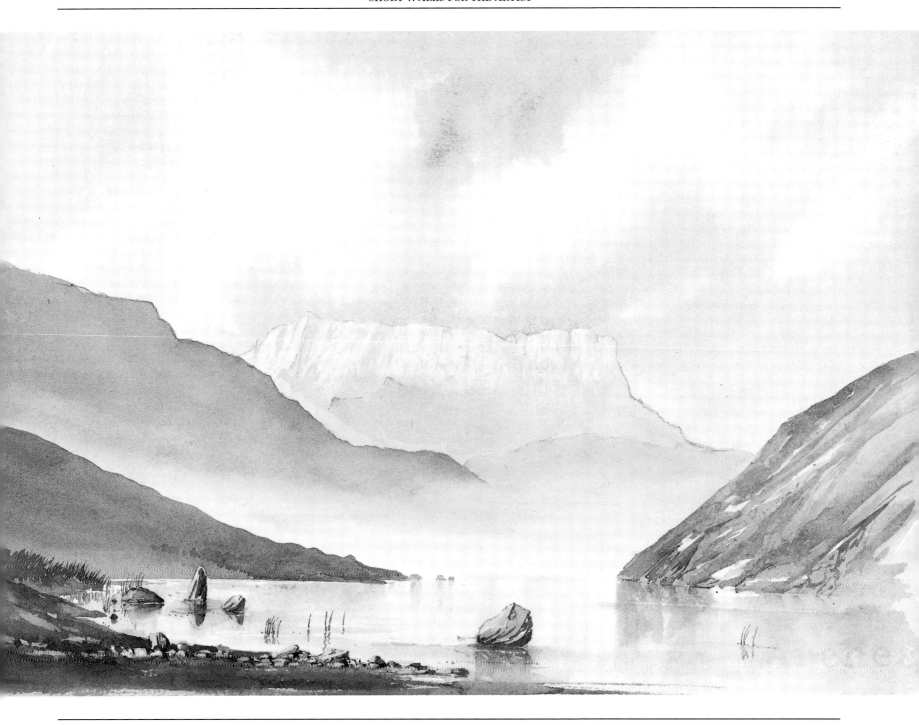

a spectacle, especially when coated with ice several feet thick. The falls are best viewed from the south-west by taking the track beside Idwal Cottage Youth Hostel. From the hostel an easy walk up a rough path will take you into the recesses of Cwm Idwal. This is mountain scenery at its most awesome, and was described by Thomas Pennant the eighteenth century Welsh naturalist, traveller and squire as 'a fit place to inspire murderous thoughts.' High above Llyn Idwal, the great cirque of cliffs displays a sombre countenance. Note the Devil's Kitchen, a dark evil slit. If you walk round the lake you should find many subjects.

The fit can follow a path up to Llyn Bochlwyd away to the east. This is higher and rougher, for the tarn lies at the foot of the shattered north face of Glyder Fach. It is then not far to Bwlch Tryfan, the col between Tryfan and Glyder Fach, from where you can climb Tryfan to the left, Bristly Ridge (only if you have a head for heights!) to the right. Climb the scree and boulders below the ridge up the summit of Glyder Fach, or return to base. Note that these climbs are really strenuous, and care is needed. Glyder Fach is an amazingly wild place, with boulders everywhere as though tossed around by a disgruntled giant. Watch out for the Cantilever, a huge balanced slab on the summit which looks like the sort of thing that penguins should fall off, and on the way towards Glyder Fawr, the incredible spikey outcrop of Castell y Gwynt (Castle of the Winds). Views across to the Snowdon Range on a clear day are magnificent. Continue over Glyder Fawr if you feel up to it, and down to Cwm Idwal, a sharp drop, or cut it short by descending Y Gribin. If you do the full round you will need a long day to take it all in and sketch. Tryfan is a fine mountain but you need to use your hands to get to the top, the most usual route being up the north ridge from the eastern end of Llyn Ogwen. It provides an excellent composition from many positions to the east. Y Garn and Foel Goch can be sketched particularly well from the eastern end of the lake, and a further possibility is up the footpath going to Penyrolewen, just level with Tal-y-llyn Ogwen: put the farm in the foreground.

Just to the south is the Snowdon massif. Snowdon has many routes to the top, and you can even take the train to the summit. An easy walk into the centre of this magnificent scenery is up the miners' track from Pen-y-Pass where there is a car park. After about a mile the peaks forming the Snowdon Horseshoe come into view, and soon you come to the shores of Llyn Llydaw with Snowdon itself rising ahead across the lake. This is mountain scenery at its grandest. If you follow the track to the right you cross a causeway and can walk along the northern shore to the long-disused mine buildings. Then the track gets steeper and if you continue you eventually reach Glaslyn, a smaller lake in the very shadow of Snowdon. The going then becomes extremely steep and rough up the zig-zags, only recommended for the superbly fit. From the top of the zig-zags (whether reached by climbing or by train) there is, weather permitting, a fine prospect of Crib Goch to the east.

Another sketch-enticing track into the Snowdon range goes from Nantgwynant up Cwm y llan, taking you past several old ruins with many opportunities for sketching subjects. Beyond these it is a long, steep route to the summit, however. The range can be viewed to advantage from many points. Perhaps the most famous of all is from Capel Curig where a number of different foregrounds can be utilized. Just past the Plas y Brenin Mountain Activities Centre on the Snowdon side is a path down to Llyn Mymbyr. In little more than a hundred yards from the road you are presented with a tremendous view of the whole Snowdon range on a clear day. Just past the western end of the lake is an interesting old bridge from which another composition arises, with the bridge itself a good subject. From Llyn Gwynant there is an impressive view of Yr Aran, one of Snowdon's satellites, after which you have to travel all the way round the mountain to

ICE-FORMS ON SNOWDON

Strong low sunlight at the end of the day illuminated this absolutely inhospitable place where ice-spears jut out of ice-glazed rock and ice-beads whistle past, blown hissing across the hard-packed snow by the wind. Snowdon mountain evokes in me a strong spiritual feeling that goes beyond any comprehension. The Rev William Gilpin dismissed the summit of Snowdon with ' . . . it was a bleak and dreary waste'. Snowdon may at times be bleak, but never dreary.

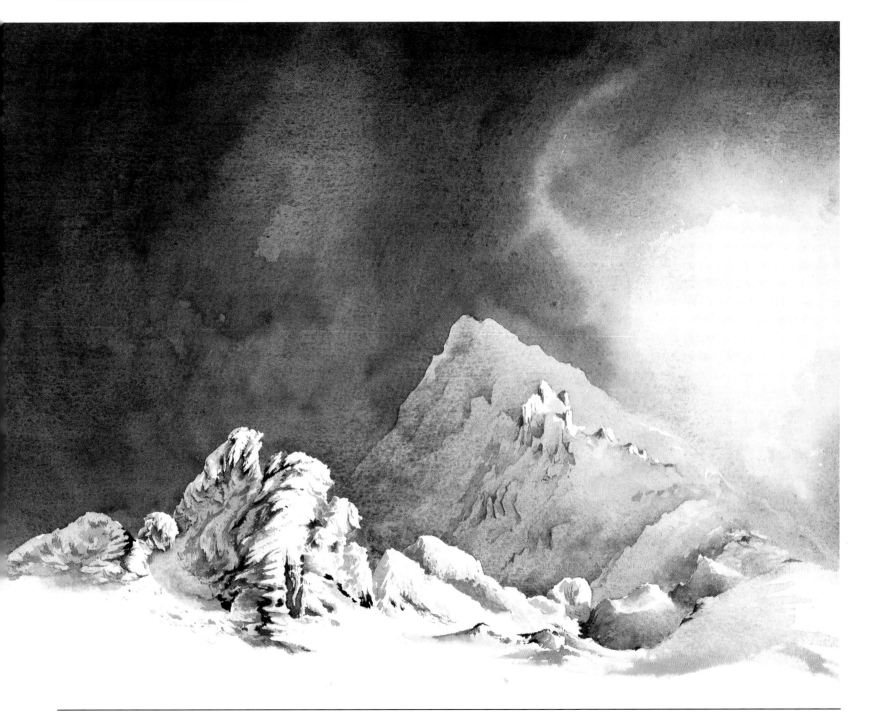

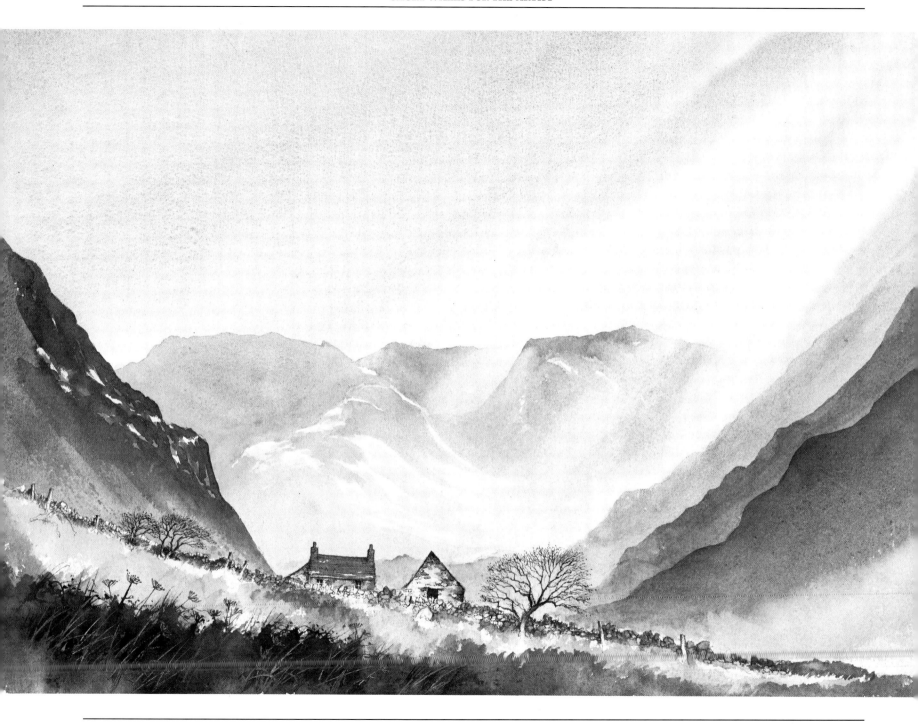

Rhyd-Ddu before further possibilities are evident from low-level. Here, on the western shore of Llyn-y-Gadair, is an admirable composition. Further west at Llyn Nantlle Uchaf the Ordnance Survey have even symbolized the view for you on their maps. Looking towards Snowdon, this was the view that captured the inspiration of many artists in the past, including Richard Wilson.

South of Beddgelert lies the Pass of Aberglaslyn, again well loved by artists, and again the Ordnance Survey have obliged with a symbol, where we view the scene from the bridge. Parking here is awkward, however, so be prepared to walk a little way. The river tumbles down a boulder-strewn course through the tree-clad gorge. On a bad day when mist envelopes the tops it is magnificent. If you continue along the main road towards Porthmadog you are soon rewarded with superb views of the Moelwyn range, which includes Cnicht, from this angle quite sharp, although it is really chisel-shaped. They also present a fine profile from Blaenau Ffestiniog.

I cannot leave North Wales without a visit to Cadair Idris, once thought to be the highest mountain in Wales. There are three main routes up the moutain, the best pictorially being from near Tal-y-Llyn at Dol-y-Cae. Initially the path goes through woods, and quickly steepens. Though not dangerous, it takes plenty of exertion. Eventually the route climbs above the tree-line and into the wild cwm to Llyn-y-Cae, another scene made famous by Richard Wilson. Get here by early morning when, if the sun is out, light falls across the cliffs rising out of the water. To continue to the summit involves climbing the ridge to the left of the lake: more steep going, and rough in places, but with stupendous drops to the lake below as you reach the top of the cliffs. Then it descends before the final slog to the summit.

THE GLYDERS FROM NANT FFRANCON
Back-lighting on the subject caused a loss of detail and a marked illusion of aerial recession on the ridges to the right of the painting.

THE YORKSHIRE DALES

This is walking country *par excellence*, with such variety that the artist should never run short of inspiration. Swaledale is one of my favourite dales with splendid topography, compact little villages and an amazing number of barns that litter the hillsides. What absolutely marvellous subjects these make, and Yorkshire artists are certainly not slow to capitalize on these features.

For most of its length, Wharfedale provides much beauty, with a contrast in the upper reaches, which tend to be more open, and the lower reaches around Bolton Abbey which seem more secretive, and hemmed in by tall trees. The Strid in the woods above the abbey is a natural honey-pot for tourists, but all along this part the river provides fascinating compositions and makes for easy walking. A walk embracing several types of scenery can be taken from the river up the Valley of Desolation, past a delightful waterfall cascade, through woods and out on the moors beyond. The moors are capped with massive sleeping boulders, quite a contrast to what has come before. Then descend over the brow back into Wharfedale, stopping for a farm tea if you're lucky, before continuing downriver past the Strid to your starting point.

If you like bridges Dentdale to the north-west is a goldmine. The road through the dale passes over a considerable number of old sketchable bridges, one of which looks as though it has been squashed by something far too heavy, then stretched. Such problems have to be exaggerated, otherwise like the fish-less angler, you won't be believed. Dent village gave me quite a start when I suddenly found myself on cobbles. It has some quaint old corners in which to sketch.

The Malham area is well known by geologists, with the great cliff of Malham Cove to the north of the village and Goredale Scar a short walk away to the east. Goredale Scar has inspired many artists in the past, the huge fault strikingly impressive. Note the cascade of water through what appears to be a huge ring of rock above. If you are doing a circular walk taking in Malham, Goredale Scar and

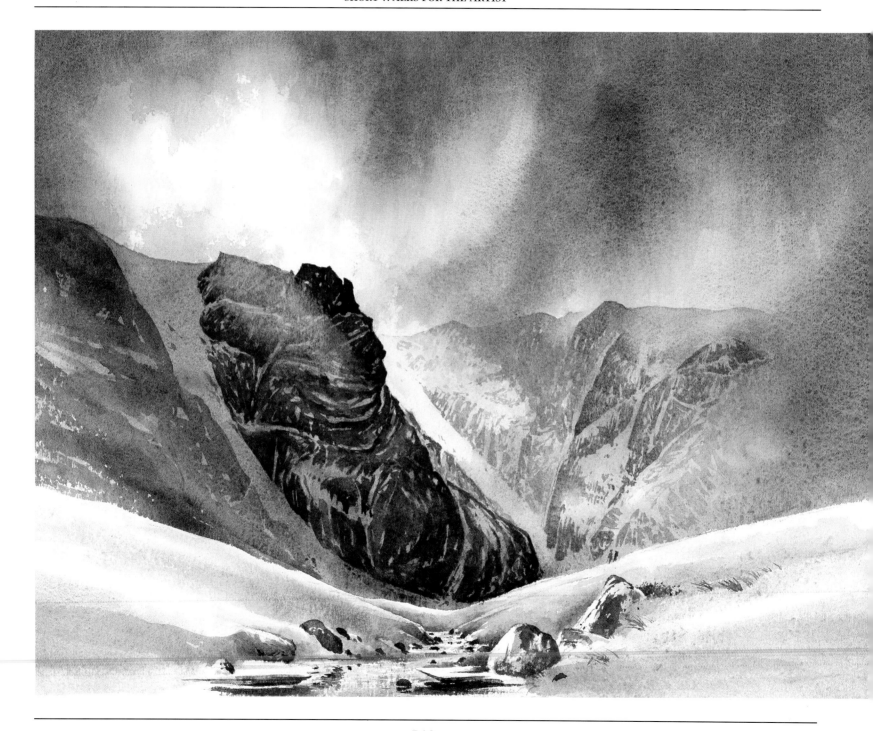

SNOWSTORM COIRE ARDAIR

As I headed into the corrie the strong sunshine falling over Creag Meagaidh began to dissolve into the wildness of the approaching storm. The atmosphere became electric. I stood rooted to the ground, for moments quite incapable of getting my sketching gear out of the rucksack. When I did come to my senses I managed three quick watercolour sketches, but all were inadequate when compared to the spectacle of awesome power of natural forces that seemed to be tearing Meggie apart.

Malham Tarn it is advisable to do it anticlockwise, as I have seen people come to grief descending Goredale Scar, when doing it the other way round. And it is visually more exciting that way.

No mention of walking in Yorkshire would be complete without the three peaks of Ingleborough, Whernside and Penyghent. All three peaks make impressive compositions from many angles, with farms, barns and cottages in the foregrounds. You don't even have to leave the car, but it is a crime not to walk some distance and get that perfect viewpoint. Ingleton and Horton-in-Ribblesdale make excellent centres. I have been to the Three Peaks many times, and they never fail to impress, never fail to give me many sketches, and never fail to excite me. Perhaps in all England no mountain has the compelling attraction of Penyghent, nor such a distinctive profile.

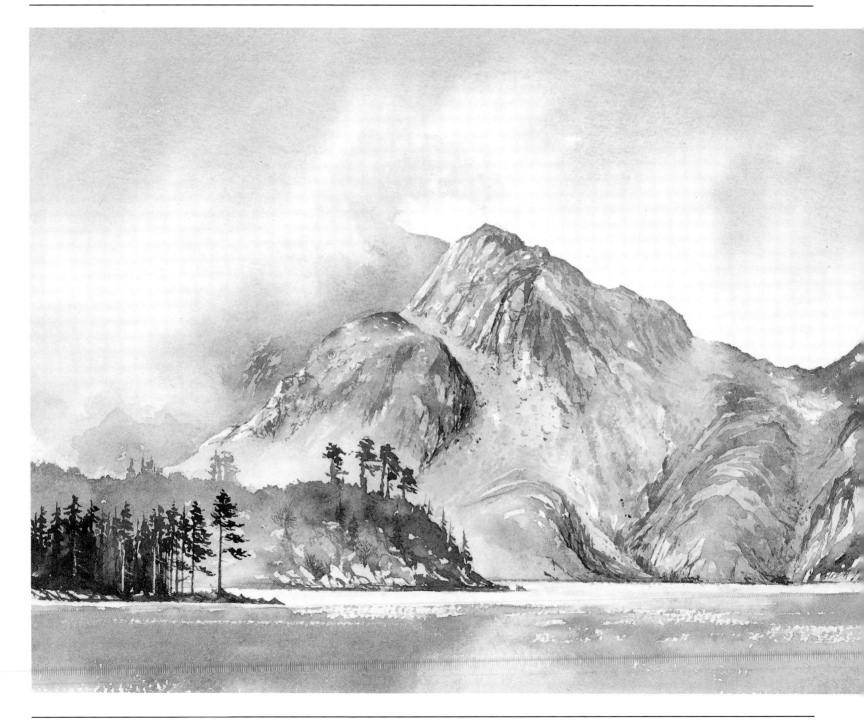

IO
EQUIPMENT AND MATERIALS

*Your thumb is one of the best tools
you've got, you know*

L S LOWRY

LOCH KATRINE
*I deliberately lightened the middle part of
the mountain so that the trees high up on
the island stood out dark against the
background, repeating the exercise with
the trees in the bottom left. A dry-brush
approach was adopted on the loch itself.*

Today the range of art materials available is quite staggering. Never before has there been such a choice, which to the newcomer must appear as a bewildering maze. It is easy to spend a great deal on materials that are either not needed or do not perform the task so well. In this chapter I shall provide lists of materials for both sketching outdoors and working in the studio, and analyse the more important items.

BRUSHES

The most important tool for painting is the brush. By far the finest brush for watercolour is the red sable, which holds a generous amount of colour, keeps a good point and springs back into position instantly: three essential features for good watercolour practice. However, sables are expensive, the larger ones are quite astronomical in price, and not always obtainable because of the rarity of the Kolinsky sable. Still, technology is improving brushes enormously, and there is a wide range of both synthetic, and mixed synthetic and sable brushes on the market, all cheaper than pure sables. Many of them keep their points extremely well and perform to a high quality. Of these brushes, the Dalon range, marketed by Daler-Rowney, is excellent value—springy, retaining a fine point and long-lasting. I use their one-and-a-half-inch flat brush in this range for large washes and find it invaluable. Winsor and Newton produce the fine Sceptre range of brushes which are a mixture of sable and synthetic fibres. On one occasion I lost my sketching brushes and the only ones I could buy locally were by Pro Arte. Made of Prolene, a synthetic filament which they claim has more spring than the finest Kolinsky sable, they performed extremely well. Pro Arte also manufacture a magnificent number twenty size brush which I find superb for rendering mountainsides or broken ground: in a flash you can change from broad washes with the side of the brush to fine detail with the tip. All the above manufacturers produce fine sable brushes, well worth buying if you can afford them: I wouldn't swop my Diana sables (the Daler-Rowney top series) for anything. Try one—they really are the Rolls Royce of brushes. Jakar International market sable brushes with triangular handles

designed for use by arthritic artists. These handles allow a better grip for those who have difficulties with normal brushes. They also inhibit the brushes from rolling over a precipice, one of my eternal problems. These brushes perform very well and would probably be useful in below zero temperatures, when gripping a brush becomes awkward, although I have not had the opportunity of testing them yet under such conditions. After use brushes should be washed in clean, cold water, shaped and left to dry naturally. Never leave them standing on their hairs.

WATERCOLOUR PAINTS

Watercolour paints consist of pigments held together by a gum binder, which in most cases is gum arabic. Colours come in artists' and student grades, pans and tubes, with some colours permanent, some fugitive, and can be bought separately or in attractive boxed sets. How does the student even begin to decide on what to buy? Firstly, if you are new to painting I would recommend you buy student colours as these are cheaper than artists' quality, and can be used for sketching later if you wish to change. If you are selling your work regularly you owe it to the customer to use the finest materials available, so I recommend artists' colours when you reach that stage. Pans or tubes? This really is up to the individual. Personally I prefer tubes because the colour is moist as you squeeze it from the tube, and as much can be squeezed out as is needed—often quite a large amount with some washes. Pans may be more convenient out of doors, but I still prefer tubes, even during a blizzard on a sixty-degree ice-slope when fiddling with the tube-caps is just about the last thing you want to do. Before choosing colours

HOAR FROST, SNOWDONIA
For this work I used Arches paper with a NOT surface. In the sky I laid on a mixture of French ultramarine and crimson alizarin with some streaks of cadmium yellow. When the sky had dried I introduced the hills, mainly with crimson alizarin, blending some French ultramarine into the lower parts. The cottage was painted with raw sienna and French ultramarine and for the final part of the painting, the foreground covered in hoar frost, I mainly used French ultramarine with a touch of raw umber and raw sienna here and there.

get hold of the manufacturer's colour charts. These not only show you the range of colours available but also give information on the permanence of each colour. Avoid fugitive colours, and try to build up a palette of the more permanent ones. Don't feel obliged to buy a boxed set as you may well be lumbered with a few colours that are hardly ever needed. Start out with seven or eight colours and build up your range gradually by adding an extra colour now and then, and get used to its qualities before buying any more. Too many colours is confusing when you are starting out.

The number of different ranges available now has mushroomed with more European manufacturers adding to the first-class paints marketed by Daler-Rowney and Winsor and Newton. Talens' Rembrandt, artists watercolours made in Holland, have a comprehensive range of colours and a fine reputation. The German firm Schmincke produce the Horadam watercolours, whilst in France the PC Lambertye professional range of watercolours is made by Conte à Paris.

You will need to become thoroughly familiar with the characteristics of the various colours, but to give you a start I shall outline some of the more widely used colours. Note that although many colours have the same name by different manufacturers they do at times vary in characteristics. Prussian blue is classed as being more permanent in one range than another; French ultramarine is transparent in one, but not so in another; and Payne's grey varies between almost black and a definite bluer colour. These are but a few examples.

Raw sienna: An extremely useful colour. I prefer this to the alternative yellow ochre which is more opaque and dull.

French ultramarine: Probably my most-used colour, as it mixes so well to produce lovely greys and greens among other colours. It tends to granulate, ie, the pigment separates with a speckled effect, particularly on rough paper. If you don't like this try Rowney's **Permanent blue**, which is the closest alternative.

Burnt umber: Another of my essential colours, superb for producing dark tones and mixing lovely greys.

Crimson alizarin: This is a cool, transparent red, fine for mixing and glazing over other colours. Can be addictive!

Light red: Fine for brickwork, rust-coloured bracken and for mixing warm greys.

Payne's grey: Some artists dislike this colour, but I find it versatile, for mixing rich dark greens, getting really dark tones and for sombre mountain days.

Lemon yellow: A cool, fresh yellow, essential for spring subjects.

Cadmium yellow: A strong, opaque yellow which I prefer in the paler tint.

Burnt sienna: A lovely colour in mixes, producing warmer greys than burnt umber, and excellent for warm-coloured passages.

Indian red: A fine mixer, being a deep, rich red.

Cobalt blue: A transparent blue I use sparingly—it can be overdone on the blue-sky effect if you are not careful.

Raw umber: A subtle, opaque colour I often use in foregrounds and for mixing greens.

Monestial blue: A greenish blue rather like Prussian blue, but more permanent; a useful colour.

Naples yellow: A dreadful mixer, making everything appear milky, but I invariably use it pure to warm up a sky. Fine on tinted papers because of its opaque quality.

Viridian: If you need a ready-bought green viridian is a versatile, transparent colour, and a good mixer.

WATERCOLOUR PAPER

Watercolour paper normally comes in imperial sized sheets, that is 22 × 30 in, and in varying thicknesses or weights. The more common weights of paper are 90lb, 140lb and 300lb, this being the weight of a ream (500 sheets). Experiment with the various papers available, to see which suits you best. Some artists use watercolour boards, but I see no real advantage with these. The diversity of surfaces by different manufacturers gives quite a wide choice, so I will go through some of the characteristics of the more common papers

Bockingford: A cheap but good, sympathetic surface to work

on and a fine paper to begin painting in watercolour and for sketching.

Cotman: Another non-expensive paper which has an interesting surface. An excellent watercolour sketching paper. It needs care with glazes.

Lanaquarelle: This like all the following papers, comes in the three types of surface—rough, hot pressed and NOT. A good paper with a pleasing surface, manufactured in France.

Saunders Waterford: I like this new paper very much. The rough variety is becoming a strong favourite because of the quality and responsiveness of the surface.

Arches: This is a superb French paper which has been my favourite for many years. Slightly creamier in colour it has a pleasing surface, though I prefer the rough to the NOT.

Fabriano: An Italian paper which in the rough surface is very good. The NOT variety is too mechanical for my taste.

Two Rivers: This small Lancashire firm produces hand-made papers, including tinted ones with interesting surface textures. It's a marvellous treat to work on one of these superb papers.

Whatman: So many artists talk sadly of how marvellous the old Whatman paper was before it was discontinued, but is it romantic wishing? I'm too young to know! I feel this newer surface, because of its greater absorbency will appeal to certain artists and not others—try it and see.

PALETTES

Go into any art shop and you will normally see a bewildering array of watercolour palettes, of all sizes, shapes and depth of mixing wells. For your large washes you need quite a reasonably-sized area for mixing the colours, and here a saucer, plastic tray or plant-pot tray will be quite adequate: but make sure it is white. Kitchen departments of stores can be a fruitful area in which to search, where that bit of white plastic can often be much cheaper. For smaller mixes, particularly for detailed work, the normal palettes with a number of wells are fine. Rounded wells are easier to clean as they have no corners. Finally there are those palettes that combine the attributes of both the large tray type and the small wells, and one of these is the excellent Spencer-Ford palette available at many art shops. The palette has a lid, which can also be used for mixing large washes, but the beauty of this palette is that it is especially useful for those who need to put away their work after every session: with the lid on you can stack what you like on top of it—well almost!—and it won't get covered in paint. This feature also makes it ideal to carry around, although it would not stand up long to the rigours of a mountain expedition. For working in the wilds I take an aluminium palette which bends back into shape if you sit on it: a plastic one would soon break. Although the wells of the aluminium palette are quite shallow it is sufficient for small-scale work, and vital when the going gets rough.

SKETCHING EQUIPMENT

Initially there is no need to splash out on an outdoor sketching kit as well as a studio one, but later on you may find it saves much reorganizing of materials. Emphasis should be on restricting materials as far as possible, and try to keep everything lightweight.

Recommended list of sketching materials:
2B, 3B and 4B pencils
Berol Karisma Graphite Aquarelle pencils
Black ordinary watercolour pencils
Watercolour paints
3 or 4 brushes
Cartridge sketchbook
Watercolour paper/pad/block
Tube to hold brushes and pencils
Water pot and container
Robust palette
Retractable Stanley knife
Pens
Charcoal or Conte crayon

Tissues
Bulldog clips and rubber bands

Watercolour paints in tubes can be kept in a watercolour paintbox as supplied by the manufacturer, in a plastic box of suitable size, or as I often do when on expedition and weight is a problem, in a plastic bag. Pans come in their own boxes: the whole pans are best for sketching, as they are larger than half pans and twelve colours are quite sufficient for outdoor needs. These boxes usually have room on the lids for mixing colours. There are a considerable number of sketchbooks on the market, and it really is worth shopping around to see what suits you. Bockingford pads come in a variety of sizes and weights. The Cotman sketchbooks are fine, though being only in 140lb weight are a bit of an overkill for small-scale work. For years now I've found Daler S1 series wirebound cartridge sketchbooks fine for pencil or watercolour sketching. The Daler 'Lyndhurst' book is rather attractive and, being wirebound and a convenient size, would make an excellent pictorial diary. Additionally there are several beautifully bound sketchbooks, some with tinted papers, on the market. Watercolour pencils come in boxed sets or individually packed. It is wiser to buy them individually, because then you can choose your range of colours and buy say four or five black pencils. It is useful to have several blacks as being so soft they need sharpening frequently and nothing is more frustrating than having to stop to sharpen a pencil during a sketch. The Derwent Watercolour Pencils by Rexel are really superb, and being soft, blend so much easier than most other ranges, when washed over with a wet brush. I find them indispensable in the hills.

The materials can be carried in a haversack, rucksack or whatever you find suitable. As I am nearly always walking and sketching I rarely use anything other than a rucksack. There is a vast range available from small day sacks to large expedition types, to suit all tastes and pockets. Some have a number of separate compartments which can be used to hold sketching gear without need to open up the main part of the rucksack. My small rucksack has an integral closed-cell

foam pad which slots into the back of the sack: in the rucksack it forms a firm support against which I position my sketchpad and paper (in a heavy-duty plastic envelope), and I use it to sit on when sketching. Being impervious to water, it is comfortable on wet grass, mud or snow. The foam pads, or mats, called Karrimats, can be bought at mountain gear shops and can be cut to size if necessary. Both mountain gear shops and fishermen's shops are excellent places in which to find useful outdoor accessories, from rucksacks, haversacks, thin gloves, waterproof cagoules, mapcases for keeping sketching paper ready for use, woollen hats (for winter) and floppy hats (for summer), and even little camping stools. Folding chairs are popular with artists, but do become a burden over a distance, or on rough ground. The range of outdoor clothes in mountain shops is quite extensive, and these days very fashionable. Jackets and waistcoats with several pockets can be excellent for keeping sketching gear to hand, and thermal underwear is a boon in winter. Woollen hats are vital in winter as we lose one-third of our body heat through the head. There is no better place to find these than in a mountain gear shop.

STUDIO EQUIPMENT
Kitting yourself out with everything can be a costly business, and whilst it is always advisable to buy the best quality materials you can afford, there are certain ways in which you can stretch your budget. An artbox for your materials will usually cost more in an art shop than in an ironmongers or department store, for example. Try fishermen's shops, kitchen-ware departments, general stores, large drug stores and the like for white plastic trays, large water pots, brush containers, knives, tapes, sponges and so on. Drawing boards can be made out of plywood off-cuts from your local DIY shop.

SPINDRIFT, PEAK DISTRICT
This was done on the rough 140lb variety of Saunders Waterford paper, a superb surface to work on, and one which I grow more to like as I get accustomed to it. The painting was done with French ultramarine, burnt umber and raw sienna, plus a streak of lemon yellow across the lower sky.

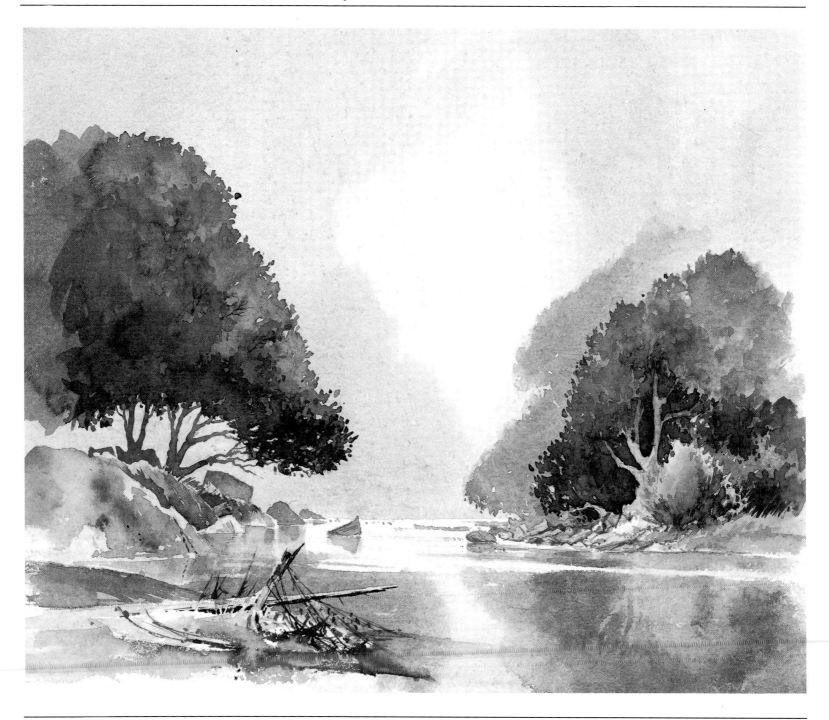

There are several mount-cutters on the market. Daler-Rowney produce a range to cater for all needs, from small hand-held ones to a professional model enabling you to cut double mounts, inlays and v-grooves, plus a cutter capable of cutting oval mounts.

Recommended list of studio materials:
Range of pencils
Watercolour paints
Brushes
Watercolour paper
Large water pot
Palette/tray
Masking fluid
Frisk low-tack film
Eraser
Fixative spray for charcoal and conte sketches
Stanley knife
Gummed tape for stretching paper
Half-imperial drawing board(s)
Sponges
Tissues
Mount-cutter
Mountboard
Steel straight-edge

STANLEY RETRACTABLE KNIFE
This is an excellent tool for sharpening sketching pencils, as it is small, light and *the blade is retractable, and not so loose that it emerges whilst in your pocket.*

METHODS OF CARRYING BRUSHES

Brush tube as made by Daler-Rowney.

Home-made brush and pencil carrier, rolled up when being carried.

Bellamy Mk II 'Pine Foam Bath' brush and pencil container, showing integral water-pot (cap). Try your supermarket *for these items. Holes have been cut in the tube to prevent mildew forming on the brushes.*

ALLEN BANKS, NORTHUMBRIA
I began by wetting the paper with clean water first, then blending in the sky using the wet-in-wet technique with a mixture of monestial blue and Indian red, to create a soft, warm grey. A darker mix of this was then washed in without delay to suggest the far misty trees, and the painting left to dry. Gradually I worked on the closer trees, causing deliberate run-backs in the foliage of the trees on the left by dropping in quite liquid cadmium yellow and Indian red in patches. This had the effect of creating a *warm, autumnal look and when it was dry I masked off some of the run-backs with darker tone where I wanted shadow areas.*

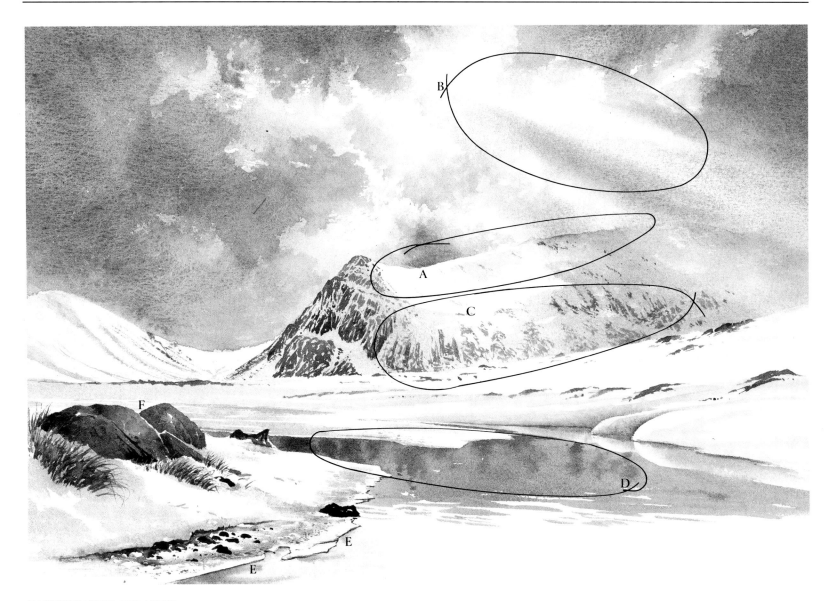

SNOWY WASTES, BEN ALDER

A Counterchange on the skyline where the ridge changes from light to dark.
B Sun's rays done by rubbing with a sponge.
C Glaze over the mountainside to create shadow area.

D Reflections indicated by dropping dark colour into wet wash.
E Hard line at the edge of the ice caused by shadow
F Warmth of rocks provides a contrast and depth.

RIGHT:
SNOWY WASTES, BEN ALDER
After a hard slog up from Culra Bothy with a heavy pack I was glad of the rest, despite a cold wind. The scenery was truly outstanding. Once the sketch had been completed my route lay round the frozen loch to the left and then up over the col seen towards the left-hand side of the picture.

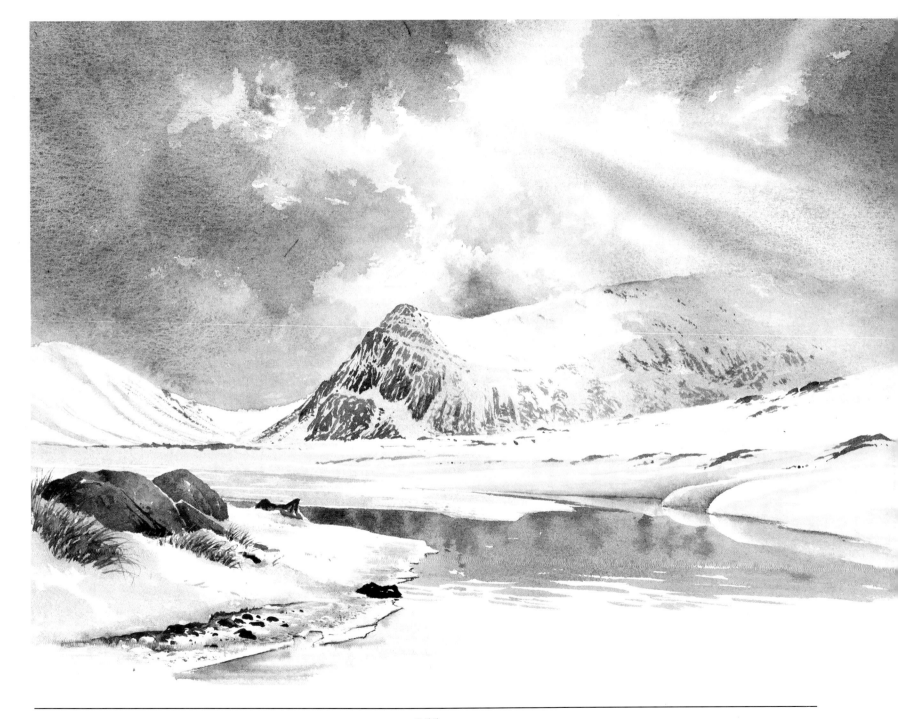

SUPPLIERS AND ORGANIZATIONS

Beaver Art Supplies
Monk Street
Monmouth
Gwent

Berol Ltd
Oldmedow Road
King's Lynn
Norfolk PE30 4JR

Daler-Rowney Ltd
PO Box 10
Bracknell
Berkshire RG12 4ST

Daler-Rowney in USA
Leisure Craft
3061 Maria Street
PO Box 5528
California 90224

Estia Designs Ltd
5–7 Tottenham Street
London W1P 9PB

Frisk Products Ltd
4 Franthorne Way
Randlesdown Road
London SE6 3BT

Frisk Products (USA) Inc
PO Box 88189
Atlanta
Georgia 30338

M Grumbacher Inc
460 West 34th Street
New York 10001

Inveresk Ltd
St Cuthberts Paper Mill
Wells
Somerset BA5 1AG

Jakar International Ltd
Hillside House
2–6 Friern Park
London N12 9BX

Pro Arte
Sutton-in-Craven
Nr Keighley
West Yorkshire BD20 7AX

Rexel Ltd
Gatehouse Road
Aylesbury
Bucks HP19 3DT

Two Rivers Paper Company
Pitt Mill
Roadwater
Watchet
Somerset TA23 0QS

Winsor & Newton
Whitefriars Avenue
Wealdstone
Harrow
Middlesex HA3 5RH

THE ARTIST 63–65 High Street, Tenterden, Kent TN30 6BD
Contains practical art and other articles of interest to artists, plus exhibition, book and material reviews and a gallery guide

AMERICAN ARTIST Billboard, 1515 Broadway, New York, NY 10036
The American equivalent to The Artist

ARTIST'S AND ILLUSTRATOR'S MAGAZINE 4th Floor, 4 Brandon Road, London N7 9TP
Has in-depth articles on art materials plus features on artists, galleries and practical articles

LEISURE PAINTER 63–65 High Street, Tenterden, Kent TN30 6BD
Excellent instructional magazine for beginners and experienced artists alike, crammed with practical articles plus reviews

Royal Institute of Painters in Watercolour (RI) The Mall Galleries, 17 Carlton House Terrace, London SW1Y 5BD

Royal Watercolour Society (RWS) Bankside Gallery, 48 Hopton Street, London SE1

British Watercolour Society 41 Lister Street, Ilkley, Yorkshire LS29 9ET

SELECTIVE BIBLIOGRAPHY

Ball, Wilfred *Weather in Watercolour* Batsford 1986

Bellamy, David *The Wild Coast of Britain* Webb & Bower/
 Michael Joseph 1989

Bellamy, David *The Wild Places of Britain* Webb & Bower/
 Michael Joseph 1986

Blockley, John *Country Landscapes in Watercolour* Watson-
 Guptill 1982

Evans, Ray *A Pocket Guide to Sketching* Collins 1986

Fletcher-Watson, James *Watercolour Painting: Landscapes
 and Townscapes* Batsford 1982

Jamison, Philip *Capturing Nature in Watercolour* Watson-
 Guptill 1980

Mayer, Ralph *The Artist's Handbook of Materials and
 Techniques* Faber & Faber 1972

Merriot, Jack *Discovering Watercolour* A & C Black 1973

INDEX

ACKNOWLEDGEMENTS

I would like to offer my grateful thanks to Sandra Warne for checking the manuscript, to Noel Smith of Burnicle Studios, Newport for taking the stage-by-stage colour photographs, and not least to Catherine for sharpening no less than sixty-three pencils one evening. The quotation by L S Lowry at the start of chapter ten is taken from *The Drawings of L S Lowry* by Mervyn Levy.